THE WATERCOLOUR FLOWER PAINTER'S A TO Z

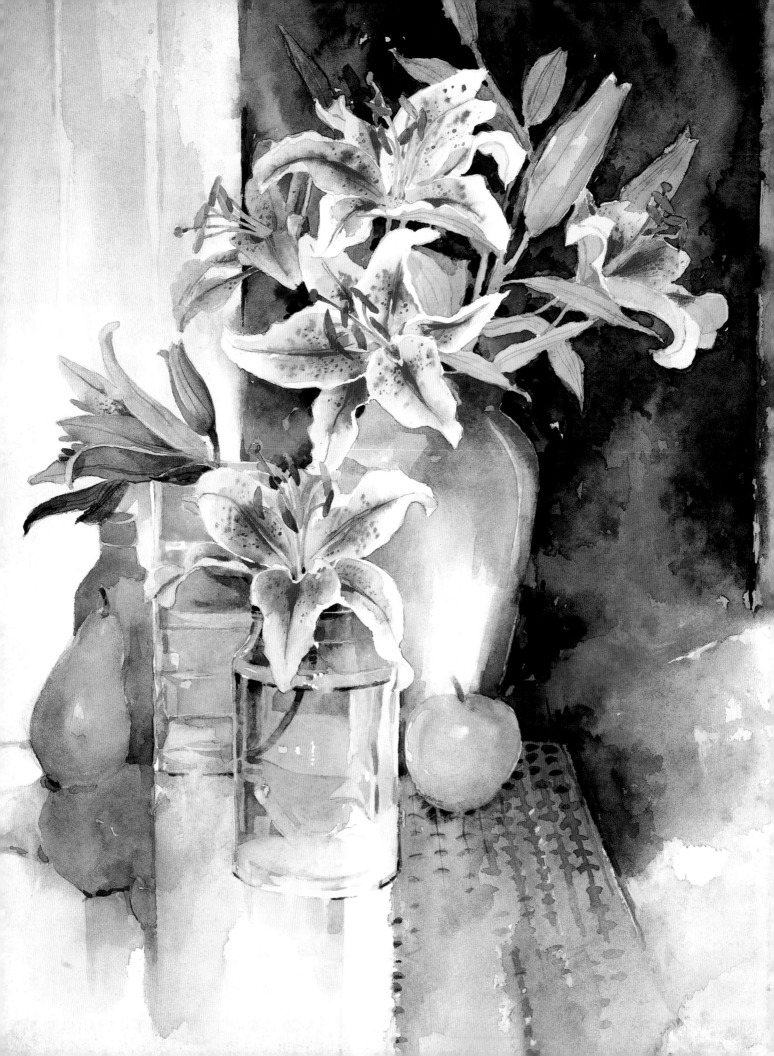

THE WATERCOLOUR FLOWER PAINTER'S A TO Z

The Watercolour Flower Painter's A to Z

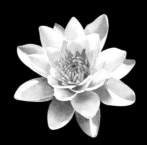

An illustrated directory of techniques for painting 50 popular flowers

SEARCH PRESS

Adelene Fletcher

A QUARTO BOOK

Published in 2001 by Search Press Ltd
Wellwood
North Farm Road
Tunbridge Wells
Kent TN2 3DR
United Kingdom

Reprinted 2002 (twice) , 2003

Copyright © 2001, 2002 Quarto plc.

ISBN 0 85532 978 5

QUAR.TWFP

Conceived, designed and produced by
Quarto Publishing plc
The Old Brewery
6 Blundell Street
London N7 9BH

Project Editor Nadia Naqib
Art Editors Caroline Hill, Jörn Kröger
Copy Editor Hazel Harrison
Designer Johanna Dean
Assistant Art Director Penny Cobb
Photographer Paul Forrester
Proofreader Sue Viccars
Indexer Diana Le Core

Art Director Moira Clinch
Publisher Piers Spence

Manufactured by Regent Publishing
Services Ltd, Hong Kong
Printed by Star Standard Industries
(pte) Ltd, Singapore

Overview

HOW TO USE THIS BOOK

The core of *The Watercolour Flower Painter's A to Z* focuses on how to paint 50 different
species of flower. The opening section looks at the main materials and techniques that every
flower painter will need, while the final section explores aspects of painting floral groups.
**This overview provides a breakdown of each of the three sections (Essentials,
Directory of Flowers and Composition) to enable you to enjoy and benefit**
from this book to the utmost.

*Each of the basic techniques of watercolour painting
are demonstrated using step-by-step photography
and explanatory text.*

*All the core materials needed
by the watercolour painter
are illustrated and
described in full.*

*A brief introduction outlining
the flower's distinguishing
characteristics and colours.*

*The complete colour palette needed to
paint the flower.*

*Special techniques are suggested to help the
painter capture certain vital characteristics
of the flower.*

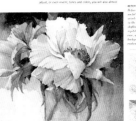

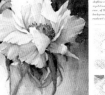

The name in italic type denotes the first part of the flower's Latin or botanical name. The name in roman type denotes the flower's common name.

Detailed step-by-step instructions showing the painter how to paint the flower. Cross references to watercolour painting techniques described in the Essentials section are printed in small capital letters (e.g., WET-IN-WET).

A stunning full-colour image shows the final flower painting.

Aspects of the main flower painting are highlighted for the painter's interest. Tips are given on how the flower's smallest details can be enhanced.

Delphinium elatum

The flower's binomial Latin or botanical name.

The Composition section shows the painter how to paint floral groups. Aspects of composition, such as leading the eye, and warm and cool colours are discussed. All cross references to this section are printed in small capital letters (e.g., COMPOSITION).

Contents

introduction

Flowers are so irresistible that it is not surprising that generations of painters have turned to them for inspiration. Today's artists are especially fortunate in that watercolour, once seen as the poor relation of oils, has fully come into its own as a painting medium, and is the perfect choice for rendering the beauty and fragility of flowers and their vivid or delicate colours. The aim of this book is to show you how to paint a wide variety of flowers in detail, using a range of different techniques and colour mixes.

Floral subjects require a different colour palette from other subjects, for example landscape, and it is important to discover which of those in the vast range now available are best for each type of flower. It is equally important to learn how to mix colours without dulling them, and how to exploit the special qualities of individual pigments – some are more transparent than others, for example. In each of the step-by-step demonstrations that form the core of the book, I have shown the palette of colours that I use, and explained which pigments I mix, or use as transparent overlays, to achieve depth of tone, shadow colours and texture effects.

Each demonstration deals with an individual flower: in all there are 50 of the most popular species, for which I have provided botanical information in addition to painting tips. The idea is to hone your skills on single flowers before building up towards full-scale floral still-life groups, examples of which are shown at the end of the book. You may, of course, wish to restrict yourself to single specimens, taking a botanical approach, and if so, I hope that the book will provide some useful hints.

As well as dealing with the basic watercolour methods, from transparent washes and glazes of colour to more saturated areas of pigment, I have also suggested some special techniques to

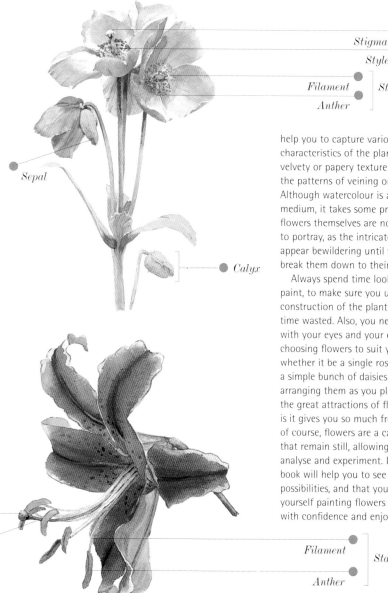

Stigma *Pistil*
Style

Filament *Stamen*
Anther

Sepal

Calyx

Pistil

Stigma

Style

Filament *Stamen*
Anther

help you to capture various vital characteristics of the plants – the velvety or papery texture of petals, or the patterns of veining on leaves. Although watercolour is a lovely medium, it takes some practice, and the flowers themselves are not always easy to portray, as the intricate shapes can appear bewildering until you learn to break them down to their simplest form.

Always spend time looking before you paint, to make sure you understand the construction of the plant – this is never time wasted. Also, you need to respond with your eyes and your emotions, choosing flowers to suit your mood – whether it be a single rose, an orchid or a simple bunch of daisies in a jug – and arranging them as you please. One of the great attractions of flower painting is it gives you so much freedom – and, of course, flowers are a captive subject that remain still, allowing you time to analyse and experiment. I hope that the book will help you to see some of the possibilities, and that you will find yourself painting flowers in watercolour with confidence and enjoyment.

materials and techniques

materials for flower painting

You don't need a vast quantity of materials and equipment to paint beautiful flowers in watercolour. If you are painting flowers for the first time, it is useful to restrict yourself to just a few basic materials to begin with until you have evolved the colours, brushes, paper and other equipment suited to your favourite techniques and particular style of working. This section gives you information on all the basic materials and equipment you will need for watercolour flower painting.

Paints: The choice of colours is vitally important to the flower painter. If you look at the recommended colours shown below, you may notice that the palette is larger than that used by, say, a landscape painter. This is because a mixture of two or more colours is never as vivid as one straight from the tube. Although mixtures are fine for the greens of leaves, you will want to use bright, clear colours for the flowers themselves. The quality of the paint is also of great importance. Transparent watercolours come in two qualities – artist's colours and student's colours. The latter are not always labelled as such, but the former always are, so look for the label 'Artist's watercolour' on the tubes or pans, and don't be tempted by the cheaper versions. Tubes of paint are good for large-scale work, but many artists find pans more convenient, as they fit within a paintbox, and can be carried around easily for outdoor work.

Paintboxes made for pans have central recesses to hold the pans, and fold-out outer 'wings' for mixing colours. If you are using tube paint you will need a separate palette. There are many different versions on the market today.

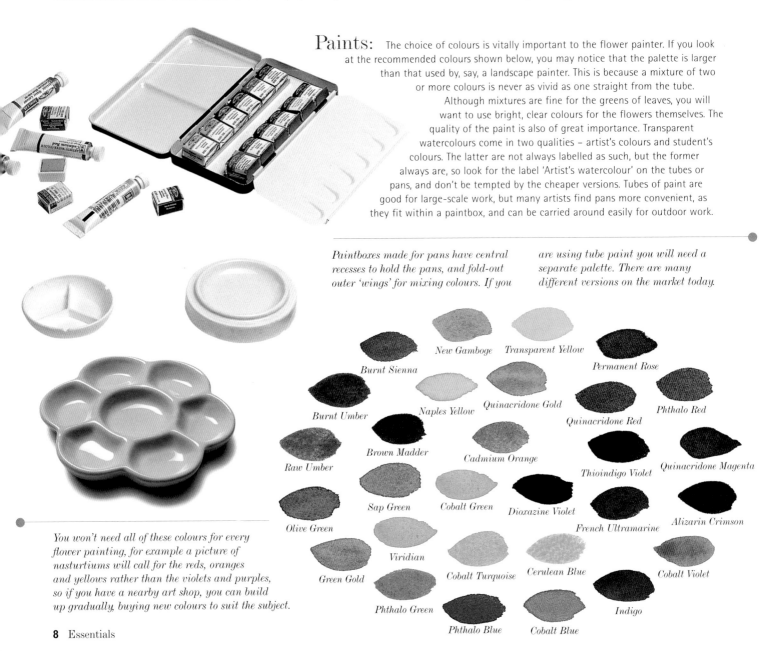

You won't need all of these colours for every flower painting, for example a picture of nasturtiums will call for the reds, oranges and yellows rather than the violets and purples, so if you have a nearby art shop, you can build up gradually, buying new colours to suit the subject.

New Gamboge Transparent Yellow
Burnt Sienna Permanent Rose
Burnt Umber Naples Yellow Quinacridone Gold Phthalo Red
 Quinacridone Red
Raw Umber Brown Madder Cadmium Orange Thioindigo Violet Quinacridone Magenta
Olive Green Sap Green Cobalt Green Dioxazine Violet French Ultramarine Alizarin Crimson
 Viridian Cobalt Turquoise Cerulean Blue Cobalt Violet
Green Gold
Phthalo Green Phthalo Blue Cobalt Blue Indigo

Brushes and Equipment:

Brushes are every bit as important as paints, but you don't need a large range, and depending on the subject, you can often complete an entire painting, from first washes to final details, with just one brush. The best brushes are Kolinsky sable, but there are many less expensive alternatives, either sable and synthetic mixtures or wholly synthetic. Apart from paints, brushes and paper (see following page), you will only require a few additional bits and pieces, many of which you will probably have around the house already, such as jars for water.

Round brushes are extremely versatile, enabling you both to make a great variety of different brushmarks and to paint linear detail. When buying, make sure that the brush comes to a fine point without the hairs splaying out. The rigger brush (bottom, below) is used for very fine detail such as tiny hairs on stems and so on, while the Chinese brushes (second from top, below) produce the calligraphic brush effects seen in Oriental flower paintings.

Kitchen towel is useful for general cleaning up, and can also be used for various lifting out techniques.

Waterpots can cost virtually nothing, as the most commonly used receptacle is a recycled jam jar or yogurt pot, but for clumsy people, or those working outdoors, a non-spill pot (below) is especially useful.

Masking fluid (left) is painted on to reserve highlights (see RESERVING WHITES), and cotton buds (above) and small sponges (below right) are both useful for lifting out paint and softening edges.

You will also need a drawing board, but this can be simply a piece of plywood or other board cut to a size that suits you.

Gummed brown-paper tape (left) is used for stretching paper to prevent it buckling when wet paint is applied. Thicker paper can be attached to the board with masking tape (below left).

Smooth (Hot-pressed) paper (far left) causes the paint to puddle, as there is not enough texture to hold it in place. Some artists like to exploit this characteristic. Cold-pressed paper (center) is the best all-rounder, used by the majority of watercolour painters. Rough paper (left) is less suitable for detailed work, as the grain breaks up the brushmarks, creating broken lines and areas of colour.

Paper:
Watercolour paper is made in three different surfaces: smooth (or Hot-pressed), medium (also known as Cold-pressed, or Not surface) and Rough. Not surface is the most commonly used, as it has sufficient texture to hold the paint but is smooth enough to enable you to paint fine detail. Watercolour paper also comes in different weights, usually expressed in pounds (lbs) referring to the weight of a ream. In general, any paper lighter than about 140 lbs will need stretching, or it will buckle when wet paint is laid on. To do this, simply soak the sheet of paper briefly in the bath, then shake off the surplus water, and lay the paper on a board. Cut four lengths of gummed brown-paper tape, damp them with a sponge, and stick them around the edges, starting with the two longer edges. The paper should be left to dry naturally, not with a hairdryer, so it is wise to do this the evening before painting. The process may sound laborious, but it can be a money-saver, as thin paper is relatively inexpensive.

The delicate mutli-shaped flowers of the Aquilegia are painted with washes of yellow, violet, red and brown (see pages 24–25).

You do not need to buy a wide range of pencils to make flower drawings. A good-quality 2B pencil will give you a wide scope of expression as it is soft enough not to damage the paper but not so soft that it will smudge.

The major paper manufacturers produce paper in both sheet and pad form, the latter being available in a wide range of sizes. Most watercolour pads contain 10–12 sheets, usually of 140-lb paper, which is just heavy enough to use without stretching. If you are using WET-IN-WET techniques involving a lot of water, you might consider tearing off a sheet and stretching it. Cartridge paper, which is very smooth, is used mainly for drawing, though good-quality cartridge will take paint if it used rather dry.

techniques for flower painting

Watercolour lends itself to many different techniques, and there are various tricks of the trade that are particularly helpful to flower painters. It is instructive to know that some of the most valuable flower painting techniques produce textures and patterns without the aid of a paintbrush. Many painters have one or two favourite techniques, and the basic techniques of flower painting can be the starting point for much in the way of experimentation and improvisation. This section looks at the basic techniques used in watercolour flower painting with each technique explained using step-by-step demonstrations.

GRADED WASH ADDING WATER TO LIGHTEN

A graded wash is one that varies in tone, in this case becoming lighter towards the bottom. The gradation is achieved by gradually adding water to the colour.

VARIEGATED WASH TONE AND COLOUR VARIATIONS

1 A variegated wash can contain two or more colours, worked WET-IN-WET. Start by painting the whole shape with a fully loaded brush. Do not apply too much pressure, as this will create unevenness.

2 Wait until the paint has lost its shine, then apply the second, darker colour. This requires practice, as you need to judge the wetness of the first wash with care.

3 The second pigment has diffused easily into the damp surface, resulting in soft edges where the dark colour meets the lighter one. Avoid making any corrections, as this could cause streaking.

VARIEGATED WASH WORKING ON WET PAPER

1 This time, wet the shape first with clean water, bearing in mind that the layer of water will dilute the paint so that the colour will dry even lighter than it would if laid on dry paper. Paint the colour over about half the shape, up to the point where the other colour is to be used.

2 Paint in the rest of the damp shape with the other colour, either going just up to the first colour or overlapping it a little.

3 Leave the colours to blend on the damp surface. Again, resist the temptation to make corrections – just wait to see what happens as the paint begins to dry.

CHANGING THE ANGLE OF THE BOARD COLOUR GRADATIONS

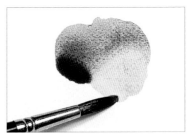

1 If you tilt the board at an angle the
 paint will flow downhill in the
direction of the tilt. Paint the shape with
a fully loaded brush of strong colour – in
this case yellow – then immediately tip
in a darker colour.

2 The first colour will flow gently
 downward and merge with the second
colour creating a very soft, hazy effect.

Gradations of colour can be made in a
similar way, but this time by introducing a
new colour to the first and letting them
blend together as you proceed down
the paper.

BRUSHMARKS VARYING THE BRUSHSTROKES

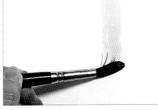

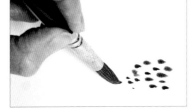

A fully loaded round brush will deposit a lot
of paint on the paper. Charge the brush
with colour, hold it sideways at about a
30-degree angle to the paper, then pull it
downward, pressing the whole body of the
brush onto the surface.

Now try picking up just a little paint with
the tip of the brush and applying it to the
paper, varying the pressure to create light
and dark feathery marks.

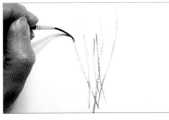

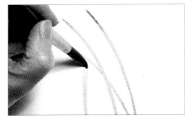

Graceful and supple linear marks can be
made with a rigger brush, using a stroking
motion and keeping the brush vertical to
the surface.

Here heavier linear lines are made with a
thicker brush. The stroking motion is made
against the natural form of the brush,
creating a brushstroke that is thinner at the
top than it is at the bottom.

BRUSHMARKS BRUSH PRESSURE

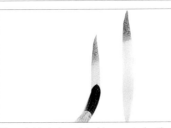

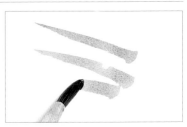

If a petal is to be painted in one stroke, the
pressure of the brush can be altered so that
the brushstroke describes the shape. Using
a pointed, semi-loaded brush place the tip
firmly on the paper and pull down in a
fluid movement, at the same time pressing
the bristles flat.

This shape, which could be a leaf or a petal,
requires two strokes. Pull the first one
downward from the point at the tip,
pressing the brush down to the bottom of
the shape, then lift the brush to reverse the
stroke so that it meets the first at the
starting point.

Diagonal marks can be made by pushing
the brush to the left or right, starting with
a firm pressure and gradually lifting the
brush to finish with a point.

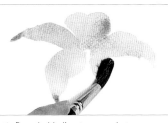

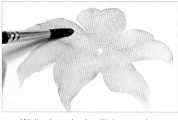

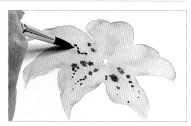

1 For a bold, direct approach, try combining some of the previous strokes. To start, paint the lily petals with a pale Permanent Rose, using one or two brushstrokes for each one.

2 While the paint is still damp, paint a central strip down each petal, using one stroke of pale Transparent Yellow.

3 Before the petal colours have dried completely, stroke in the spotted effect on each petal, using the tip of the brush and stronger Permanent Rose.

BRUSHMARKS TWO-COLOUR BRUSHWORK

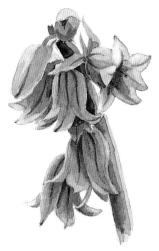

1 Mix a quantity of each colour, in this case a mid-toned Permanent Rose and a fairly strong New Gamboge.

2 Dip a round brush into the Permanent Rose.

3 Holding the brush level, dry the tip with a clean tissue and then dip it into the yellow.

4 Holding the brush slightly sideways and at a flattish angle to the paper so that both the colours come into contact with the paper, press down from the tip, pulling the stroke downward. Variations can be created by holding the brush more vertically.

BLENDING SOFT EDGES SOFT BLENDED COLOURS

Painting wet-in-wet simply means working in new colours, or water, before the first washes have dried, creating soft edges and subtle blends. Paint the bulk of the petal, stopping just before the base, and then use a damp brush to stroke the edge of the wash so that the colour grades softly.

1 Paint the entire petal with a well-charged brush of a strong watery colour, letting it dry a little until the surface has lost its shine.

2 While the paint is still damp, but not too wet, you can add further colours to achieve soft blends, but it is vital to learn to judge the wetness of the first washes. Drop stronger paint or a darker colour at the base of the petal and leave to blend.

1 This method is a variation of wet-in-wet in which wet colours are butted up to one another to blend. First paint a stroke of Permanent Rose.

2 Before the first stroke has dried, paint a strip of Cobalt Blue up to and just touching the previous stroke so that the two colours blend softly.

1 The mottled effect of backruns often occurs by accident, causing dismay, but they can also be deliberately induced. Paint a shape of wet Phthalo Blue onto dry paper, and let it dry just until it loses its shine.

2 Now drop either watery paint or clear water from the tip of a brush onto the damp blue. The water content of the dropped-in colour must be higher than that of the previous colour.

3 You can see that the watermark effect might not be welcome in a flat wash for, say, a sky, but for a floral subject it can be very effective.

1 A wet wash laid on dry paper forms hard edges as it dries. Here a shape of Sap Green is painted on, and will be allowed to dry before adding further colour.

2 To exploit the crisp edges, always allow the first wash to dry. Here clearly defined leaf veins are painted wet-on-dry with a small brush.

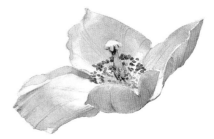

1 In this method, the first layer of colour must be fully dry before further thin layers of pure colour are laid over it. Begin with a pale wash of yellow, the lightest colour. This is not suitable for glaze as it does not cover the other pigments well.

2 After the yellow has dried, apply a second wash, or glaze, of pale Permanent Rose. Notice how this changes the colour by warming it. Never go back over a glazed area, as this will stir up the colours and destroy the effect.

3 When the rose layer is dry, paint on a final layer of Cobalt Blue. Glazing is a way of mixing colours on the painting surface rather than in the palette, and you can use any combination of colours the subject demands.

HARD AND SOFT EDGES

SHARP, CRISP EDGE

1 To achieve a crisp edge on a stem, first paint a very wet linear stroke using a green such as Sap Green.

2 With the green still wet, use the tip of the brush to lightly touch in watery yellow down the centre of the stem.

3 This works in the same way as backruns, pushing the green pigment to the outside of the first brushstroke to give a very characteristic watercolour edge.

HARD AND SOFT EDGES

SOFTENING EDGES WITH A TISSUE

1 Paint the leaf with a watery but strong yellow, and while still wet, touch in stronger green with the tip of the brush, letting the colours merge softly.

2 Wipe across the edges to be softened, immediately, whilst the paint is still wet, with some clean paper tissue. You might need to repeat the process.

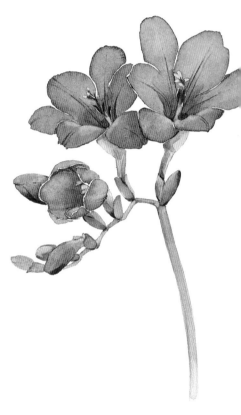

HARD AND SOFT EDGES

USING A SPONGE

1 To soften edges with a sponge, paint the shape with two tones of Burnt Sienna and allow to dry. To soften the edge, dampen the sponge and wipe the area to coax the paint off the paper. Use a tissue to blot away any paint that escapes the edges.

2 The dry paint creates a slightly broken quality and is useful for suggesting fine linear markings found on some petals.

DRY BRUSH

TIPS FOR DRY BRUSHWORK

1 You will need a small piece of spare paper (the same as you are working on) to test your strokes.

2 Open up the hairs in the round brush so that they fan out, then press the bristles right down to the ferrule on the spare paper.

BROKEN COLOUR

This technique uses the bare minimum of paint on the brush, so that the colour just skims over the surface of the peaks in the paper.

RESERVING SMALL HIGHLIGHTS

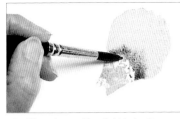

1 Reserving intricate highlights such as these stamens seen against a poppy petal are awkward to paint around, so the best method is to reserve them with masking fluid before painting. Use an old brush, and wash it out immediately with warm, soapy water.

2 When the masking fluid is dry, it can be freely painted over as it acts as a block to the paint. Here New Gamboge and Permanent Rose are used to complete the petal washes.

3 When the paint has dried, the masking can be removed by gently rubbing with a finger or a soft eraser to reveal clean, white paper. If the highlights are a pale colour rather than pure white, they can be tinted in the final stages.

MASKING SPECIAL EFFECTS WITH WAX

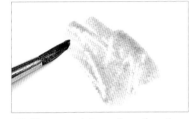

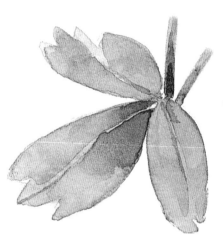

1 Wax – which can be candlewax, wax crayon or oil pastel – also blocks the paint, but less completely than masking fluid, so it can produce interesting textures. First lightly draw or scribble with a candle.

2 When you paint over the surface, the colour will slide off the waxed areas, setting in the troughs of the paper grain. This gives a delightfully unpredictable speckled effect.

NEGATIVE PAINTING DEFINING LIGHTER SHAPES

1 An alternative to masking out to create light shapes and highlights is to paint around them with darker colours, known as negative painting. Paint the leaf shape with a wash of pale yellow and let it dry.

2 You need to plan in advance where the leaf veins are to be so that you can leave them as the initial wash. When you have decided, paint the second tone over the leaf, reserving the lighter vein markings.

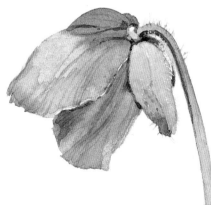

LIFTING OUT REMOVING COLOUR FOR HIGHLIGHTS

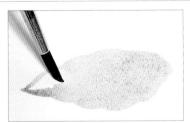

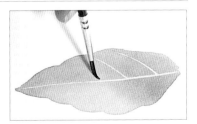

1 This is one more method of creating highlights. Paint the leaf shape with a wash of mid-toned green and let it dry completely.

2 With a small, moist brush paint in the leaf veins to be lifted, repeating the strokes until you have removed sufficient paint, then blot with a clean tissue.

LIFTING OUT LARGER DIFFUSED HIGHLIGHTS

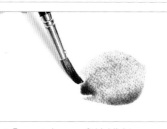

1 To create larger soft highlight areas, you can use a tissue, this time lifting out from wet paint. Paint the shape and have a clean tissue to hand.

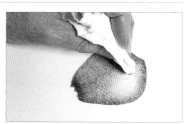

2 Lift out the highlight immediately. This is the best method for creating soft, indefinite shapes, such as the subtle sheen on a petal or leaf.

USING A STICK PETAL AND LEAF VEINS

1 Pressing into wet paint with a stick indents the paper so that the paint flows into it, resulting in darker lines ideal for veining. Lay a wash to create a poppy petal, lightening the tone at the base.

2 With the paint still wet, draw lines with the stick to describe the veins. The effect is similar to pencil marks, but more subtle.

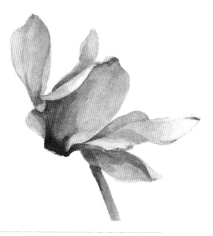

BODY COLOUR USING WHITE GOUACHE

1 Gouache is the opaque version of watercolour, and is often used for highlights, either on its own or tinted with watercolour. Here it is used for stamens, as an alternative to masking out. Paint the petal with yellow, and when nearly dry, paint the petal markings with a darker red.

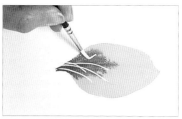

2 In this case the white gouache is being tinted. When you do this, avoid diluting the gouache too much, or it will not cover the earlier colours – you need only just enough dilution to produce a painting consistency.

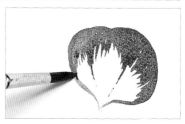

3 Paint in the stamen stalks with a small brush, using the body colour sparingly, as gouache has a matt surface which can look dull and out of place beside a watercolour wash.

SCRATCHING OUT WITH A BLADE

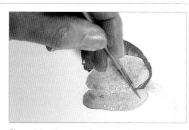

Fine white lines can be created by scratching colour away with a blade to reveal the white paper, a method known as *sgraffito*. Let the painted surface dry completely, then use the point of the knife to scratch into it, taking care not to make holes in the surface.

RESERVING WHITES CLASSIC METHOD

Before painting aids such as masking fluid were invented, highlights were reserved by carefully painting around the white shape, and some watercolour painters still take pride in their mastery of this classic method.

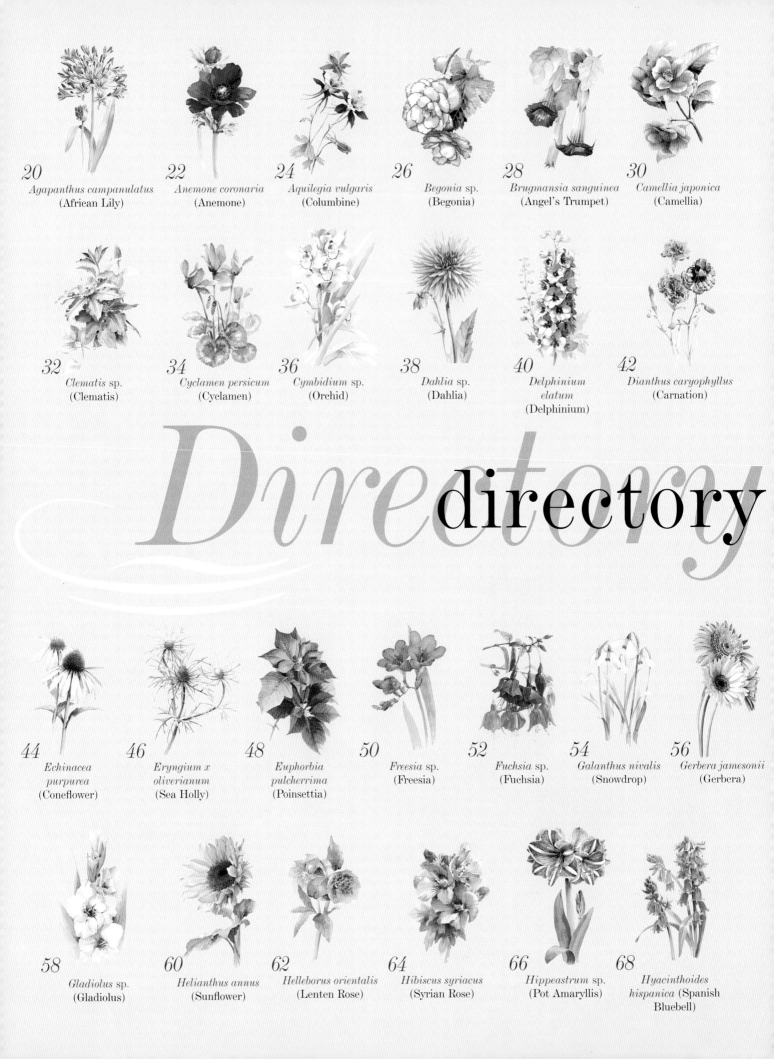

20
Agapanthus campanulatus
(African Lily)

22
Anemone coronaria
(Anemone)

24
Aquilegia vulgaris
(Columbine)

26
Begonia sp.
(Begonia)

28
Brugmansia sanguinea
(Angel's Trumpet)

30
Camellia japonica
(Camellia)

32
Clematis sp.
(Clematis)

34
Cyclamen persicum
(Cyclamen)

36
Cymbidium sp.
(Orchid)

38
Dahlia sp.
(Dahlia)

40
Delphinium elatum
(Delphinium)

42
Dianthus caryophyllus
(Carnation)

Directory

directory

44
Echinacea purpurea
(Coneflower)

46
Eryngium x oliverianum
(Sea Holly)

48
Euphorbia pulcherrima
(Poinsettia)

50
Freesia sp.
(Freesia)

52
Fuchsia sp.
(Fuchsia)

54
Galanthus nivalis
(Snowdrop)

56
Gerbera jamesonii
(Gerbera)

58
Gladiolus sp.
(Gladiolus)

60
Helianthus annus
(Sunflower)

62
Helleborus orientalis
(Lenten Rose)

64
Hibiscus syriacus
(Syrian Rose)

66
Hippeastrum sp.
(Pot Amaryllis)

68
Hyacinthoides hispanica (Spanish Bluebell)

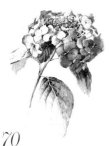

70
Hydrangea sp.
(Hydrangea)

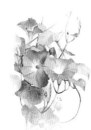

72
Ipomoea purpurea
(Morning Glory)

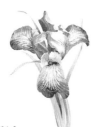

74
Iris douglasiana
(Pacific Coast Iris)

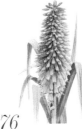

76
Kniphofia uvaria
(Red Hot Poker)

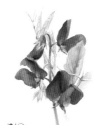

78
Lathyrus odoratus
(Sweet Pea)

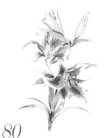

80
Lilium orientalis
(Stargazer Lily)

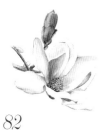

82
*Magnolia x
soulangiana*
(Magnolia)

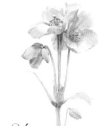

84
Meconopsis grandis
(Himalayan Blue
Poppy)

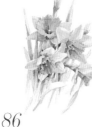

86
Narcissus sp.
(Daffodil)

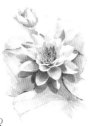

88
Nymphaea x marliacea
(Waterlily)

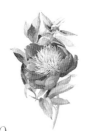

90
Paeonia lactiflora
(Peony)

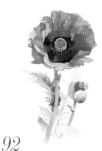

92
Papaver orientale
(Poppy)

of flowers

94
Passiflora caerulea
(Passion Flower)

96
*Pelargonium x
hortorum*
(Geranium)

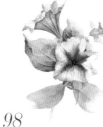

98
Petunia sp.
(Petunia)

100
Primula vulgaris
(Primrose)

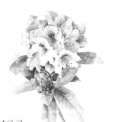

102
*Rhododendron
yakushimanum*
(Rhododendron)

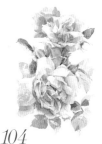

104
Rosa wichuraiana
(Rambler Rose)

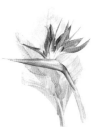

106
Strelitzia reginae
(Bird of Paradise)

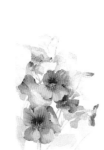

108
Syringa vulgaris
(Lilac)

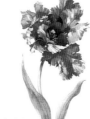

110
Tropaeolum majus
(Nasturtium)

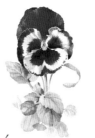

112
Tulipa sp.
(Tulip)

114
Viola x wittrockiana
(Pansy)

116
Wisteria sinensis
(Chinese Wisteria)

118
*Zantedeschia
aethiopica*
(Calla Lily)

Agapanthus African Lily

Agapanthus, which blooms at the hottest time of the year, reflecting its African origins, makes a speciality of the colour blue. It is multi-headed with basically cone-shaped florets that grow on a single supporting stem, each floret being segmented into petals that flare out to form a trumpet. The stalks of the florets radiate out from one point and collect to form a sphere. Observe how light and shade give roundness to the form – in this case most shadow is on the left – and how the background florets are paler and less detailed than those in the front.

sequence start to finish

Transparent Yellow

Permanent Rose

Dioxazine Violet

Cobalt Blue

Phthalo Blue

French Ultramarine

Sap Green

Olive Green

Quinacridone Gold

1 Working on hot-pressed paper, and with a 2B pencil, draw in faintly the florets and stems. Mask out (see MASKING) the white stamens in the open flowers.

2 Paint one floret at a time. Using a No. 6 round brush and a palette of Cobalt Blue, French Ultramarine, Permanent Rose and Dioxazine Violet, both in mixes or on their own, paint a facing floret with a pale colour, basically blue but with a hint of Permanent Rose now and then. With the paint still damp, paint in thin central petal veins and allow colours to blend a little. Give a similar first wash to all the buds and florets, then leave to dry.

3 Now add petal shadows, using the same colours as before. Work around the sphere to the left-hand side where most of the florets are in shadow. Vary the tones of the buds and florets to make them recede or advance. Use Dioxazine Violet to paint final accents.

4 With a small brush, and again using Dioxazine Violet, strengthen most of the central petal veins, but watch how the light affects the tone – the veins are not equally dark down their full length. On the facing florets, add a green throat with mid-toned Sap Green.

5 Paint the stalks of the florets with a fine brush and mid-toned Sap Green, with the addition of just a little Transparent Yellow. When dry, darken some with strong Olive Green to make them come forward. Make sure that some of the stalks are painted over buds and florets to give the impression of a few being at the back of the sphere. Paint the flower stem with Sap Green and Transparent Yellow mix, and while still wet, shade with a mix of Sap Green and French Ultramarine to give a cylindrical appearance.

6 Now paint the bud, washing over the emerging small bud shapes with mid-toned Cobalt Blue and then the bud casing with Quinacridone Gold, letting the two colours merge a little towards the bottom of the shape. Paint the stalk with the same mix as the flower stalk, and leave to dry. To finish the bud, paint a shadow on the left side of each small shape with French Ultramarine and Dioxazine Violet. Add fine lines to the casing, with darker Quinacridone Gold, following the form, and use dark Olive Green where the sepal joins the stem.

7 Lay a first wash of Sap Green and Transparent Yellow over the fleshy strap leaves, bluing the colour with pale watery Phthalo Blue on the right leaf as it recedes under the flower head. Darken the right side with a stronger mix of Sap Green and Phthalo Blue. Also darken the underside surface of the left leaf, and paint in the centre veins with a fine brush.

8 Rub off the masking on the stamens, and paint the dark anthers with Dioxazine Violet and Olive Green.

special detail control of tonal values

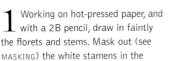

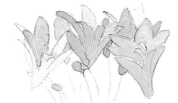

▼ *Build up the mid-tones on the florets with stronger mixes of the previous colours, and lay the first washes on the stalks with a Sap Green and Transparent Yellow mix.*

▲ *Both tones and colours need to be carefully controlled or they could become too similar. The petal backs are slightly darker in tone, and the petals in the background are a cooler bluer colour. For the first washes, use mixes of Cobalt Blue, French Ultramarine, Permanent Rose and Dioxazine Violet.*

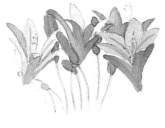

▲ *The smallest dark shapes and marks, for example the central petal veins and the dark tones on the buds, are painted last, with Dioxazine Violet. Adjust the stalk tones with some darker tones of a Sap Green and Olive Green mix, then remove the masking and tint the stamens with pale greens.*

The stamens are masked
out to reserve them as pale
shapes. Care must be taken
to make them appear to link
up with the floret stalk.

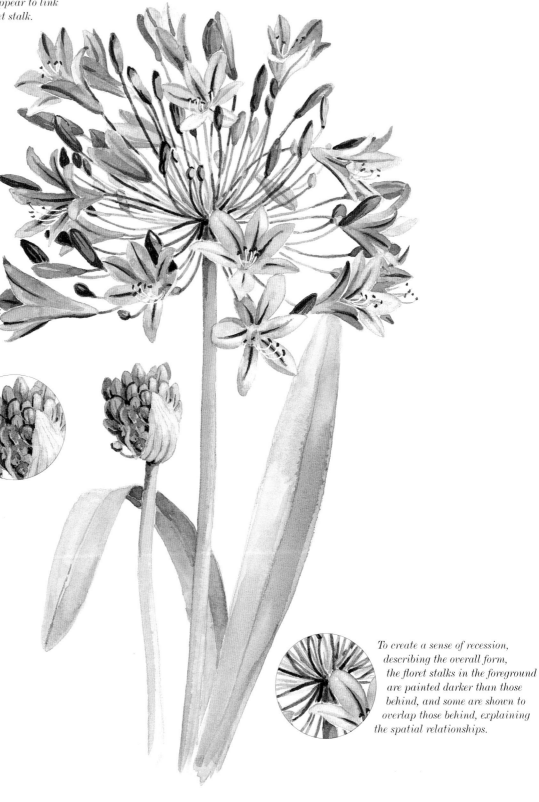

The forms of the individual
tiny buds are described
by sensitive linear details,
while the variations of
tone, from light to dark,
give the impression of the
overall spherical shape.

To create a sense of recession,
describing the overall form,
the floret stalks in the foreground
are painted darker than those
behind, and some are shown to
overlap those behind, explaining
the spatial relationships.

Agapanthus campanulatus

Anemone Anemone

This poppy-like flower in vivid reds and purples makes an eye-catching splash of colour. The stem carries a characteristic whorl of green leaf-like bracts, which form a ruffled collar of foliage framing the flower. At the base of the simple petals is a more complex centre, containing many stamens sprouting from the middle. The cup shape of the buds opens into a bowl, flattening out when fully open. Look for the way the light strikes the petals to emphasise this basic shape, giving a sense of roundness and solidity.

sequence start to finish

Transparent Yellow

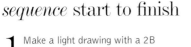

Quinacridone Magenta

Thioindigo Violet

Dioxazine Violet

Indigo

Phthalo Blue

French Ultramarine

Sap Green

Olive Green

Quinacridone Gold

1 Make a light drawing with a 2B pencil, paying special attention to the ellipse formed by the petals, and making sure that they radiate out from the centre. Mask off just a few of the stamens (see MASKING).

2 The light is coming from the right, so begin with pale washes on this side, using a No. 12 round brush to wash on pale to mid-toned shades of Dioxazine Violet, Thioindigo Violet and Quinacridone Magenta. Load the brush well, so that the colours flow onto the paper, and dab in small touches of French Utramarine for richness. The colours are generally warmer on vertical surfaces facing the light, and cooler on flat surfaces and areas in shadow. Allow to dry.

3 The bud has a soft downy texture on the backs of the petals. Begin with a first wash of pale Dioxazine

Violet, then lay a first wash on the stalks and foliage, using mixes of Phthalo Blue, Sap Green and Transparent Yellow.

4 Strengthen the washes on the flower from mid-tone to dark, using the same colours as before, but adding French Ultramarine to some mixes. Leave as much of the first wash as possible: even though the flower is quite dark-toned overall, it is important to introduce some variety in tone to create interest as well as to make the most of the cup shape.

5 Apply some dry brushwork to the bud, using Dioxazine Violet to show the texture, then paint the mid-tone on the foliage with small No. 6 brush and the colours previously used for the foliage. When dry, darken a few fronds, especially those in shadow, with stronger Sap Green and Olive Green.

6 Paint in the darkest crevices in the flower with Dioxazine Violet, and when dry, rub off the masking from the stamens. The central boss is catching the light, and must be kept pale in tone. Paint this first by wetting the shape with clear water and, when nearly dry, stroking in short, form-following brushmarks of pale Dioxazine Violet and Quinacridone Gold. Blot with a tissue to make a diffused highlight.

7 Paint in the dark anthers with a small brush and dark Indigo, then finish by adding a few of the lighter coloured anthers with white gouache tinted with Quinacridone Gold (see BODY COLOUR). When dry, add some filaments going over the pale anthers with a fine brush and Indigo.

special detail wet-in-wet within a shape

▼ *Puddle a loose wash of Dioxazine Violet over the whole of the shape, and then vary the tones and colours by dropping in French Ultramarine and Quinacridone Magenta while still very wet. Tip the board slightly towards the petal base to let the colours merge, and leave to dry in this position.*

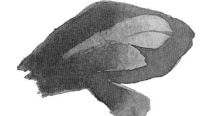

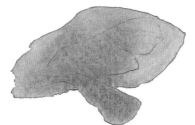

▲ *The next stage is to paint around the lighter top petal with a wash of Dioxazine Violet, immediately dropping in stronger mixes of the first-wash colours around the petal base, and still keeping the board on a slight slant. Soften the edges into the top petal, then leave to dry.*

▼ *Complete the shapes with a few small accents of dark Dioxazine Violet beneath the lighter petal, to crisp up the edges and make it stand out.*

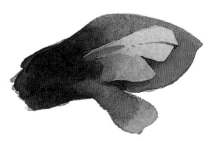

The downy texture of
the petal backs is
suggested by using the
DRY BRUSH technique.

The solid,
protuberant
form of the flower
centre catches the
light, and this
contrast with the dark
stamens creates the perfect
focal point (see COMPOSITION).

The delicate, intricate forms
of the foliage act as a foil to the
bold shapes of the flower, and
are worked more tightly than
the petals. Recession is created
by variations of tone, with the
dark parts of greenery receding and
the light ones advancing.

Anemone coronaria

Aquilegia Columbine

The old-fashioned cottage-garden perennial, the original wild columbine sometimes called 'Granny's bonnet', is less exotic than these hybrid aquilegias, with their large, often bi-coloured flowers in glorious shades. They have long slender spurs and elegant divided clumps of blue-green foliage, and are multi-shaped flowers – a flat five-petalled disk with a cup shape, also five-petalled, sitting on top. There are five spurs, which come between the outer petals but are not attached to them. Here, the 'McKana Giant Hybrid' bears flowers in cream and crimson.

sequence start to finish

Quinacridone Red

Quinacridone Magenta

Thioindigo Violet

Dioxazine Violet

Cobalt Blue

Sap Green

Naples Yellow

Quinacridone Gold

Brown Madder

1 Make a careful drawing, ensuring that the stamens line up with the stalk and that the spurs are a continuation of the cup. Mask off (see MASKING) the stamens where they disappear down the throat of the cup, light against the deep-coloured flower centre.

2 Wash over the light petals of the top cup with Naples Yellow, blotting into the wet colour with a tissue to lift out (see LIFTING OUT) highlights on the nearest front petals. Leave to dry before painting the darker back petals with a pale mix of Brown Madder and Quinacridone Red. The back petals on the top flower are cooler in colour, so add a touch of Dioxazine Violet to the mix. Allow to dry again.

3 Paint cool shadows in the centres of the cups with a pale wash of

Cobalt Blue, and on the outer surfaces, use a slightly darker mix of Cobalt Blue and Dioxazine Violet. Tint the spurs with a Brown Madder and Quinacridone Red mix, lightening the shade towards the tips, which are then spotted with Naples Yellow. Blend the colour of the spurs into the base of the segmented cups, softening the edges.

4 In the throat of each cup there is a dark blotch. Paint this with a dab of Quinacridone Magenta, dropping in a spot of Dioxazine Violet at the base while still wet (see WET-IN-WET). Strengthen the colour of the outer petals with a Brown Madder and Quinacridone Magenta mix, leaving the light central vein as the first wash. Allow this to dry then tip in colour at the petal base with Thioindigo Violet, and use a clean damp brush to pull

colour down the petal to blend. Use weaker washes but the same method for the top flower.

5 Paint the bud in the same colours, with a touch of Sap Green dropped into the damp washes, then leave to dry before adding darker details with stronger mixes of these colours.

6 Rub the masking off the stamens, and tint with Quinacridone Gold, using Thioindigo Violet for some of the anthers. For the wispy stems, use mixes of Sap Green, Cobalt Blue and Thioindigo Violet, varying the tones and shades for a three-dimensional effect. Paint first washes on the leaves, using Naples Yellow, Sap Green and Cobalt Blue, finishing with stronger but cooler mixes, and reserving the central veins.

special detail pulling color out

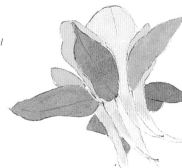

▼ *On the darker outer petals, the first wash is reserved for the central vein by pulling colour down on either side of it. Paint a mix of Brown Madder and Thioindigo Violet on the tip of the petal. Immediately, use a clean, slightly damp brush to touch into the lower edge of the new colour and lightly drag it down. Repeat the process on the spurs, this time using Brown Madder alone, starting at the tip of the spur and blending into the cup shape. Allow to dry.*

▲ *Paint on first washes with mixes of Naples Yellow and Dioxazine Violet, followed by Brown Madder and Quinacridone Red for the darker petals. Do not allow the two colours to merge. Leave to dry fully before the next stage.*

▲ *For the dark tips and bases of the red petals, use the same brushstroke, this time with Dioxazine Violet. Strengthen the back spurs with Brown Madder, and add a small touch of Sap Green in the centre to suggest a glimpse of the stalk.*

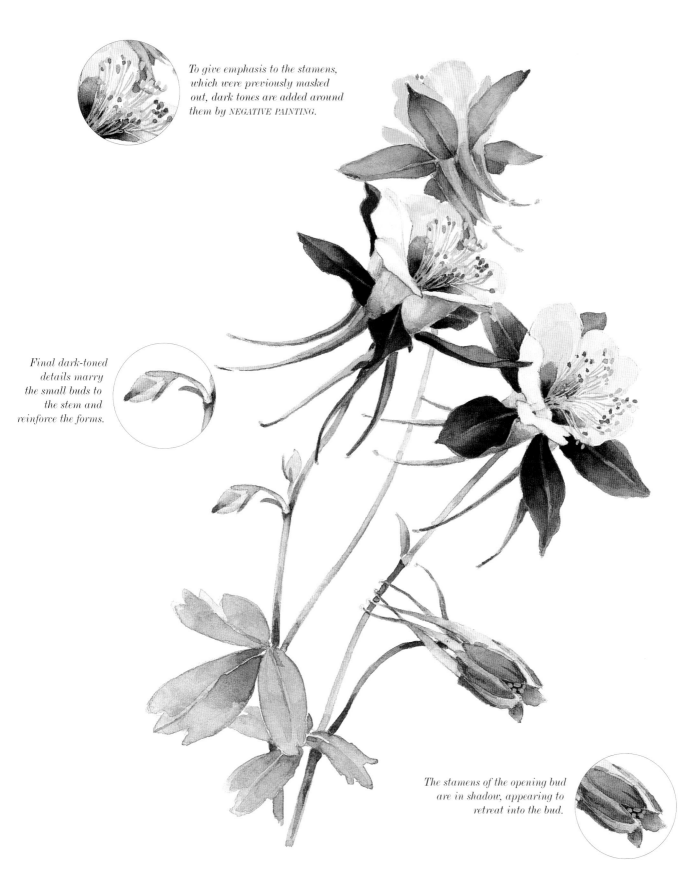

To give emphasis to the stamens, which were previously masked out, dark tones are added around them by NEGATIVE PAINTING.

Final dark-toned details marry the small buds to the stem and reinforce the forms.

The stamens of the opening bud are in shadow, appearing to retreat into the bud.

Aquilegia vulgaris

Begonia Begonia

There are a great many species of begonia, and a commensurately wide range of colours. This pendulous variety has slender drooping stems, large, handsome leaves with serrated edges, and pure white, red-margined flowers with elegantly ruffled petals. The fully opened flower is bowl-shaped, with the many curving petals radiating out from the tight centre, and becoming larger towards the outside edge. Notice how the colours become cooler as the petals turn away from the light, and how the shadows in the half-open flower are deeper than in the fully open bloom.

sequence start to finish

New Gamboge

Quinacridone Red

Alizarin Crimson

Permanent Rose

Quinacridone Magenta

Dioxazine Violet

Cobalt Blue

Phthalo Blue

Sap Green

Olive Green

Quinacridone Gold

1 Make a careful drawing, looking closely to see which way the petals curve; some will be convex and others concave. Before you begin to paint, analyse the fall of light to decide which areas you will reserve (see RESERVING WHITES) as pure white paper.

2 Treat each petal separately, laying on various mixes of New Gamboge, Cobalt Blue and Permanent Rose in either warm or cool shades. Soften edges if needed with a clean damp brush, then leave to dry. Begin to adjust the colours, strengthening them in shadowed areas by glazing with either Cobalt Blue or mixes of New Gamboge and Permanent Rose. Leave the darkest crevices till last, and paint them with Quinacridone Gold and Quinacridone Magenta. Treat the smaller flower in the same way, but notice that because it is mainly in the shade, there are more dark areas, some of which are quite warm and intense.

3 Next, paint the main leaf, using fairly pale washes mixed from New Gamboge, Sap Green and Cobalt Blue. Leave to dry, and paint around the leaf veins to reserve them, using mixes of Sap Green and Phthalo Blue, and varying the hue from green to blue-green. While still damp, mix Alizarin Crimson with Sap Green to make a mid-tone, drop in here and there and allow to blend. This creates a colour link between the leaf and the flowers. Allow to dry.

4 Return to the flowers, and start on the first stage of the ruffled edges, using a No. 8 round brush. Mix up pale to mid-toned washes of Permanent Rose, plus just a touch of Quinacridone Gold for the sunnier parts of the main flower, and edge every petal with brushstrokes (see BRUSHMARKS) of varying thickness, following the curve and curl of the petals. To complete the petal edges, use a fine brush and a mix of Quinacridone Red and Alizarin Crimson to go around each petal,

making broken marks, again letting the brush follow around the shapes. Vary the tones according to whether the petals are in light or shade. On the smaller flower, the red is paler on the lower back petals, so that they appear to recede. At the end, dab in a few of the darkest small accents with Dioxazine Violet.

5 To finish the main leaf, use strong Olive Green to paint in a few dark negative shapes behind the main flower. This deep tone pushes the flower forward and also provides a complementary contrast to the flower colour. Lay a wash of a New Gamboge and Permanent Rose mix on the small bud, dabbing out the white highlight with a tissue. Paint the stalks with the same colours, adding Alizarin Crimson to darken on the shadowed side. Keep the small back leaf very pale and delicate, again using the previous colours.

special detail blending curled surfaces

▲ *The local colour (the actual colour of the flower) is a soft cream, but surfaces catching most light can be left as white shapes. For the base colour, use a mix of New Gamboge, Permanent Rose and Cobalt Blue, and paint it all over the petals, reserving the whites, and adjusting the hue to a warm or cool version (see COMPOSITION).*

▲ *As the petals turn away from the light they become cooler in colour. Paint in these shaded areas with a mix of Cobalt Blue and Permanent Rose. This makes a cool purple, the complementary to the cream (see COMPOSITION). There is some warm-coloured reflected light in the shadows, so drop in a mix of Quinacridone Gold and Permanent Rose to blend.*

▲ *Paint the dark ruffled edges, beginning with a fairly pale mix of Permanent Rose and Quinacridone Gold and then darkening with Alizarin Crimson on the edges.*

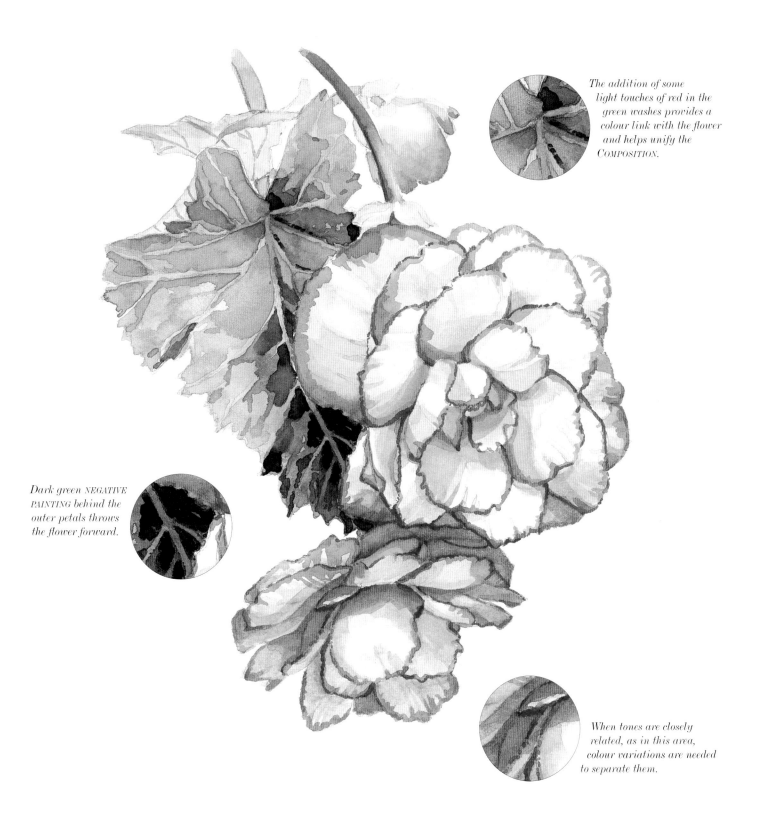

The addition of some
light touches of red in the
green washes provides a
colour link with the flower
and helps unify the
COMPOSITION.

Dark green NEGATIVE
PAINTING behind the
outer petals throws
the flower forward.

When tones are closely
related, as in this area,
colour variations are needed
to separate them.

Begonia sp.

Brugmansia Angel's Trumpet

These enormous cone-shaped flowers, some 10 inches (25 cm) long, are both bewitchingly beautiful and deliciously fragrant. They hang down from a stem attached to the centre top and flare out widely at the bottom to form a trumpet shape, the style protruding like the clapper in a bell. A well-defined side light helps to reveal the volume and the deep shadow inside, which sometimes catches a shaft of light on the back inner edge of the flare. The ribs on the tubular section need to be painted accurately and allowed to follow though into the flare.

sequence start to finish

Transparent Yellow

New Gamboge

Quinacridone Red

Alizarin Crimson

Thioindigo Violet

Cobalt Blue

Phthalo Blue

Phthalo Green

Olive Green

Green Gold

Quinacridone Gold

1 After making a light drawing, mask out (see MASKING) just the central stigmas. The best way to start painting is to first establish the broad distribution of flower and leaf shapes with pale washes, thereafter building up in stages toward the darkest tones.

2 Starting with the right-hand flower, paint a loose wash of New Gamboge right down the tubular section and lift off (see LIFTING OUT) some of the colour with a clean, damp brush on the left where light catches the form. Paint the bud with a pale wash of Green Gold, adding a small amount of Phthalo Blue to darken the shadowed areas slightly. Paint inside the flare with a mix of New Gamboge and Quinacridone Gold. Allow to dry.

3 Now work on the leaves and flower sepals, first laying watery washes of Transparent Yellow and Green Gold on the sepals, and adding a small amount of Phthalo Blue to darken them on the

right side and where they emerge from under the leaves. Lay the first pale washes on the leaves, using mixes of Green Gold, Transparent Yellow and Phthalo Blue. These first washes will be reserved as the leaf veins.

4 The ribs on the long tubes are also defined by reserving pale colour (see NEGATIVE PAINTING). Paint down either side of them with Quinacridone Gold, adding Phthalo Green for part of the left-hand flower and also the bud. Allow to dry, and then DRY BRUSH small areas between the ribs just above the flares, using a small brush and Quinacridone Red.

5 In this plant study the leaves play a very important part in the composition so paint them carefully, building up in stages, and reserving the leaf veins on the central and back leaf as the original pale wash. Use the same colour mixes as before, plus Phthalo Green and Cobalt Blue.

6 Give the flower sepals a second wash, darkening the tone but again reserving some of the first wash for light areas. The greens go from yellow and yellow-green in light-catching areas through to blue-greens in shadow. Paint the bright red flare with a mix of Quinacridone Red, Transparent Yellow and Alizarin Crimson, making the mix more orange where it catches the light, and more crimson in shadow areas. Add final accents with Thioindigo Violet in the darkest shadows.

7 Emphasise the richness of colour inside the flower with a wash of Quinacridone Gold and Thioindigo Violet, then leave to dry before rubbing off the masking and tinting the stamens and styles with pale Quinacridone Gold. Adjust the green mixes on the leaves with the same colours as before, darkening the back leaves to make those leaves at the front stand out in the light. Add accents of darker colour with Olive Green.

special detail scratching out

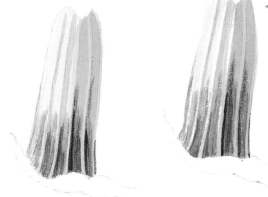

▲ Lay a wash of New Gamboge over the whole of the trumpet shape, then use a clean, damp brush to lift off some of the colour where the form is catching the light on the left side.

▲ With Quinacridone Gold, define the ribs down the trumpet length, increasing the line width toward the right side. Allow to dry, then DRY BRUSH some Quinacridone Red over the lower flared section on either side of the ribs. Add a few fine lines on the right side with Alizarin Crimson, and leave to dry completely.

◄ The fine ribs on the left side are achieved by SCRATCHING OUT with a craft knife. Drag the tip of the blade across the area to be lifted several times until sufficient white paper has been revealed. This method must always be left until last, as it scuffs the paper, making it impossible to lay more colour on top.

The foliage is often as important as the flowers themselves, and it is vital to create variety in the greens, both of tone and colour, varying colour temperature from warm to cool (see COMPOSITION).

The painting of the tubular shape must stress the roundness of the form. The light is coming from the left, with the right side turning away from the light.

The inside of the trumpet is in shadow, but the tones, although dark, are richly coloured.

Brugmansia sanguinea

Camellia Camellia

Long valued for its luxuriant, shiny, rich green foliage, and showy, waxy flowers, so perfect that they look almost manufactured, the camellia is a perfect example of a classic garden plant. The basic form is cup-shaped but opens to a wider bowl shape with several rows of overlapping petals, revealing a column of anthers in the centre. Consider how you will set about conveying the gloss on the leaves, and when you make your drawing, the way the flower and leaf stalks join with the thicker main branch.

sequence start to finish

New Gamboge

Permanent Rose

Thioindigo Violet

Dioxazine Violet

Phthalo Blue

Phthalo Green

Sap Green

Olive Green

Green Gold

Quinacridone Gold

1 Draw carefully first, then mask off (see MASKING) the column of stamens on the main flower. Work on one petal at a time, starting with one of the central ones. Wet it with clean water, and with a loaded round brush of pale Permanent Rose, flood in the colour at the base of the petal and allow it to run towards the petal tip. Note that this particular flower has white tips to its petals, so be careful to leave this small strip of white paper. Complete the other three central petals in the same way, and before the washes are dry, paint in New Gamboge around the base of the stamens and allow to blend. Complete the painting of the other petals, using slightly stronger Permanent Rose. Add a touch of Thioindigo Violet to the mix for the cooler bottom petals, and add New Gamboge to the Permanent Rose for the top left petals. Leave to dry.

2 You can now strengthen the tones of pink where the petals overlap, using stronger Permanent Rose mixed with Thioindigo Violet for cool colours or New Gamboge for warmer ones. Remember to soften edges where appropriate as you paint, for example where a diffused shadow is thrown on a petal by one above.

3 Rub off the masking on the stamens, tint with Quinacridone Gold, and leave to dry before painting the anthers with a stronger solution. When dry, mix Quinacridone Gold and Thioindigo Violet and use a small, fine brush to carefully paint the negative shape right in the centre, going around the anthers. Finish with a few linear details using Dioxazine Violet and Quinacridone Gold. Paint the second, smaller flower in a similar way, but as

it is more in shadow, cool the Permanent Rose by adding Thioindigo Violet. The stamens are also in shadow, so for these, mix Thioindigo Violet with Quinacridone Gold.

4 Now work on the leaves, starting with watery washes of mixtures of Green Gold, Phthalo Blue and Sap Green. To suggest the sheen, dab off some of the paint with a tissue in highlighted areas. Where the leaf surfaces face the sky, keep the greens cool by adding Phthalo Blue to the Sap Green, and warm the others with Green Gold. When dry, build up the darker tones gradually, with mixes of Phthalo Green, Olive Green and Sap Green, leaving the central leaf vein in first wash. Keep the brush well loaded with paint and add the darkest shadows WET-IN-WET to blend.

special detail reserving white lines

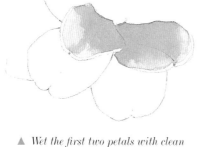

▲ *Wet the first two petals with clean water, leaving lines of dry paper at the edges, then flood on pale Permanent Rose and let it dry a little before dropping in mid-toned Permanent Rose at the base and in the centre. Tip the board slightly for the colour to flow into the petal bases. Still with the board tipped, spot in New Gamboge at the base while still damp. Leave to dry with the board in the same position.*

▼ *Complete all the petals with first washes as before, but without the New Gamboge on the lower petals. Instead, use a mix of Permanent Rose and Thioindigo Violet toward the bases to suggest shadows from petals above. Where white lines are in shadow, tint with Permanent Rose.*

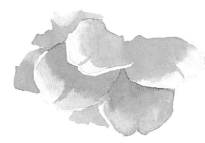

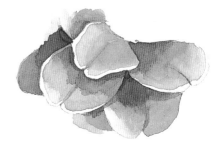

▲ *To complete, add darker, cooler tone with various mixes of the previous colours. The 'white' lines that are in shadow, although not actually white, will show up and read as white when darker tones are painted on either side. Add dark accents in the deep crevices with Dioxazine Violet.*

The stamens are masked off initially to reserve as white paper, which is then tinted to build up the details.

Dark tones and small linear details explain the structure of the stem, which is as important as the painting of the flower.

The shine on this area of the leaf is created by dabbing off parts of the wet first wash with a tissue, and then adding darker tones wet-in-wet.

Camellia japonica

Clematis Clematis

Every wall, tree or shrub is a potential support for these lovely, scrambling, flamboyant flowers. There are many different species of clematis, all with their own special charms and characteristics. This is one of the cultivars, and has flattish flower heads up to 8 inches (20 cm) across with between six to ten pointed petals, twining stalks and decorative seed heads. The flowers are circular when viewed full-face and form ellipses when seen from an angle – even the central boss of the stamens forms an ellipse. Notice that not all the petals are on the same plane; some are above others, casting shadows on those below.

sequence start to finish

Transparent Yellow

Quinacridone Magenta

Cobalt Violet

Dioxazine Violet

Cobalt Blue

Phthalo Blue

French Ultramarine

Sap Green

Quinacridone Gold

1 Make a light drawing with a 2B pencil, and then mask out (see MASKING) the central boss of stamens on both open flowers.

2 Starting with the top flower, wet two or three of the petals with clean water (see WET-IN-WET) before laying on washes of pale Cobalt Violet mixed with Cobalt Blue. Note that the foreground petals are more lilac in hue than the back ones so vary the hues a little. Before the washes are dry, lift out (see LIFTING OUT) a swathe of colour down the centre of each petal with a clean, damp brush. Again before dry, add thin central petal veins with a fine brush and Quinacridone Magenta. Strengthen the colour further towards the flower centre with Dioxazine Violet, and finish all the petals on the top flower to this same stage of completion before repeating the process on the underneath flower, using a slightly stronger mix of the same colours. Allow to dry.

3 Now paint the first washes on the leaves, using Cobalt Blue and Transparent Yellow, varying the proportions of the mixes from a yellow-green to a pale blue-green for the upward-facing parts of the leaves. Paint the closed bud in the yellow-green mixture, then lay a wash of Cobalt Violet on the opening bud. With the paint still damp, paint a line of green (Transparent Yellow and Cobalt Blue) down the back of each visible petal.

4 The flowers are in strong sunlight, so the shadows and cast shadows are very pronounced on the petals' ruffled edges. Notice that these have both HARD AND SOFT EDGES, so as you work, soften edges where needed. Paint the shadows with French Ultramarine, Dioxazine Violet and Quinacridone Magenta, both alone and in mixtures, varying the colour temperature.

5 Build up the colours on the bud, painting in the shadow with Phthalo Blue and Sap Green, and reserving some of the first wash for the rib markings (see NEGATIVE PAINTING). While still damp, lightly touch in Dioxazine Violet to give a hint of the flower to come. Strengthen the tone on the opening bud with a mix of Dioxazine Violet and Quinacridone Magenta, especially in the crevices

where parts of the front petals can be seen. Give the leaves a second wash with mixes of Sap Green, Phthalo Blue and Transparent Yellow, reserving some of the first washes for leaf veins. Lay a wash of Dioxazine Violet and Sap Green on the woody stalk, then strengthen with a darker mix of the same colours.

6 To finish the flowers, rub off the masking, and tint the stamens with a mix of Cobalt Blue, Dioxazine Violet and Quinacridone Gold, keeping the color paler for the top flower and also leaving more of the stamens white. Tint the anthers with Quinacridone Gold, and darken some by adding Dioxazine Violet and Quinacridone Gold.

7 Adjust the shading on the leaves with the same colours as before, and darken some of the background leaves to throw the top ones forward. Paint the slender stalks with a pale Dioxazine Violet and Quinacridone Magenta wash. Finally, add small dark accents on the flowers with Dioxazine Violet and on the leaves with dark French Ultramarine and Sap Green.

special detail hard and soft edges

◀ *Each petal is treated individually with each of its curves and folds described with either hard or soft edges. Lay a wash of Cobalt Violet and Cobalt Blue over the petal and, while still wet, lift out the colour (see LIFTING OUT) down the central vein with a clean, damp brush.*

◀ *With the colour still damp, paint in the three petal veins with a fine brush and a stronger mix of the same colour, creating soft, natural-looking edges. Allow to dry.*

◀ *The large cast shadow is hard edged and needs to be quite dark in tone to give the impression of the strong sunlight. For this, use a combination of the previous colours. The shading on the two ruffles is soft on the peaks, so soften these with a clean, damp brush, leaving hard edges in the crevices.*

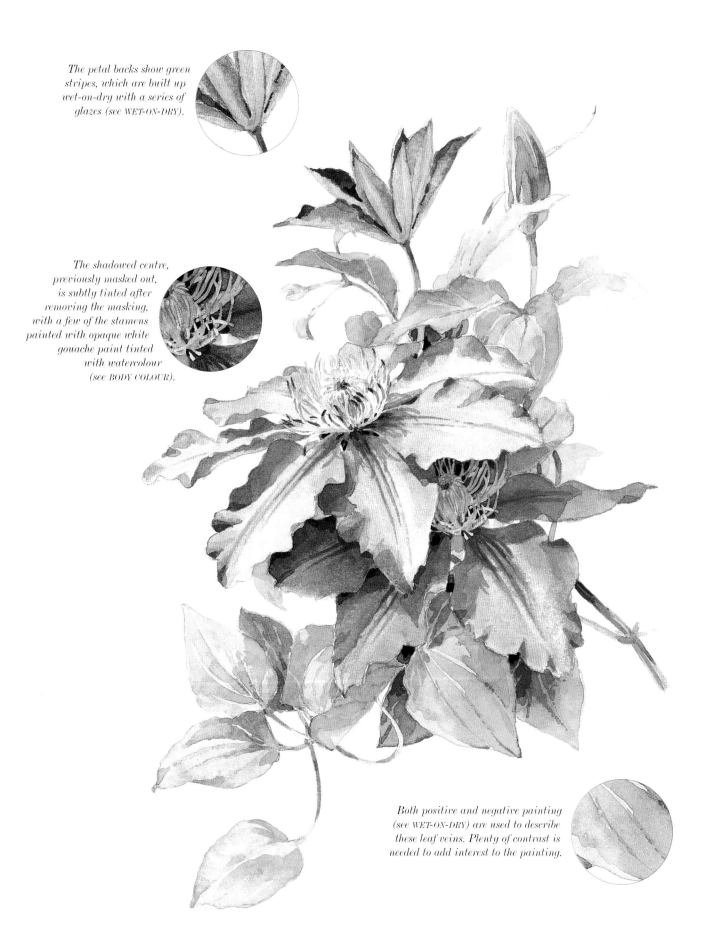

The petal backs show green stripes, which are built up wet-on-dry with a series of glazes (see WET-ON-DRY).

The shadowed centre, previously masked out, is subtly tinted after removing the masking, with a few of the stamens painted with opaque white gouache paint tinted with watercolour (see BODY COLOUR).

Both positive and negative painting (see WET-ON-DRY) are used to describe these leaf veins. Plenty of contrast is needed to add interest to the painting.

Clematis sp.

Cyclamen Cyclamen

The main characteristic of all cyclamen is their beautiful, butterfly-like, swept-back petals. Each flower has five petals in bright or pastel colours, often with throat markings of carmine on paler petals. Some varieties also have exceptionally attractive foliage with pretty silvery banding and marbling. This variety is a soft pink flushed with purplish-pink and with deep purple-red feathering at the petal base. Points to observe when drawing are the way in which the stems join the flowers and how petals will sometimes wrap themselves around the stem. The neat heart-shaped leaves fall in layers, casting shadows on those below. To suggest the overall form of the plant, create recession of leaves and flowers by painting the nearer ones in more detail and stronger tones.

sequence start to finish

Alizarin Crimson

Permanent Rose

Quinacridone Magenta

Dioxazine Violet

Indigo

Cobalt Blue

Cobalt Turquoise

Sap Green

Green Gold

1 Make a careful drawing, ensuring that the construction of the flower is correct, especially where the petals meet at the base. For the leaves, you need only a rough outline, as the BRUSHMARKS can describe the markings on the leaves.

2 Working on dry paper, lay pale washes of Permanent Rose over all the flowers and buds, reserving occasional small strips of white paper for petal edging. Leave to dry, and then begin to build up the flower forms by glazing over the petals with Permanent Rose and Cobalt Blue mixes to suggest shadows. Use a fine brush to emphasise the forms by painting in one or two petal veins. Keep the two right-hand flowers cooler and paler.

3 Allow the previous layers to dry fully before painting the deep purplish-red

feathering. Tackle each flower separately. Wet the petal base with clean water and drop in Quinacridone Magenta, allowing the colour to blend upward from the base. While still wet, tip the base edge with strong, dark Dioxazine Violet, and allow to blend (see WET-IN-WET).

4 Paint the first pale silvery colour on the leaves by washing all over them with mixes of Cobalt Turquoise and Alizarin Crimson, varying the colour slightly from leaf to leaf. Leave to dry, and then, starting with the lower front leaf, re-wet all over with clean water. Judge the wetness carefully (too wet and the paint will run too far), then paint in the dark green shapes with mixes of Sap Green and Indigo, reserving the paler blotchy pattern and leaf veins. Repeat the process for the rest of the leaves, but make the colours lighter and bluer as they recede.

5 Add a little further definition to the leaves with stronger Indigo and Sap Green mix – you only need just enough detail to bring one leaf forward from another. Avoid any dark tones on the background leaves.

6 The stalks and buds are important here, as they help to unite flowers and leaves. Paint the stalks with mixes of Green Gold and Permanent Rose, varying the tone strength from stem to stem. Darken in shadowed areas with mixes of Sap Green and Permanent Rose. To give the buds more detail, use mixes of Permanent Rose and Cobalt Blue. Paint the sepals first with pale Cobalt Turquoise, adding final details with a mix of Sap Green and Permanent Rose.

special detail using restricted washes

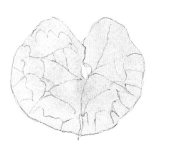

▲ *The decorative pattern on the leaves of this plant is a distinguishing feature, and requires as much attention as the flowers. Before you begin to paint, analyse the colours and tonal changes and the contrast between the banding shapes and the fine marbling lines. Begin with a flat overall wash, using a mix of Cobalt Turquoise and Alizarin Crimson. Allow to dry.*

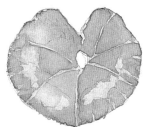

▲ *Wet the leaf all over with clean water, leaving lines of dry paper for the main leaf veins. Restrict the next wash using a mix of Sap Green and Indigo, leaving some of the first wash showing but with soft edges to the banding. Judge the wetness before adding this colour – too wet and the shapes will merge into one another. The leaf veins will remain hard-edged, as the paint will stop where it meets dry paper.*

▲ *Leave to dry a little, but not completely, and then paint on a darker shade of the second-wash colour, allowing the paint to blend in places.*

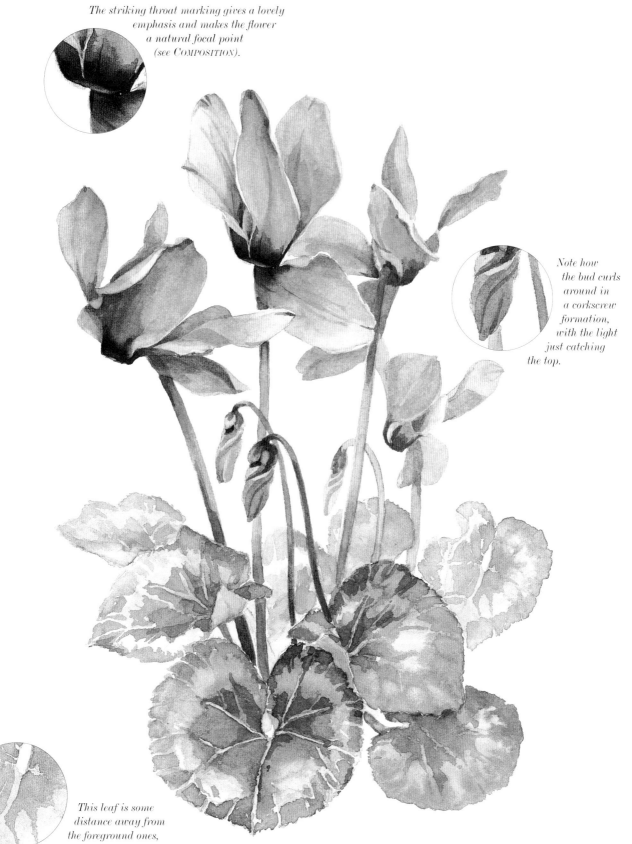

The striking throat marking gives a lovely
emphasis and makes the flower
a natural focal point
(see COMPOSITION).

Note how
the bud curls
around in
a corkscrew
formation,
with the light
just catching
the top.

This leaf is some
distance away from
the foreground ones,
and is painted in paler
tones overall, with less contrast.

Cyclamen persicum

Cymbidium Orchid

There can be few flowers as fascinating and prized as the exquisite orchid, which has been cultivated for centuries. There are many different species, but all have the same basic structure, and when cut in half lengthways each side corresponds to the other exactly. The flower consists of three outer sepals and three inner petals, the lowest of which is known as a lip; this is enlarged and is different from the others in shape, markings and colour. This orchid carries flower spikes up to 35½ inches (90 cm) tall and bears 12 or more blooms on each spray.

sequence start to finish

Transparent Yellow

New Gamboge

Cobalt Blue

Cerulean Blue

Sap Green

Olive Green

Green Gold

Naples Yellow

Quinacridone Gold

Burnt Sienna

Brown Madder

1 Make a careful drawing, taking care with the construction, and observing how the flower stalks join the main stem, then work on the flowers from front to back. Begin with watery first washes of Transparent Yellow and Cerulean Blue on the more horizontal, and thus cooler-coloured, petals, and New Gamboge and Cerulean Blue for more upright, warmer-coloured ones.

2 Paint the flower centres, which are warmer and peachy in colour, with a small brush and Naples Yellow, leaving the lower lip petal mostly white at this stage. Add touches of mid-toned Burnt Sienna to the bases of the petals on the flowers that turn away where they join the stem, and let the colours blend. Add Naples Yellow to Burnt Sienna and paint mid-toned details in the flower centres and any other crevices.

3 Continue to build up the three-dimensional quality of the flowers by painting in the shadows, taking care to foresee changes in colour temperature from warm to cool (see COMPOSITION). Use mixes of Cerulean Blue, Green Gold and small amounts of Quinacridone Gold to soften the harshness of the yellow greens. As you work, soften edges with a clean, damp brush where needed, mainly on the insides of the petals.

4 After looking carefully at the complicated flower centres, paint the yellow column with a small brush and Naples Yellow, changing to Transparent Yellow at the base, and watering the colour for the lip. Leave to dry before spotting the perimeter and inside the outer edge of the lip with dabs of Brown Madder, following the form of the petal. Make small spots also on the column and a few on the other petals and sepals. Tip the top of the column with Brown Madder, leaving a white spot in the centre.

5 To throw forward the front flowers, adjust the final shading on those at the back by darkening some of them with the previous colour mixes. Paint in the main flower spike with a mix of Sap Green, Green Gold and Cobalt Blue, darkening with Olive Green where the flowers cast shadows on it.

6 Paint first washes on the long, narrow leaves with mixes of Sap green, New Gamboge and Cobalt Blue, and when dry, paint final details with Olive Green mixed with Sap Green and/or Cobalt Blue, varying the tones to create interest. On the whole the leaves are a bluer green than the flowers, but the tones may need adjustment if they are too similar to adjacent flowers.

special detail warm and cool colors

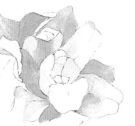

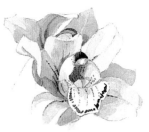

▲ *You must look closely at the plant to see the slightly differing colour temperatures. Upward-facing surfaces tend to be cooler, so use washes of Cerulean Blue and Transparent Yellow. The more vertical petals are warmer, so use a Cerulean Blue and New Gamboge mix, which is a warmer yellow. The complex flower centre has even warmer shades, so initially paint shadow areas with Naples Yellow.*

▲ *When the first washes have dried, you can now start to emphasise the warm/cool contrasts by adding the shadows, using Cerulean Blue, Green Gold and Quinacridone Gold. Bear in mind that colours are only warm or cool in comparison with adjacent or surrounding colours – at this stage, Naples Yellow is still the warmest hue.*

▲ *The warmest touches are painted last. With a small brush and Burnt Sienna either alone or mixed with Cerulean Blue, paint the warm-coloured details, including the inside of the flower centre. Finish with Brown Madder to paint the strongest colours on the petal veins and at the top of the column.*

*This centre
is carefully
modelled with
the dark red
markings
enhancing
the form.*

*Even in the
shaded areas,
the greens must
show variety.
The leaf in the
background is
dark, but is a bluer
green than the dark
parts of the stalks.*

*The form of the
back of the bloom
is built up by
delicate blending
worked WET-IN-WET.*

Cymbidium sp.

Dahlia Dahlia

Few flowers can match dahlias for their wide range of brilliant colours and huge variety of shapes and sizes. They are spectacular, statuesque flowers and, originally hailing from Mexico, adore heat. This cactus form resembles a sea urchin, with its shock of long, thin, apricot-coloured petals, which are rolled lengthwise into quills. In spite of the seeming disarray of the petals, which point in different directions, the form of the flower is a faultless sphere. The overall shape must always be kept in mind, with the feeling of roundness apparent even though many of the individual petals will create their own light and shade.

sequence start to finish

Transparent Yellow

New Gamboge

Quinacridone Red

Alizarin Crimson

Thioindigo Violet

Indigo

Cobalt Blue

Sap Green

Olive Green

Quinacridone Gold

1 Take care with the drawing, making sure that all the spiky petals radiate from the centre, and become thinner toward the outer edges.

2 The light is coming from top right, illuminating all the horizontal or near-horizontal petals. Paint these with a pale wash of Transparent Yellow, and the rest with a wash of New Gamboge. Allow to dry, and then use a small, clean, damp brush to lift the colour (see LIFTING OUT) to almost white on the tips of the petals catching most light. Next, with stronger New Gamboge, paint all the sections of petals turning away from the light, softening edges where needed (see HARD AND SOFT EDGES). Leave to dry again, then paint the petals most in shadow with Quinacridone Gold – those from the centre on the left to the lower petals, and beneath the top layer of petals.

3 Give the flower a blush of apricot colouring by glazing (see WET-ON-DRY) thin washes of Quinacridone Red over the yellows, especially on the centre mass of tight petals and on the left-hand and lower petals. Be very sparing with the glaze on the top and right-hand petals, possibly leaving some as the original yellows. Curve the shadows on the long quills, always keeping the direction of the light in mind. Make a cooler shadow colour for the left and lower petals with a thin glaze of Thioindigo Violet. Let each wash dry before adding a new layer.

4 Finish the flower by putting in the deepest tones, painting between petals with Alizarin Crimson to define them, and using the same colour for a few of the top petals near the centre, which are backlit. Paint around and between the central small petals, reserving the previous washes (see NEGATIVE PAINTING), then finally dab in the dark centres with Olive Green and Alizarin Crimson.

5 Lay a wash of Transparent Yellow on the petals of the bud, and a wash of a Transparent Yellow and Sap Green mix on the sepals. Paint the stalks with this same mix, and let dry before suggesting thin petals by dry brushing (see DRY BRUSH) over the bud petals with Quinacridone Gold and then Alizarin Crimson. Darken and detail the outer sepals with a Sap Green and Cobalt Blue mix, and use this also to shade the left side of the stalks.

6 Wash over the large leaf with Sap Green on the right side and a cooler Cobalt Blue and Sap Green mix on the left. When nearly dry, add leaf markings with a stronger Olive Green and Indigo mix, and paint around some of the lighter leaf veins, reserving these as the first wash. Darken the main flower stem with the same mix, especially under the flower, where there is a strong cast shadow.

special detail layering colour wet-on-dry

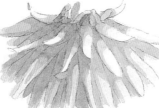

▲ *Lay a wash of Transparent Yellow on the cooler top horizontal petals and New Gamboge on the rest. Allow to dry, then use a damp brush to lift out the colour on the tips of the horizontal petals. Leave to dry again.*

▲ *Using stronger New Gamboge, paint the first hint of shading on the petals, with less colour where they catch most light. Take care to keep all the shadow edges curved to describe the roundness of the quills. When dry, glaze on Quinacridone Gold (see WET-ON-DRY) to enhance the shading, concentrating most colour on the more vertical petals, and those underneath. Allow to dry again.*

▲ *To achieve the apricot tint, cover the area with another glaze of Quinacridone Red, leaving some of the previous layers as yellow, then continue building up the colours and tones with Thioindigo Violet washes, and lastly, with accents in an Alizarin Crimson and Thioindigo Violet mix. Avoid using any blues in mixtures, as this would muddy the colours, and take away from the flower's warm glow.*

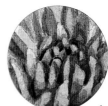

The base of each petal must appear to be anchored within the closely packed centre. Edges are softened, and dark accents added, leaving the tips light.

To reinforce the cylindrical form of the stem, the cast shadow must be shown as curling around it.

The spherical shape is described by directional dry brushwork (see DRY BRUSH) on the petals and sepals.

Dahlia sp.

Delphinium Delphinium

These flowers, one of the most attractive of tall perennials, making a spectacular display in a summer herbaceous border, are characterised by spikes of irregular, cup-shaped, spurred flowers. Their name comes from the Greek word 'Delphis', which means dolphin. First look for the overall shape, which is basically a cylinder, then half-close your eyes and you can more easily see the general light and shade. Then look more closely at each individual floret and note how it casts a shadow onto its neighbour, and also pay attention to the central detail of the black eye.

sequence start to finish

Dioxazine Violet

Indigo

French Ultramarine

Cobalt Blue

Cerulean Blue

Sap Green

Olive Green

Green Gold

Quinacridone Gold

1 When you have made the drawing, paint a pale, watery wash of Cerulean Blue and Cobalt Blue over the open florets, strengthening it to a mid-tone for the shadowed right side. For the small unopened buds, use pale Green Gold, giving added depth to those on the left, which are nearer than those behind the flower spike, with Green Gold and Quinacridone Gold. Suggest the buds at the top of the spike, which are about to open, by dropping a touch of Cerulean Blue into the damp Green Gold wash.

2 Take care not to lose the roundness of the spike and the direction of the light – half-close your eyes to simplify the tones. Leave as much of the first wash as possible, paint in the mid-toned shadows with mixes of French Ultramarine, Dioxazine Violet and Cerulean Blue, softening edges as you paint. On the right-hand side, where you can see the floret backs, drop Sap Green into the wet blue-purple shadow colour and allow to blend in places.

3 The final stage of painting the florets is to add the darkest tones for the cast shadows, which are darker overall on the right side. Use the same mixes as before but darken with more Dioxazine Violet. Look out for tiny crevices between some of the florets, and paint these to define the petal shapes. With Sap Green and Olive Green, paint in the visible parts of the central stalk and add small stems to some of the florets. With a small brush and Indigo, paint in the dark eyes to the florets, leaving a space in the very centre. When the Indigo is almost dry, colour this in with Quinacridone Gold.

4 Complete the painting of the buds by adding small accents of Olive Green. The leaves only need to be hinted at, so as not to detract from the flower spike, so here use just two pale tones of an Indigo and Sap Green mix.

special detail shadows

▼ *The light is coming from top left, catching on the lower petals. The top ones, bending inwards slightly are in shade, and there are strong shadows on the right and where one floret overlaps another. Begin to suggest the shadows immediately, laying a cool, pale wash of Cobalt Blue over the florets and darkening it to mid-toned on the right (see GRADED WASH).*

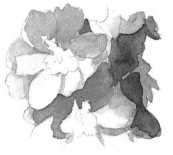

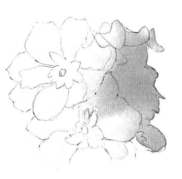

▲ *Starting from the left side, and using Cobalt Blue, French Ultramarine and Dioxazine Violet mixes, introduce a mid-tone on the shadowed upper petals and the cast shadow beneath the main floret. Darken the tone farther on the right side, painting deep blue-violet shapes WET-ON-DRY and then dropping Sap Green into the wet paint to suggest the floret backs.*

▼ *It is vital to maintain the overall roundness of the spike: the side petals at the extreme right side remain mid-toned, thus appearing to continue behind the spike, but the shadows and cast shadows are progressively darker to this point. Continue to build up the tones, and finally add the very dark floret centres.*

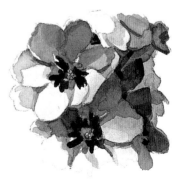

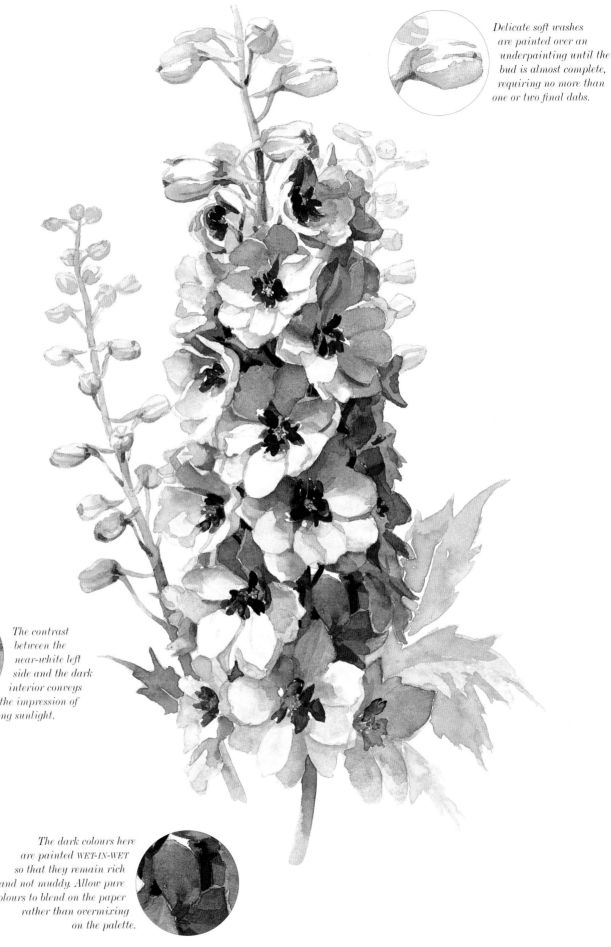

*Delicate soft washes
are painted over an
underpainting until the
bud is almost complete,
requiring no more than
one or two final dabs.*

*The contrast
between the
near-white left
side and the dark
interior conveys
the impression of
strong sunlight.*

*The dark colours here
are painted WET-IN-WET
so that they remain rich
and not muddy. Allow pure
colours to blend on the paper
rather than overmixing
on the palette.*

Delphinium elatum

Dianthus Carnation

Carnations are steeped in myth and symbolism. They have featured in literature from the Middle Ages onwards, and have been depicted in tapestries dating from Tudor times. In the sixteenth century double carnations, with their petals often striped or splashed with a different colour tone, known as picotees, were seen on Persian pottery and tiles. In spite of the frilly petals of the flowers, they are basically a simple star shape, flattish in appearance, and forming ellipses when seen at an angle. The bud reveals the prominent tubular calyx carried on slender stems. Note how the lance-shaped leaves, buds and flowers are sometimes joined to the stalks at quite acute angles.

sequence start to finish

Transparent Yellow

Alizarin Crimson

Permanent Rose

Thioindigo Violet

Dioxazine Violet

Cobalt Blue

Cerulean Blue

Sap Green

1 Take time to analyse the junctures of the leaves and buds to the main stem before making a careful drawing. Then mask out (see MASKING) a few of the split stamens.

2 Apply a pale wash of Permanent Rose on the flowers and the opening top flower. Make short, stabbing brushstrokes to describe the serrated petal edges, following the curve of the petals. Allow to dry. To complete the shading and describe the folds and shadows, carefully paint cast shadows in and between the folds, using Permanent Rose and Cobalt Blue mixes. Make the shades cooler on left and lower petals, and slightly darker towards the centres. Soften edges as you work around the flower. Leave to dry.

3 Next, paint pale first washes on the stalks, leaves and buds. These should be mostly Cerulean Blue, but where you see warmer, greener hues in some areas, such as the junctures of leaves and stalks and on some leaves and parts of buds, add Transparent Yellow to Cerulean Blue.

4 Return to the flowers for the next stage, starting with the right-hand flower. Using mixes of Alizarin Crimson and Thioindigo Violet in a mid-tone, paint in the petal markings with a small brush, letting the brushstrokes follow the curves of the petals. For the other flowers, which are receding slightly, make the mix a little paler and bluer by adding Cobalt Blue. To finish the flowers, rub off the masking when the paint has dried, and tint the

stamens with Permanent Rose. Add the darkest crevices and give an extra emphasis to the markings with a Dioxazine Violet and Alizarin Crimson mix. Make the colour strongest on the right-hand flower, as it is the nearest.

5 Finish the greenery, using Sap Green and Cerulean Blue plus Dioxazine Violet in various mixes. Strengthen sections of stalks and buds with cast shadows and shading.

special detail amending colours by glazing

▼ *Instead of adding blue to a palette colour to cool it, you can glaze over an existing colour. Paint a wash of pale Permanent Rose over the petals, reserving a few lines of white for the ruffled edges. Allow to dry.*

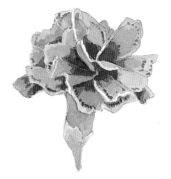

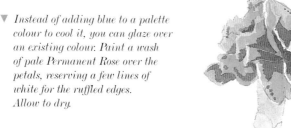

▲ *With a stronger Permanent Rose, paint in the shadows in the creases and folds of the petals. When dry, paint in the petal markings with a mid-toned mix of Alizarin Crimson and Thioindigo Violet.*

▲ *To create the cooler colour suggesting recession, let the previous wash dry fully, then glaze over the petals with a thin wash of Cobalt Blue, making the colour very slightly darker on the left. Let dry before adding the final darkest touches to the markings with mixes of Alizarin Crimson and Thioindigo Violet. Finally, wash Cobalt Blue over the green calyx with a touch of the previous colour dropped in WET-IN-WET.*

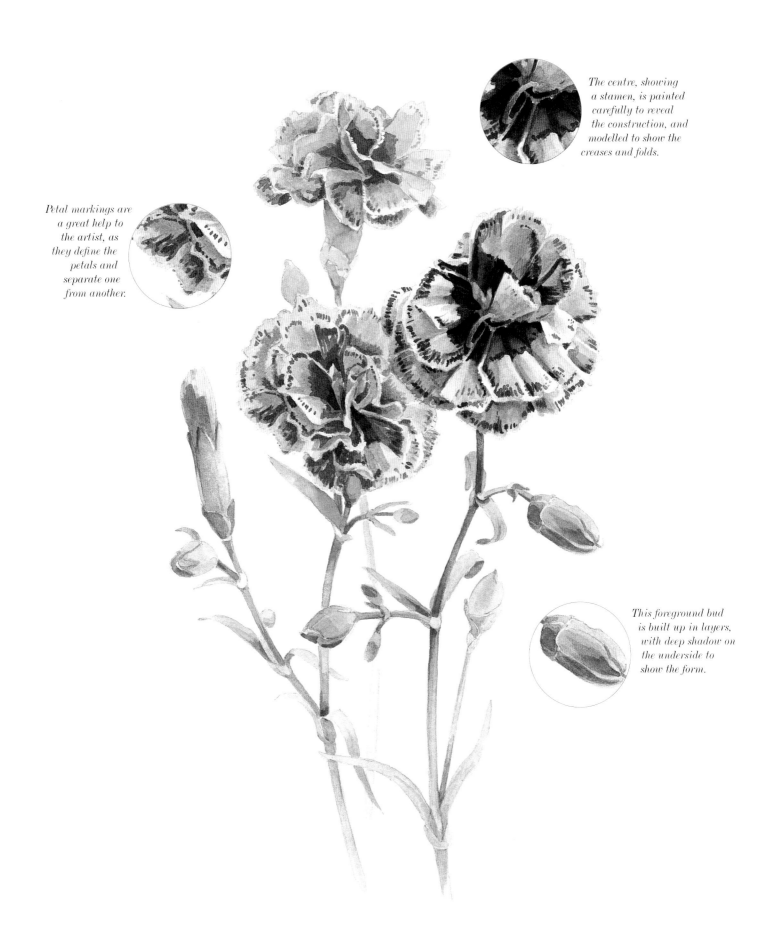

The centre, showing a stamen, is painted carefully to reveal the construction, and modelled to show the creases and folds.

Petal markings are a great help to the artist, as they define the petals and separate one from another.

This foreground bud is built up in layers, with deep shadow on the underside to show the form.

Dianthus caryophyllus

Echinacea Coneflower

Indigenous to North America, this plant was prized by the native Americans for its healing properties. The name is derived from the Greek for 'hedgehog', alluding to the flower's prominent central cone. It is commonly known as the 'purple coneflower', but it comes in other shades including the cream of this example. The strong, erect stems carry single, large, daisy-like flower heads with spreading, drooping ray petals. The lance-shaped leaves are rough textured and a rich green. The central boss is a tightly packed mass of pointed bracts coloured a glorious shade of deep gold and brown. The form is basically a round cone shape atop a sphere, with the petals curving down to encircle the stem. Observe how the light plays on the petals, casting shadows on the tips and on the cone.

sequence start to finish

Dioxazine Violet

Phthalo Blue

Cerulean Blue

Phthalo Green

Sap Green

Green Gold

Quinacridone Gold

Burnt Sienna

Burnt Umber

1 Make the drawing, checking that the petal bases follow around the cone base and that the petal tips appear to continue around the back of the flower. Mask off (see MASKING) the tips of the cone bracts, where they catch the light.

2 Lay a pale watery wash of Green Gold over all the main flower's petals, and blot with tissue (see LIFTING OUT) before dry to create highlights. Paint the first wash on the cone using a Quinacridone Gold and Green Gold mix.

3 Where petals overlap and where the backs of petals can be seen, and at the base of the cone, add a slightly stronger tone mixed from Cerulean Blue and Green Gold. As the petals curve downward, they receive less light, so increase the proportion of Cerulean Blue to tint the tips with thin washes. Allow to dry, and then glaze over the smaller, deeper shadows with a Cerulean Blue and Dioxazine Violet mix.

4 Lay first washes on the leaves and stalks with mixes of Sap Green, Green Gold and Phthalo Blue. Allow to dry then paint a dark wash of Phthalo Green and Burnt Sienna on the central cone, softening this edge into the outer bract colour of Quinacridone Gold. Tip the paper a little to let the wet paint run to the cone base (see WET-IN-WET). Before dry, strengthen and darken the color toward the cone base with a darker tone of Phthalo Green and Burnt Sienna. When almost dry, dot in dark Dioxazine Violet at the base where the cone curves under. Allow to dry.

5 The cone casts a shadow on the petal bases, which is cool on the central petals and warmer and more yellow on the outside petals. Use the same flower colours as before, varying the proportions of the mix, and increasing the strength of tone where the petals disappear into the cone base. Allow to dry.

6 Rub off the masking on the main flower cone to reveal the light spots at the tips of the bracts. Then, starting at the top of the cone, tint the small spots with pale Quinacridone Gold, intensifying the shade as you go down the cone. At the base, add Sap Green to the Quinacridone Gold to tint the smallest spots.

7 Shade the first wash on the petals of the back flower by painting in the shadows and back petals with pale Cerulean Blue. Wash over the cone with the same colours as used before, but in a paler tone and without the Dioxazine Violet. Leave to dry, rub off the masking, and tint the white spots with Green Gold.

8 Continue to define the leaves and stems with Phthalo Green and Burnt Sienna mixes. To finish the leaves, add strong accents with mixes of Phthalo Green and Burnt Umber.

special detail letting the pencil drawing show

▲ *Pencil lines are often just a guide in a painting, eventually becoming lost or erased. Here, however, the flower is pale on white, so the pencil line is a useful device. Make a faint drawing then wash Green Gold on the petals. Paint the stem with a Phthalo Green and Green Gold mix, lifting out centre highlights.*

▲ *Strengthen the petals with a mix of Cerulean Blue and Green Gold for the shadows where petals overlap and turn away from the light. Paint the stem with Phthalo Green and Burnt Sienna to darken.*

▲ *Add final detail with mixes of Dioxazine Violet and Cerulean Blue, painting a few thin petal veins and some linear detail on the stem. When dry, draw in the pencil detail where required to enhance the painting, using a 2B pencil, and varying the pressure to create darker or lighter lines.*

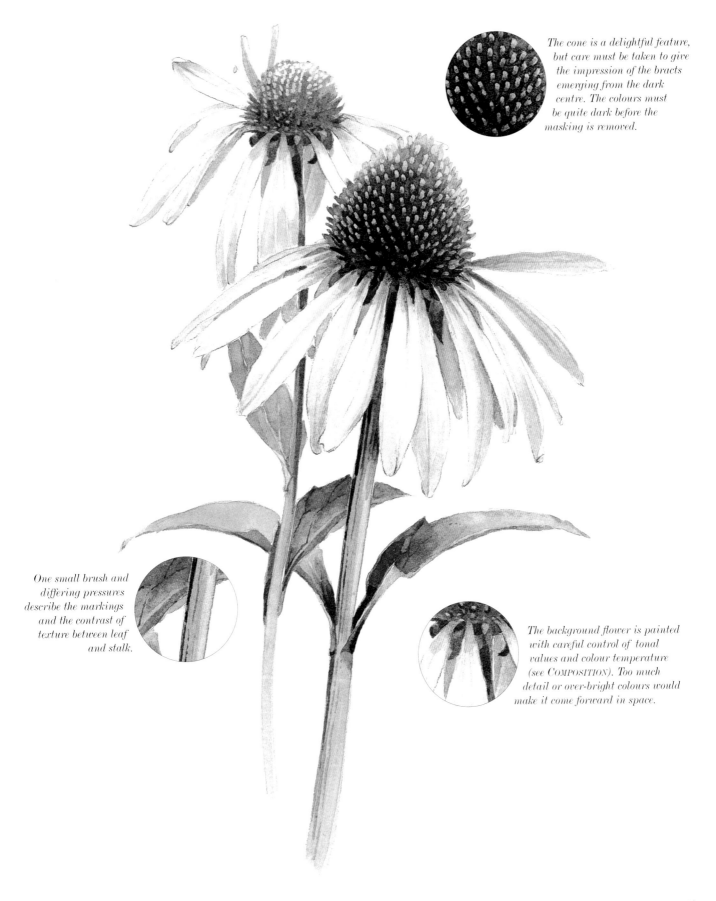

The cone is a delightful feature, but care must be taken to give the impression of the bracts emerging from the dark centre. The colours must be quite dark before the masking is removed.

One small brush and differing pressures describe the markings and the contrast of texture between leaf and stalk.

The background flower is painted with careful control of tonal values and colour temperature (see COMPOSITION). Too much detail or over-bright colours would make it come forward in space.

Echinacea purpurea

Eryngium Sea Holly

This is one of the 'architecturally' useful groups of perennials; even when no longer flowering it still looks elegant and stylish with a spiked effect. The individual plants are quite delightful, with deeply cut blue-green leaves and branching candelabra-like stems of metallic blue. These carry bright blue elongated heads of tiny flowers, densely packed and surrounded by whorls of narrow, spiny silvery-blue bracts. Everything about the plant is round, from the almost cylindrical cones, the plate-like bracts, and the swirl of the leaves, so you will need to emphasise this feeling in the painting with the strongest tones on the nearest flowers.

sequence start to finish

Transparent Yellow

Dioxazine Violet

Indigo

Phthalo Blue

Cerulean Blue

French Ultramarine

Sap Green

Olive Green

1 When drawing, pay attention to the flat disks of the ellipses to the bracts. Make sure the stalks are at the correct angles to be projected through the centres of the flower heads. Mask out (see MASKING) some small flowers on the heads and just a few of the bracts on the nearest, largest flower, especially where these overlap the background bracts.

2 Paint the background flowers first, starting with the top right flower. Using a small round brush paint the bracts with pale French Ultramarine and, while wet, tip the ends with pale Sap Green. Lay a first wash of Transparent Yellow on the head, dropping in a Sap Green and French Ultramarine mix WET-IN-WET, reserving spots of yellow at the top. Repeat the process on the left-hand flower, using a French Ultramarine and Cerulean Blue mix for the bracts. Paint the leaves with pale Sap Green, French Ultramarine and Transparent Yellow mixes, adding Dioxazine Violet for the stems. Leave to dry.

3 Now return to the background flowers, strengthening the blue bracts in places with French Ultramarine, especially in areas away from light. Allow to dry, then rub off the masking and paint in the shadow with Phthalo Blue and Olive Green, teasing out a few whiskers from the outside edges. Leave to dry again, then paint around some of the white shapes with the shadow wash, and tint them with pale Dioxazine Violet. Darken the stalks under the dome base with a Phthalo Blue and Olive Green mix, and strengthen the background leaves a little with the same mix.

4 Wash over the head of the main flower with Sap Green, dropping in mixes of Cerulean Blue, French Ultramarine and Dioxazine Violet while wet. Allow to dry, then rub off the masking on the head and the bracts. Tint the white shapes on the head with the previous mixes, and when dry, dot in some dark Dioxazine Violet.

5 Using a fine-pointed brush, wash over the bracts on the main flower with pale tints of Dioxazine Violet and Cerulean Blue, adding pale Sap Green to the tips to blend. At the bract bases, add mid-toned Cerulean Blue to blend.

6 Darken the main stem, especially under the flower head, with an Olive Green and Phthalo Blue mix, pulling the colour down the stem with a clean damp brush to grade it from dark to light. When dry, use a very small brush and Indigo to outline some of the nearest bracts with fine lines, using the same colour to add accents of dark tone where needed. Finish the leaves with a stronger Olive Green and French Ultramarine mix on the nearest group, leaving a light vein down the centre of the leaflets.

special detail texture with positive and negative shapes

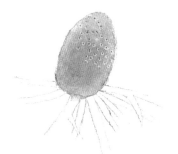

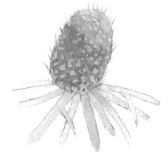

▲ *Mask off some of the small flowers on the head near the top. Paint a first, mid-toned, VARIEGATED WASH over the head with Sap Green, Cerulean Blue, French Ultramarine and Dioxazine Violet to give a grading from green at the top to mid violet at the base. Allow to dry.*

▲ *Rub off the masking. Use the previous colours to tint the white shapes. Let dry. With a slightly darker Dioxazine Violet and French Ultramarine mix, paint around the small flowers. When dry, paint in some of the fine hairs of the head's outside edge. Put first washes on the bracts with Dioxazine Violet and Cerulean Blue mixes.*

▲ *Reinforce the colour of the bracts by painting in strong Cerulean Blue at the base of the head and pulling the colour down. Return to the head, and apply dark Indigo spots in the flower centres from the middle to the base. Add a few dark hairs with this colour, and finish with a few Indigo touches at the base of the head and the start of the stalk.*

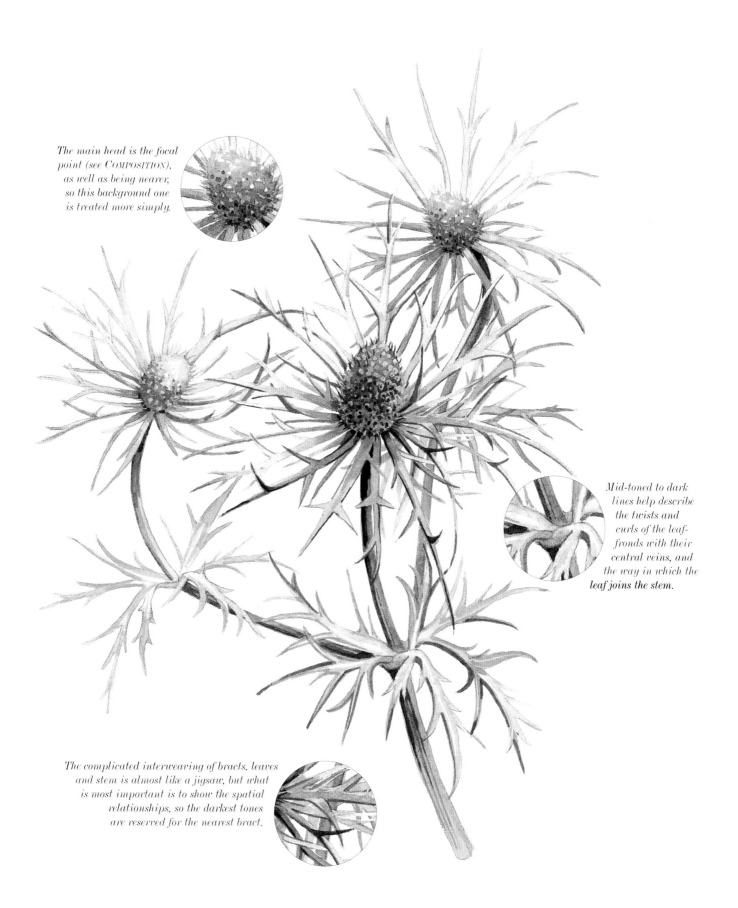

The main head is the focal point (see COMPOSITION), as well as being nearer, so this background one is treated more simply.

Mid-toned to dark lines help describe the twists and curls of the leaf-fronds with their central veins, and the way in which the leaf joins the stem.

The complicated interweaving of bracts, leaves and stem is almost like a jigsaw, but what is most important is to show the spatial relationships, so the darkest tones are reserved for the nearest bract.

Eryngium x oliverianum

Euphorbia Poinsettia

Poinsettia, beloved as a Christmas decoration, is a native of Mexico. The true flowers are clustered in an insignificant flattened head of small greenish-white blooms, which is surrounded by extremely showy bright red leaf-like bracts, which make a dazzling display. The leaves are oval to lance-shaped, shallowly lobed, and together with the bracts make a stunning complementary colour scheme. The bracts form disk-like shapes, and radiate out from the tiny flower-head-like wheel spokes, casting shadows on each other and on the bracts and leaves below. The prominent bract and leaf veins add a lovely repetitive pattern to the whole plant.

sequence start to finish

New Gamboge

Quinacridone Red

Alizarin Crimson

Thioindigo Violet

Cobalt Blue

Sap Green

Olive Green

1 Make the drawing, paying attention to the veining on the bracts and leaves. Mask out (see MASKING) the blobs of the flower heads.

2 Paint a loose wash of pale Quinacridone Red over all the bracts, and leave to dry before building up the top flower. The light is coming from top right, catching these bracts the most, so leave a lot of the first wash to suggest this. Working on one bract at a time, paint in the next tone, using Alizarin Crimson, on its own or mixed with New Gamboge, according to whether the colour is cool or warm. Before dry, soften edges with a clean damp brush. Feather out the colour from the shapes with a small brush to describe the veins, using a stronger mix

of the same colours where they appear darker, and Sap Green for the green veins. Repeat the process on the lower flower, but leave less of the first wash.

3 For the leaves, lay a warm mix of New Gamboge and Sap Green on light-facing areas, and a cooler mix of Sap Green and Cobalt Blue on the rest of the leaf surfaces. Allow to dry before laying a second wash of a Sap Green and Cobalt Blue mix, painting around the veins to reserve them as negative shapes (see NEGATIVE PAINTING). Vary the hues, as the colour is darker in the shaded areas.

4 Return to the top flower, and paint the shadows and cast shadows with

a mid-toned mix of Alizarin Crimson and Quinacridone Red, going around all the bracts in turn, softening edges where needed. Repeat for the bottom flower, but this needs a stronger tone for its shadows, so use Alizarin Crimson or an Alizarin Crimson and Thioindigo Violet mix. Darken bract veins where required with stronger mixes of the colours used previously.

5 Rub off the masking on the little flower heads, tint them first with New Gamboge and, when dry, paint around and between them with Sap Green, leaving the yellow tops. Crisp up the definition of the leaves by adding some darkish Olive Green, especially below and behind the bracts.

special detail using complementary colours

▼ *The red-green complementary colour contrast (see COMPOSITION) is seen in many red-flowered plants, but here it is spectacularly noticeable. Try unifying the composition by introducing touches of red among the greens and vice versa. Paint in first washes on the bracts with either Alizarin Crimson or a mix of Alizarin Crimson and New Gamboge. For the leaf, use a mix of New Gamboge and Sap Green, leaving a thin white edge on the main bract. Allow to dry.*

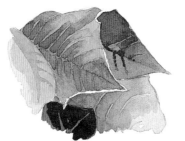

▲ *Paint in a second tone on the bracts using variations of the previous colours, and tease out the colour in places for veins. On the main bract, use the NEGATIVE PAINTING method (see also WET-ON-DRY), leaving the veins mostly in the first wash. Lay a second tone on the leaves, adding Cobalt Blue to the mix.*

▼ *Strengthen the red on the bracts with Alizarin Crimson, including the veins. With a fine brush, paint the thin green veins on the main bract and around the outside edge with Sap Green. Lastly, make an Olive Green hue by mixing Sap Green, a little New Gamboge, and Alizarin Crimson, and use to darken the shadow on the leaf and to accent the green bract veins.*

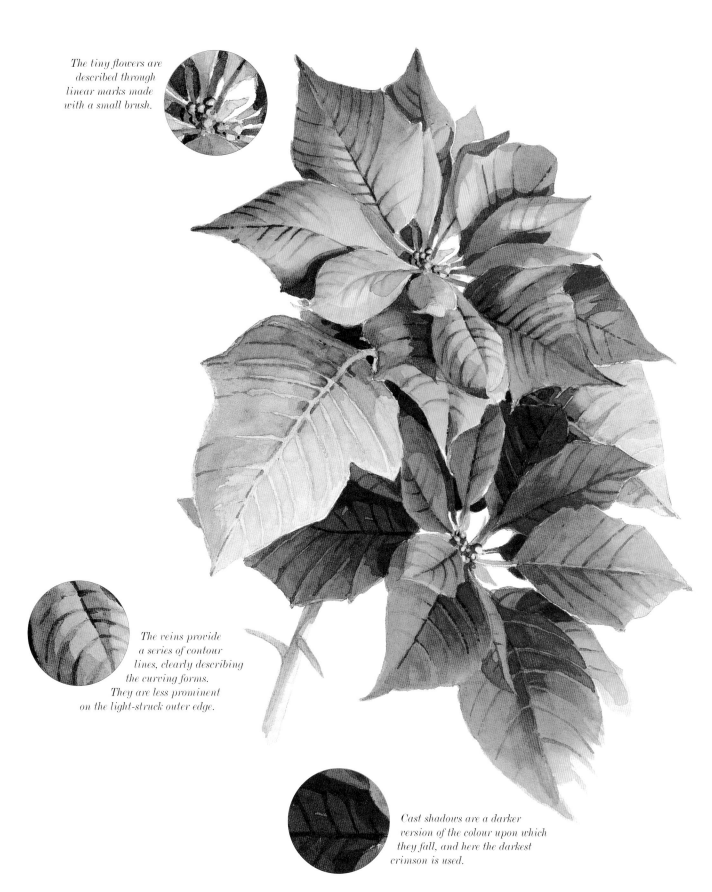

The tiny flowers are described through linear marks made with a small brush.

The veins provide a series of contour lines, clearly describing the curving forms. They are less prominent on the light-struck outer edge.

Cast shadows are a darker version of the colour upon which they fall, and here the darkest crimson is used.

Euphorbia pulcherrima

Freesia Freesia

Freesias are among the most fragrant of all flowers, and are also a feast for the eye, as they come in a wide range of lovely, delicate colours. The flower stem, which bends horizontally near the top, bears a spike of upright six-petalled flowers, evenly spaced along the spike, with those at the tip opening last into the familiar trumpet shape. When drawing, pay special attention to the way in which the flowers join the stem. The leaves are narrow and sword-shaped, and grow from the base to form erect bright green fans.

sequence start to finish

Transparent Yellow

New Gamboge

Alizarin Crimson

Permanent Rose

Thioindigo Violet

Dioxazine Violet

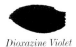
Cobalt Blue

Sap Green

Olive Green

Quinacridone Gold

1 Begin by masking off (see MASKING) the stamens and stigma. These freesias have petals with darker red edges, and you will need to paint each one with a well-loaded brush. Using mid-toned Permanent Rose, and starting with the largest flower on the right, flood on the colour, leaving thin white lines between each petal to prevent the colours running into one another. When the petals are complete, but before the paint has dried, mix a watery wash of New Gamboge, and use the brush tip to flood this onto each petal centre, allowing the colour to flow to the edges. Leave to dry. Paint the other flowers and buds in the same way.

2 Paint the funnel base with a fairly pale tone of Quinacridone Gold, changing to pale Sap Green where it goes into the sepals and the linking stalks. Strengthen the throats of the flowers with an Alizarin Crimson and Quinacridone Gold mix, soften the edges, and add a few central petal veins with a small rigger brush (see BRUSHMARKS). Add a final dark accent to the throat with a touch of Thioindigo Violet, and paint the funnel shadows with a Quinacridone Gold and Dioxazine Violet mix.

3 For the leaves, use the same technique as for the petals, first flooding on mid-toned Sap Green and then dropping in a watery Cobalt Blue and Transparent Yellow mix to blend. With the paint still wet, use a pointed twig to etch in leaf veins (see USING A STICK). Add more Cobalt Blue to the main leaf behind the flower to provide a complementary contrast to the orange (see COMPOSITION).

4 Rub off the masking, and tint the stamens and stigma with Alizarin Crimson and Quinacridone Gold. Finally, add fine details to the sepals and tiny joining stalks with Olive Green and Sap Green.

special detail increasing the water content

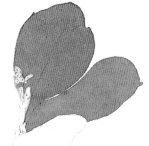

▲ *Mask off the stamens and stigma, then use a No. 8 round brush to flood in a wet mid-tone Permanent Rose over both petals, leaving a thin white space between them.*

▲ *Immediately, tip a paler and more watery wash of New Gamboge into each petal centre two or three times, using the tip of the brush. Do not attempt to brush in the colour or it will lift away too much of the first wash. Leave to dry naturally. This method, of dropping clear water or very watery colour into a previous richer wash, gives a special bloom to the petal.*

▲ *To finish, add a darker mix of Quinacridone Gold and Alizarin Crimson to the flower's throat, teasing some of this colour out into the petal veins with a rigger brush (see BRUSHMARKS). Add darker Thioindigo Violet at the base, and when dry, lighten the top edge of the foreground petal by LIFTING OUT some of the colour.*

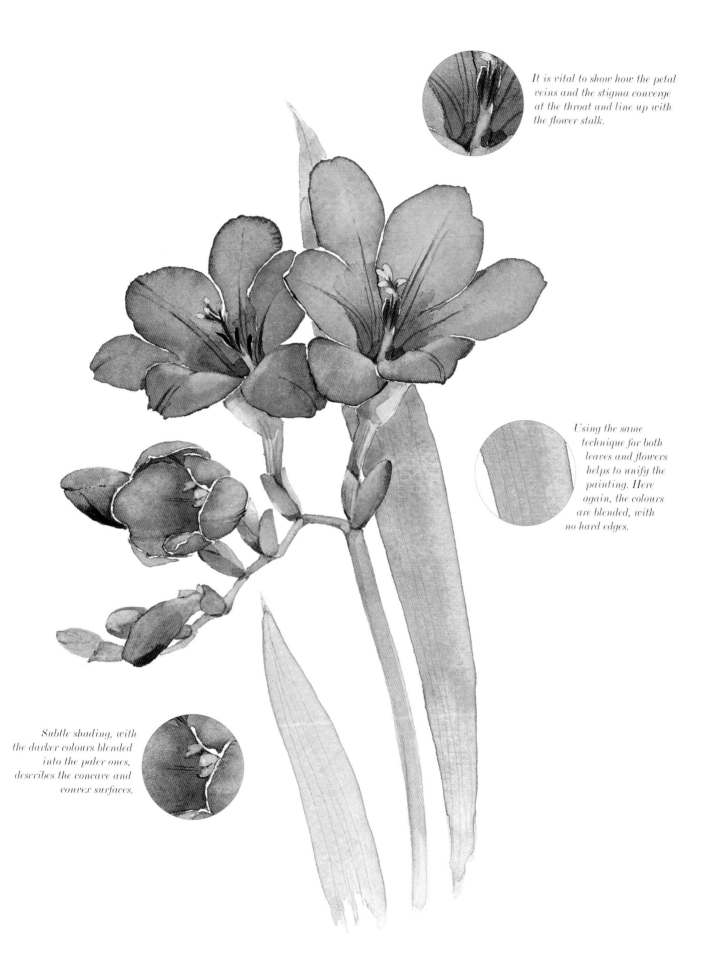

It is vital to show how the petal veins and the stigma converge at the throat and line up with the flower stalk.

Using the same technique for both leaves and flowers helps to unify the painting. Here again, the colours are blended, with no hard edges.

Subtle shading, with the darker colours blended into the paler ones, describes the concave and convex surfaces.

Freesia sp.

Fuchsia Fuchsia

These flowers, beautifully structured with bell-like flowers in rich shades of pink, red and purple, are a traditional favourite for hanging baskets, and take pride of place in many flower shows. They are a native of Central South America and New Zealand and are named after a sixteenth-century German botanist, Leonhard Fuchs. The plant is almost always pendulous, with graceful arching stems. The flower sepals on some varieties curve back to reveal a skirt or corolla of shapely petals often of a different hue to the sepals. Another attractive characteristic of the flowers is the long stamens that hang beneath the corolla.

sequence start to finish

Phthalo Red

Alizarin Crimson

Permanent Rose

Thioindigo Violet

Dioxazine Violet

Cobalt Blue

Sap Green

Olive Green

Quinacridone Gold

1 Mask off the stamens on the two prominent flowers, and work on these first. Paint the red sepals and tube with a well-loaded, pointed brush and a mix of Alizarin Crimson and Phthalo Red. The light is coming from the right, so when dry lift off some of the colour with a damp brush (see LIFTING OFF). Next paint the corolla with a Dioxazine Violet and Thioindigo Violet mix, dropping in watery Permanent Rose while still wet to blend. Allow to dry, and then paint the background flowers with paler washes of the same colours.

2 The leaves have a prominent red central vein, which must be reserved as white paper when painting the leaves. Start with fairly pale first washes in various mixes of Sap Green, Olive Green and Cobalt Blue, making the colours paler and cooler on the leaf backs where visible. Paint the tiny buds and their stems with the same colours, allowing colours to blend WET-IN-WET a little.

3 Return to the main flowers and large bud, adding shadows to the red sepals with an Alizarin Crimson and Thioindigo Violet mix. Using a small rigger brush (see BRUSHMARKS) and the same colours, paint a central vein down each sepal and also on the bud. Paint shadows and cast shadows on the corollas with Dioxazine Violet and Thioindigo Violet mixes. Keep the back branch of flowers cooler in colour and with less tonal contrast, or the painting could become confused. Glaze Cobalt Blue on the corollas and Thioindigo Violet on the red sepals.

4 Strengthen the leaves, branches and small buds with stronger mixes of the previous colours, adding Alizarin Crimson to Olive Green to emphasise the foreground branch. Again, keep the back branch simple and cool in colour. Add the red leaf veins with Alizarin Crimson.

5 Rub off the masking, and tint with Thioindigo Violet and Dioxazine Violet, varying the tones – where the stamens disappear into the skirt of the corolla, the tone is the same as the surrounding purples. Dab in the anthers with Quinacridone Gold, adding Thioindigo Violet in places to strengthen the colour.

special detail varying the focus

You don't have to paint everything you see, or to give equally sharp focus to everything in the subject, but it is important to make a visual connection between all the elements in the composition. Here the main branch is in sharp focus, with the other painted in paler colours and with less tonal contrast to push it back – this is known as atmospheric perspective.

▲ *When the flower is first drawn, it will appear cluttered and rather involved.*

▼ *Tone – the lightness or darkness of colour – will clarify the drawing, so as an exercise, paint the flowers in monochrome, using strong contrasts in the foreground and pale to middle tones in the background to make them appear further back in space.*

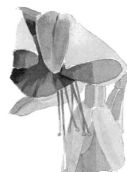

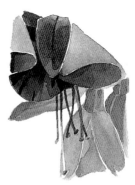

▲ *Paint the flowers again, this time with colours corresponding to the tones in the previous step. Make the foreground stronger and warmer in colour, with more tonal contrast, and the background tone cooler and paler for recession.*

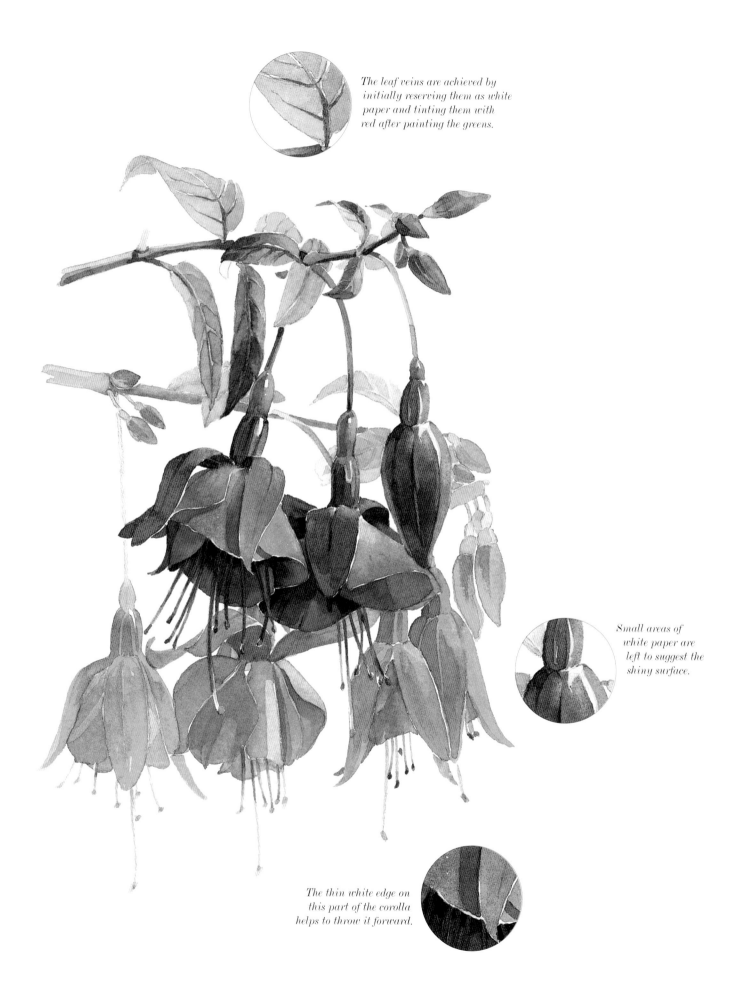

The leaf veins are achieved by initially reserving them as white paper and tinting them with red after painting the greens.

Small areas of white paper are left to suggest the shiny surface.

The thin white edge on this part of the corolla helps to throw it forward.

Fuchsia sp.

Galanthus Snowdrop

The snowdrop is one of the most popular of all bulbs for naturalising, as it spreads rapidly, rewarding us with the sight of crowds of delicate nodding heads in early spring. The beauty of the flower lies in its detail – look at the familiar pear-drop shape closely and you will see the lovely intricate inner green markings. The long, narrow leaves are bluish green, growing in pairs, and the flower is bell-shaped, with three outer pure white petals and three inner smaller ones, which are tipped or blotched with a spot of bright green.

sequence start to finish

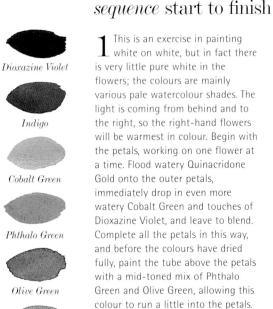

Dioxazine Violet

Indigo

Cobalt Green

Phthalo Green

Olive Green

Green Gold

Quinacridone Gold

1 This is an exercise in painting white on white, but in fact there is very little pure white in the flowers; the colours are mainly various pale watercolour shades. The light is coming from behind and to the right, so the right-hand flowers will be warmest in colour. Begin with the petals, working on one flower at a time. Flood watery Quinacridone Gold onto the outer petals, immediately drop in even more watery Cobalt Green and touches of Dioxazine Violet, and leave to blend. Complete all the petals in this way, and before the colours have dried fully, paint the tube above the petals with a mid-toned mix of Phthalo Green and Olive Green, allowing this colour to run a little into the petals. Paint the inner petals with a watery Phthalo Green and Olive Green mix, dropping in watery Quinacridone Gold to blend. Leave to dry.

2 Using Cobalt Green, Quinacridone Gold, Olive Green and Phthalo Green mixes, lay the first washes on the leaves, keeping the colours cooler where the leaf surfaces face upward. Adjust the warm and cool greys on the petals, LIFTING OFF colour where needed, especially at the front of a pair of overlapping petals. Lay a pale wash of Phthalo Green on the inner petals to send them more into shade. Paint the stalks with the same mixes as used for the leaves.

3 Finish painting details on the leaves with the previous mixes, adding Indigo for the darkest greens, and varying both the tones and the colours. The greens will give interest to the painting, so aim for a good variety – warm and cool, light and dark. Pay attention to the curl of the leaves and where they catch the light. Build up the forms of the stalks, again varying the tones so that they don't appear too silhouetted and stiff.

4 Return to the flowers, painting in details such as the darks on the flower tube with a mix of Olive Green and Phthalo Green. To paint the green markings on the inner petals, carefully wet an area around each marking with clear water, and paint the marking first with Green Gold, adding darker shapes with a Phthalo Green and Olive Green mix when the paint has dried a little, and allowing the two colours to blend on the top edge.

5 Scratch out one or two white lines with a craft knife (see SCRATCHING OUT) on the foreground petals to make them come forward (although the flowers are technically white, these are the only pure white marks to appear in the painting). Then use a sharp 2B pencil to lightly reinforce some of the petals and leaves. Don't overdo it; aim at just a touch of emphasis here and there.

special detail painting white on white

▼ *Light coming from the top right makes white flowers against white appear darker than the background, and provides colour variations, with the back petals, nearer the light, warmer in colour than those towards the front of the picture. To achieve these colours, lay a watery Quinacridone Gold wash over the outer petals, and drop in pale Cobalt Green and some Dioxazine Violet.*

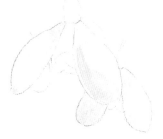

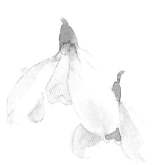

▲ *Strengthen the shadows with a Cobalt Green and Dioxazine Violet mix. Paint the inner petals with a Phthalo Green and Olive Green mix, adding in pale Quinacridone Gold. Paint the tubes and stalks with a darker version of this mix, dropping in Green Gold at the base. Soften this colour into the petals.*

▼ *Darken the main flower's inner petals with Dioxazine Violet. When dry, paint the green marks by first wetting the petal with clear water, leaving a dry edge at the tip. Add Green Gold then use the tip of a small brush to paint the shape with a Phthalo Green and Olive Green mix. Paint a small shape on the left side of the tube with this dark colour.*

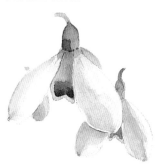

Always pay attention to the small but important structural details, such as the way the tiny flower stalk joins the main stem.

The flower centre marking is given a natural look by careful control of the edge qualities. The upper edge is soft and the lower one crisp and sharp.

Contrast on the leaves adds interest to the painting. Here the cool blue-green of the leaf is juxtaposed with the warmer greens of the stem and background leaf.

Galanthus nivalis

Gerbera Gerbera

This evergreen, upright perennial has daisy-like flower heads borne on long stems, with rosettes of large, jagged leaves at the base. It comes in a wide range of colours that seem to beg to be painted, from reds, oranges and yellows to delicate apricots, soft creams and pale pinks. Seen straight on, the flowers are circular, with petals radiating out from the centre, while from an angle they are elliptical or disc-shaped. Care must be taken drawing the stalk which must appear to come from the centre of the flower, and equal attention needs to be paid to the play of light, which describes the solid form of the flower head.

sequence start to finish

Transparent Yellow

New Gamboge

Cadmium Orange

Permanent Rose

Dioxazine Violet

Sap Green

Olive Green

Naples Yellow

Quinacridone Gold

Burnt Sienna

Brown Madder

1 Draw carefully, taking special care to give yourself a guide for the encircling tiny petals on the back flower. The light is coming from the top left in this case, so make a mental note where to leave areas of white paper in the first wash (see RESERVING WHITES).

2 Begin with the yellow front flower, working anti-clockwise from the top. With a loaded brush of New Gamboge, paint the top petals, then work around the head, laying a wash on both layers of petals. When you reach the right-hand side petals, switch from New Gamboge to Transparent Yellow, which is cooler, and leave streaks of white paper showing in the light-struck areas.

3 Allow the washes to dry, then work on the top flower, starting from the centre, which has a complex form of tiny petals radiating outward. With a fairly small round brush, paint the central button with New Gamboge, decide where you need to reserve white paper, and cover the rest of the area of small petals with

this wash. Paint the outer petals in a Transparent Yellow and Brown Madder mix, then allow to dry before painting the right-hand flower with a Naples Yellow and Permanent Rose wash.

4 Now return to the front yellow flower to build up the mid-tone. Again starting at the top, and working round the left side first, paint the petals in shadow with stronger New Gamboge, leaving small areas of petal tips and edges as the first wash. On the right side, paint the darker colour around the light petals.

5 Paint in shadows to the outer petals on the top flower using Cadmium Orange and Brown Madder, leaving a little of the first wash on the right side. To describe the small inner petals, use a linear technique, with a small brush and the same mix, starting on the right side. On the left, leave the petal tips in the first wash. Strengthen the right flower with a darker Naples Yellow and Permanent Rose mix, reserving some of the first wash where the petals catch the light.

6 Paint the central disc of the yellow flower with a Quinacridone Gold and Burnt Sienna mix, teasing some of this colour up between the petals, especially on the shadow side. When dry, paint negative details (see NEGATIVE PAINTING) with a Dioxazine Violet and Brown Madder mix, leaving tiny shapes of the previous wash. Lastly add the very dark button centre with Dioxazine Violet.

7 On the top flower, give the linear treatment to the small petals left of centre, using a small brush and a mix of Dioxazine Violet and Brown Madder. Add tiny touches of Dioxazine Violet for the darkest shadows, then paint the central button with Sap Green, carefully painting around the small yellow petals. Finish by painting the very centre with Olive Green, and then add a few further accents to the right-hand flower using Permanent Rose darkened with Brown Madder. Finally, paint the stalks with Sap Green and Olive Green tones.

special detail linear brushstrokes

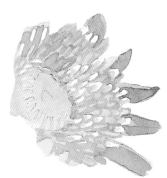

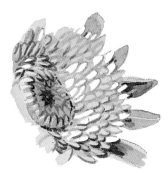

▼ *Make a Cadmium Orange and Brown Madder mix and, using a small brush, paint this colour on the outer petals. With the same colour, begin to describe the small yellow petals with linear details, radiating the fine lines out from the central button.*

▲ *Pencil in a few of the small petals that you intend to keep white, to reserve during the first wash. Paint a New Gamboge wash over the centre up to the larger petals, taking the colour around the white petal tips. Paint the large petals with a Transparent Yellow and Brown Madder mix. Leave to dry.*

▲ *Paint the button with Sap Green, reserving yellow for the small outer petals. Strengthen the brown petal line further in places with the addition of Dioxazine Violet to the previous mix. To describe the button petals in the very centre, add Olive Green to the mix and paint small lines.*

These tiny petals are described by building up from light to dark in four tones.

The light shapes are described using negative painting, then blended into the overall shading in the final stages.

To cool the colours and suggest recession, crimson is used, rather than blue, which would muddy the colours. Crimson is a relatively cool red.

Gerbera jamesonii

Gladiolus Gladiolus

This flower takes its name from the Latin word *gladius*, because the bud tip that breaks through the foliage resembles the short, broad blade of the Roman gladiator's sword. Gladioli are outstanding summer flowers, eye-catching in a garden, and excellent for indoor arrangements. Some hybrids are spectacularly tall and come in deep, rich colours, sometimes with ruffled edges. Each spike has trumpet-shaped flowers arranged on opposite sides of the stem, either vertically touching each other or alternating with slight spaces between. The buds open from the bottom to the top of the stem, making an inverted cone shape. The stiff leaves form fans, and from an artist's or florist's point of view, create useful strong green verticals to complement the freer forms of the blooms.

sequence start to finish

Quinacridone Magenta

Dioxazine Violet

Indigo

Cerulean Blue

Sap Green

Green Gold

1 After making a careful drawing, mask off the stamens, then begin the painting, treating each petal separately. The overall colour is a pale yellow-green, so start by laying a watery wash of Green Gold over one of the petals of the main open flower, leaving white paper for the central vein. While still wet, flood in watery Cerulean Blue, which will push the Green Gold to the outside edges. Keep an eye on the paint as it dries, but avoid trying to make major corrections. Leave to dry fully before repeating the process on the other petals of the main flower. Allow to dry again, and if the white vein requires reinforcing, lift more colour out with a clean damp brush (see LIFTING OUT).

2 Paint the rest of the flowers and buds in the same way, using a Cerulean Blue and Green Gold mix for the bud and opening flower. Allow to dry, then use the same two colours to add all the mid-tones, including those on the ruffled edges, softening edges where required. Notice that the colour is greener and more intense on the bud and opening flower. Paint the leaves with Cerulean Blue and Sap Green mixes, and while wet, draw in leaf veins with a sharpened twig (see USING A STICK). Paint the sheaths around the buds and stems with the same colours.

3 Paint the richly coloured throat of the main flower with Quinacridone Magenta, darkening the colour in the crevices by dropping in Dioxazine Violet and then feathering out the colour and stippling in places. Allow to dry before rubbing off the masking and tinting the stalks of the stamens with a Green Gold and Dioxazine Violet mix. On the bottom flower, keep the tones in the middle range so that it does not compete for attention with the main flower.

4 To finish the leaves, add pale washes of Green Gold to brighten them in places, and put in touches of Dioxazine Violet for shadows. Finally, add Indigo to the previous colours to make small accents of darker tone.

special detail painting within a limited colour range

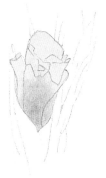

▲ *The bud and leaves are very similar in colour and tone, which could make this area of the painting dull unless all the subtle differences are explored. Begin with a wash of Green Gold on the bud, dropping in Cerulean Blue towards the base.*

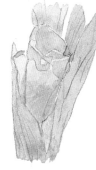

▲ *There are no strong contrasts in tone, just variations of similar colours. Paint washes on the leaves with mixes of Cerulean Blue and Sap Green, etching in veins with a sharpened twig while still wet (see USING A STICK). Add a second tone to the bud with pale Cerulean Blue.*

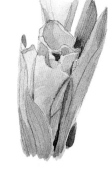

▲ *Paint a second tone on the leaves, adding touches of pale Dioxazine Violet while wet. Allow to dry before adding darker accents to the leaves with Indigo and Sap Green mixes, and Dioxazine Violet and Sap Green mixes for the small purple dark shapes. Shade the buds a little more using a darker Cerulean Blue and Green Gold mix.*

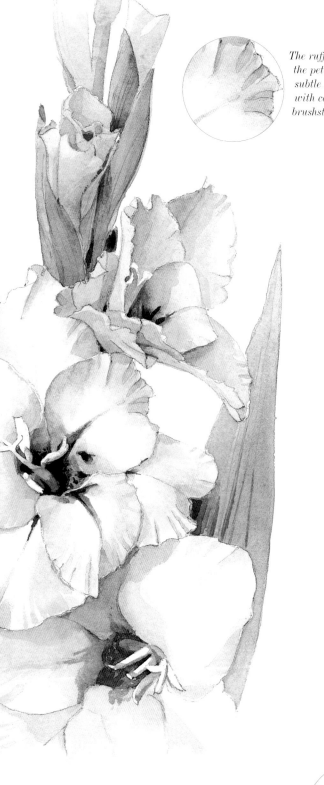

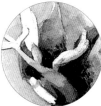

The deep magenta
and spotted texture
provide the perfect foil
for the yellow-green of
the ruffled petals.

The ruffled edge to
the petal is achieved by
subtle shading combined
with careful directional
brushstrokes.

The leaves are painted boldly
and simply, with the veins
etched into wet paint with a
sharpened stick.

Gladiolus sp.

Helianthus Sunflower

Sunflowers are marvellous painting subjects, with their imposing height and large, bold leaves and flower heads. They are native to the Great Plains region of America, and the world height record is 29 feet (8 m). They have daisy-like flowers, usually yellow, but sometimes now in a range of reds, and large oval serrated mid-green leaves. The halo of petals surrounds a large brown or purplish dome that grows in a spiralling manner to become a collection of massed seeds as the flower dies. Be conscious of the ellipses formed, including that of the central dome, when the head turns away from you.

sequence start to finish

Transparent Yellow

New Gamboge

Dioxazine Violet

Indigo

Cobalt Blue

Phthalo Green

Sap Green

Olive Green

Green Gold

Quinacridone Gold

Brown Madder

Raw Umber

1 Mask off (see MASKING) a few of the spiralling seeds in the flower centre, and paint in the first wash, starting with the top left petals, and using a No. 10 round brush and a Transparent Yellow and New Gamboge mix. Continue down the flower's left side to the lower petals, and thence to the right side and back to the top, here using New Gamboge alone. Allow to dry.

2 Still using the large brush, but with a Quinacridone Gold and New Gamboge mix, paint anticlockwise from the top, picking out some of the petals that catch less light. On the right side use Quinacridone Gold only, leaving just the tips of the petals as the first wash. Next, paint the first washes on the leaves, making the colours cooler on the upward-facing surfaces. To vary the colour temperature (see COMPOSITION), start with a base colour

of Phthalo Green and Sap Green, dropping Green Gold or Cobalt Blue into the wet washes. While still damp, use the point of the brush and Raw Umber to tip in the main prominent leaf veins. Paint the substantial flower stem in a paler, warmer version of the leaf colours, darkening on the right with Raw Umber.

3 Work on the flower centre, starting with a mid-toned wet Quinacridone Gold wash. To prevent the dome from looking stark, make it hard-edged on the right side and softer-edged elsewhere. With the first wash still wet, drop in Brown Madder, then allow to dry slightly before spotting in a stronger mix of Brown Madder and Dioxazine Violet with the tip of the large brush. In the very centre, tip in dark Dioxazine Violet and use a small rigger brush (see BRUSHMARKS) to draw some spiralling lines with this same colour. Let dry.

4 Return to the petals again to darken the tone on those on the right and at the top and bottom. For those most in shadow, use a wash of Quinacridone Gold and Brown Madder, concentrating most of this colour on the right side, and using only a touch on the left.

5 Add definition and detail to the leaves using a Phthalo Green and Olive Green mix, dropping in Green Gold while wet.

6 Rub off the masking on the central dome and tint with a Quinacridone Gold and Dioxazine Violet mix, finishing with a few dots of Indigo.

special detail making the most of light

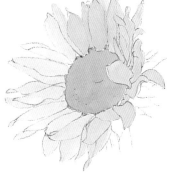

▲ *Here, a strong light coming from top right, shows up the forms of the petals and flower centre. As an exercise, paint a wash of New Gamboge over all the petals then paint the central disc with Quinacridone Gold.*

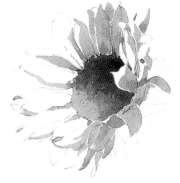

▲ *Starting again with a different drawing, paint in just the darker shadows using Quinacridone Gold for those on the petals, and a Brown Madder and Dioxazine Violet mix on the disc centre. You can now see the pattern of light on the petals more clearly.*

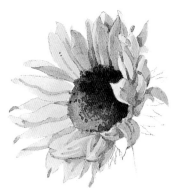

▲ *Paint the sunflower by combining the first two stages, observing the way the light affects the foreshortened petals on the right side.*

The texture is created in a number of ways – masking, *LIFTING OFF*, and painted lines and dots.

SCRATCHING OUT creates a broken white line that separates this leaf from the one behind while still giving a soft impression.

The difference in the edge quality of these veins, varying from hard to soft, helps to marry them to the leaf.

Helianthus annus

Helleborus Lenten Rose

These flowers are especially prized by gardeners as they are frost-hardy, and flower in winter. They are also very attractive, with the nodding, cup-shaped flowers with overlapping petals rising from evergreen dense divided foliage. The flowers, in shades of white, green, pink and purple, are sometimes darker-spotted on the insides, but these markings, as well as the centre boss of gold stamens, often go unnoticed because they remain hidden until the flowers are turned upward or have opened fully into their flattened bowl shape. In this variety, the predominant colour is green, so you will need to be creative in showing variety, even exaggerating a little to show up the subtle differences in the hues.

sequence start to finish

Dioxazine Violet

Indigo

Cobalt Blue

Phthalo Green

Sap Green

Olive Green

Green Gold

Quinacridone Gold

Brown Madder

1 Mask off (see MASKING) the stamens and nectaries that surround the base of the stamens. Lay a Green Gold wash over the main flower with a No. 8 pointed brush, and while wet, lay a mid-toned watery wash of the same colour on the adjoining leaves. With the wash for the leaves still wet, drop in watery Cobalt Blue and/or a mix of Green Gold and Phthalo Green, depending on whether the leaf section is facing upward and is thus cool in colour, or is more vertical and thus warmer. Repeat the process on the small bud and its leaves before painting a wash of coolish Green Gold and Cobalt Blue mix on the back flower.

2 Now start on the main flower. Using mixes of Green Gold, Phthalo Green and Cobalt Blue, paint in the shading, starting at the top and working down to the lower tips, and cooling the colour with more blue towards the lower petal tips. Allow to dry very slightly, then drop in darker Olive Green around the base of the stamens, and Quinacridone Gold right in the centre of the stamens.

3 Paint around the thin, spidery leaf veins with mid-toned greens made from Olive Green, Phthalo Green, Sap Green and Cobalt Blue. To vary the greens, drop any of these colours into newly laid washes, softening the edges into the first washes. Add spots of wet but fairly dark Indigo at the base of some of the leaves for a darker tone, but take care not to let the paper dry; this must be worked WET-IN-WET to blend.

4 Return to the main flower, and use a small brush and a Brown Madder and Dioxazine Violet mix to paint in the spotted markings in the centre, following the curve of the petals. Paint the back flower centre in the same way, but make the colours much paler. Allow to dry, and rub off the masking. Tint the anthers of the main flower with Quinacridone Gold and their stems with a Green Gold and Olive Green mix. Use this same mix for the nectaries and the very small stamens right in the centre, which are a little darker. Paint the centre of the back flower in the same way, but again with paler mixes of the previous colours.

5 Add final details to the bud and leaves. Start by glazing on small accents of mid-toned Phthalo Green, then allow to dry and touch in final dark accents with Indigo.

special detail painting luminous greens

▼ *Glowing greens can be achieved by using ready made transparent greens, rather than blue and yellow mixes. Lay a watery wash of Green Gold over the shape, and while wet, drop in watery Cobalt Blue on the top half of the leaf, and a Green Gold and Phthalo Green mix on the lower half, allowing these colours to blend to create a VARIEGATED WASH.*

▲ *From the top, paint around the leaf veins with pale Cobalt Blue, adding Sap Green as you go down. To the right of the centre rein, take a Sap Green and Phthalo Green mix to the bottom, and drop in an Indigo and Olive Green mix where the leaf curls away from the light. Paint the flower part with darker Green Gold, adding Phthalo Green, and leaving the petal edges in the first wash.*

▼ *Add final details on the leaves with accents of Indigo, and touch in small spots of Brown Madder on the petals.*

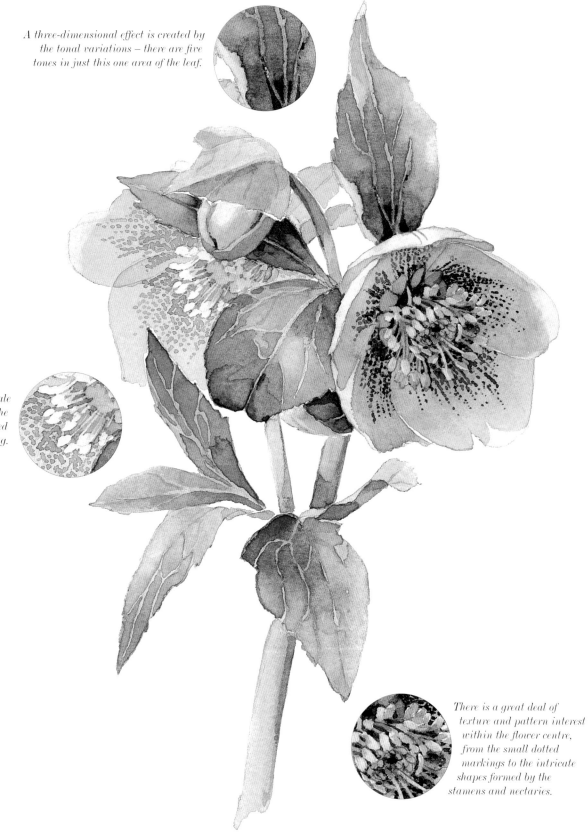

A three-dimensional effect is created by the tonal variations – there are five tones in just this one area of the leaf.

To separate the pale colours in this area, the stamens were masked off before painting.

There is a great deal of texture and pattern interest within the flower centre, from the small dotted markings to the intricate shapes formed by the stamens and nectaries.

Helleborus orientalis

Hibiscus Syrian Rose

This shrub plant is characterised by wonderful tropical-looking flowers with wavy-edged petals, their exoticism shown off by dark green lobed foliage. In this particular variety the large disc-shaped flower is lilac blue with a magenta center, from which project a cluster of golden-yellow stamens. The flower is an uncomplicated five-petal star shape, with the main interest lying in the contrasting shapes of leaves and flowers, and the differing textures and colours, all of which need to be described to give the overall feel of the plant.

sequence start to finish

Transparent Yellow

Quinacridone Magenta

Dioxazine Violet

French Ultramarine

Sap Green

Quinacridone Gold

1 Mask off the central bosses of the stamens. Paint one petal at a time, starting with the left-hand main flower. With a No.10 round brush, lay a VARIEGATED WASH of two colours – Dioxazine Violet and French Ultramarine – on the petal, using the blue alone for the cooler upward-facing surfaces, and the violet alone for the warmer, more upright surfaces. With the wash still damp, brush in some fairly dry, mid-toned Quinacridone Magenta. Tease out some colour for the pale petal veins with a small rigger (see BRUSHMARKS), then reinforce the petal-base marking with stronger Quinacridone Magenta. Before the paint has dried, use the rigger to paint the wispy petal veins from the base towards the tip with a dark Quinacridone Magenta and Dioxazine Violet mix. Complete the other main-flower petals in the same way before moving on to the other flowers. Allow to dry.

2 Paint the first washes on the leaves with French Ultramarine and Sap Green mixes, warming the colour where the leaves catch the light with Transparent Yellow.

3 Return to the flowers, and paint the shadows and cast shadows with French Ultramarine and Dioxazine Violet, at the same time suggesting more folds and creases to describe the crinkly texture of the petals. Strengthen just a few of the darker petal veins with Dioxazine Violet, again using the rigger.

4 When the leaves' first washes have dried, lift off colour (see LIFTING OUT) for the lighter leaf veins with a small damp brush and blot with a tissue. Then emphasise the veins by painting around them with stronger Sap Green and French Ultramarine mixes to throw them into relief.

5 Paint the buds very simply then leave to dry and rub off the masking on the stamens. Tint with Quinacridone Gold, leaving a little white here and there. Allow to dry again and then describe the dot pattern made by the stamens by painting around them with a mix of Dioxazine Violet and Quinacridone Gold. If the petal shadows require strengthening, especially on the lower flower, glaze over them (see WET-ON-DRY) with French Ultramarine and/or Dioxazine Violet.

special detail using a rigger brush

▼ *Mask off just the very edge of the stamens touching this petal. With a large No. 10 round brush, paint in a watery Dioxazine Violet and French Ultramarine wash, instantly LIFTING OUT a little colour from the top of the petal folds with a folded tissue or a clean damp brush.*

▲ *With this first wash still wet, lightly touch in mid-toned Quinacridone Magenta at the base of the petal, and use a small rigger brush (see BRUSHMARKS) to drag the colour out into the petal veins, keeping the colour very pale towards the tip.*

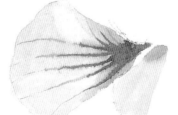

▼ *Again while damp, use the rigger to strengthen the petal veins with a Dioxazine Violet and Quinacridone Magenta mix from the base to mid-way up. Add very dark veins with a stronger mix of the same colours, then paint pale shadows on the petals with a Dioxazine Violet and French Ultramarine mix. Paint the small green sepal at the back of the petal with a Sap Green and French Ultramarine mix. Allow to dry before rubbing off the masking.*

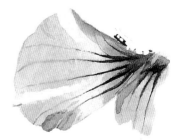

After removing the masking on the flower centre, just enough detail is added to suggest the shape and structure of the stamens.

Don't be afraid of dark shadows. Here they play an important part in giving emphasis to the light petals.

The central leaf veins are achieved by LIFTING OUT colour with the point of the brush.

Hibiscus syriacus

Hippeastrum Pot Amaryllis

Large-flowered hippeastrum, popularly known as amaryllis, is striking by any standards, with majestic lily-like flowers. Each spherical flower head is a collection of four to six cone-shaped blooms growing from the same spot on a single stem. This particular cultivar has white flowers with fascinating broken stripes of strawberry red and a green throat. Although it is so colourful, the red stripes are really just decoration, so think of it initially as a white flower and paint the shadows to show the form as it turns away from the light, paying special attention to the dark shadow of the deep throat, into which the stamens disappear.

sequence start to finish

Transparent Yellow

Phthalo Red

Quinacridone Red

Alizarin Crimson

Dioxazine Violet

Cobalt Blue

Sap Green

Olive Green

Green Gold

Quinacridone Gold

1 Make a careful drawing including a few indications of the petal veins, as these are prominent in this species, and it is important to place them correctly. Then mask out (see MASKING) the stamens and stigma to allow yourself more freedom when painting the petals.

2 Pretend that you are dealing with a white flower, and start to build up the forms by painting the shadows, leaving areas of white paper, especially on the right flower, which catches most light. Using a No. 10 round brush and mixes of Cobalt Blue, Dioxazine Violet, and Quinacridone Gold, paint watery washes, varying the colours from pale blue-violet on shadowed areas to light gold on vertical areas facing the light. Soften the edges.

3 Each of the blooms has a green throat. Glaze on a thin first wash of Green Gold. Soften the outer edge running into the petals, and then drop in Sap Green and allow to blend.

4 DRY BRUSH work is the ideal technique for the broken-colour effect of the markings. On the right-hand bloom, use Quinacridone Red mixed with Quinacridone Gold, and on the left-hand bloom, use Alizarin Crimson and Phthalo Red. Follow the vein lines and darken or lighten the tones to describe the curl of the petals. Then paint in the delicate petal veins with a fine round brush and the same mixtures. Take care with these, as they describe the flower form. For the backs of the petals showing at the top, work WET-IN-WET, adding the few veins lightly while the first wash is still wet. Leave to dry before edging the petals with a very fine and delicate red line.

5 Lay a wash of Transparent Yellow and Sap Green over the whole of the stalk, and while wet, add mid-toned Sap Green on the left side to give solidity to this substantial form. Again while wet, drop in a touch of dark Alizarin Crimson under the petals to blend (see WET-IN-WET). This marries the stalk to the flower by providing a colour echo. Paint the fleshy leaves wet-in-wet with the same colors plus Cobalt Blue, again dropping in a little Alizarin Crimson to finish.

6 Paint the bud in a blend of the flower colours with accents of dark Alizarin Crimson and Olive Green added at the end. To finish the flowers, rub off the masking and tint the stamens at the base with Sap Green. Tint the anthers with Quinacridone Gold, leaving the stigma white. Spot in the small, dark crevices with an Olive Green and Alizarin Crimson mix, then use dark crimson for the red petal veins where they curl into shadow.

special detail dry brush

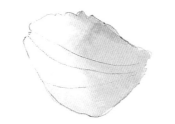

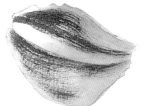

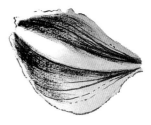

▲ *This petal is in shadow, and thus does not appear white, so begin by painting a VARIEGATED WASH of Quinacridone Gold, Cobalt Blue and Dioxazine Violet. When dry, paint in a soft Green Gold wash from the middle to the base of the petal, softening the edge inside the petal. While still wet, drop in some Sap Green at the base and allow to blend outward to the petal centre. Allow to dry.*

▲ *Now begin the dry brush work, using Alizarin Crimson and Phthalo Red. Take a No. 8 round brush, press out the excess water, dip it into the paint and splay out the bristles on a piece of spare paper. Starting at the petal tip, drag the red paint down both sides of the central vein, gently fanning the colour out to the edges and tapering the brushstrokes at the petal base.*

▲ *Paint in a few petal veins with Alizarin Crimson, following the contours of the petal, and lastly add a very thin red edge to the petal.*

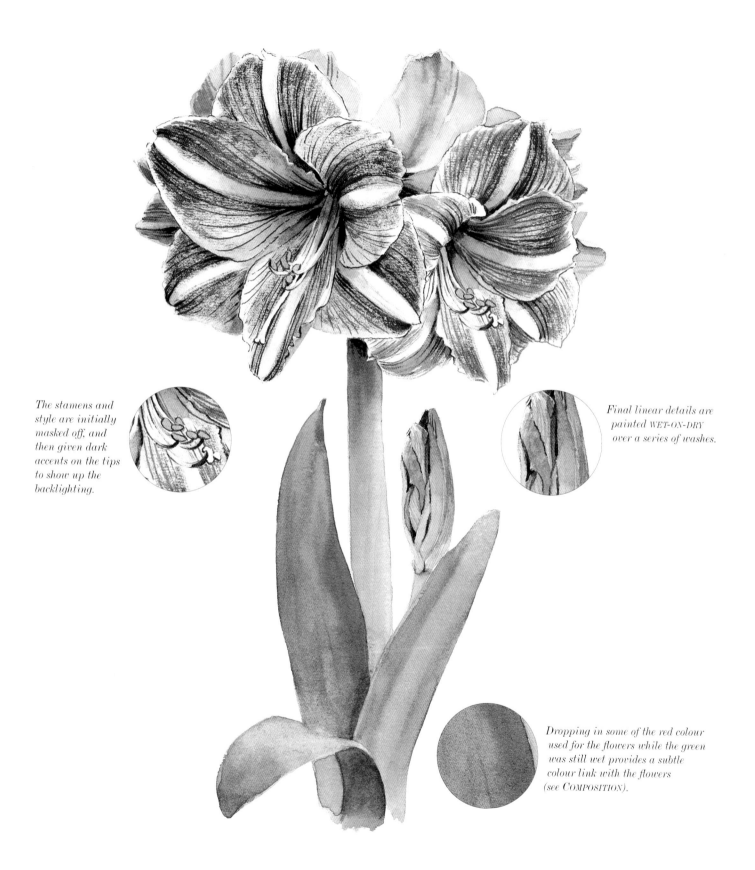

The stamens and
style are initially
masked off, and
then given dark
accents on the tips
to show up the
backlighting.

Final linear details are
painted WET-ON-DRY
over a series of washes.

Dropping in some of the red colour
used for the flowers while the green
was still wet provides a subtle
colour link with the flowers
(see COMPOSITION).

Hippeastrum sp.

Hyacinthoides Spanish Bluebell

This is a plant of the woods and shady hedgerows, and when found in abundance creates a lovely carpet of blue-violet beneath the fresh new greens of early summer, an ever-popular subject for painters. The bluebell plant has very long, glossy, strap-shaped leaves which all rise up from a bulb, with the flower stem standing above them in the middle. The bell-shaped flowers are arranged in a long curving line, and each has two bracts at the base of the short stalk that unite it with the main stem, and are arranged alternatively up it. The Spanish bluebell has rather larger flowers than those of the native species, and comes in pink and white shades as well as blue.

sequence start to finish

Permanent Rose

Dioxazine Violet

French Ultramarine

Cobalt Blue

Sap Green

Olive Green

Green Gold

1 After making a careful drawing, block in the whole right-hand spike with a VARIEGATED WASH. Start with watery Permanent Rose on the light-catching outer edges of the florets, and change to pale watery French Ultramarine for the rest, letting the two colours blend. Because the flowers are backlit, there are no very light tones on the central florets. Complete the other two spikes to this same stage, dropping in watery Green Gold at the tops of the small buds. Allow to dry.

2 Carefully paint in the second tones, using a small brush and Cobalt Blue and/or French Ultramarine, leaving the light first wash at the edges and for some of the curled-back petal tips. Paint the centre petal veins with Cobalt Blue, then leave to dry before continuing to build up the tones with French Ultramarine and Dioxazine Violet, each time reserving some of the previous washes. Repeat the process on the left-hand spike, but leave the central flowers relatively pale so that they recede into the background.

3 Paint the leaves and stalks with mixes of Green Gold and French Ultramarine, varying the shades from warm to cool (see COMPOSITION) depending on whether the surface catches the light or is further back in space. Allow to dry, then finish with stronger washes of a Sap Green and Olive Green mix, ensuring that the front curled-over leaf comes forward by darkening or cooling the colours of those behind it.

4 With a Dioxazine Violet and Green Gold mix, paint in the small stamens visible on some of the open florets, and then add final dark accents on the flower stalks and unopened buds on the left stalk with stronger mixes of the previous flower colours.

special detail analysing the structure

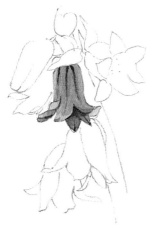

▲ *Each individual floret is a bell or cone shape that hangs down from a central stem. When drawing, bear this basic structure in mind, especially when the floret is more horizontal, as is the one at top right.*

▼ *The single cone-shaped floret is segmented into six flaring petals at the tip. Deep inside, in shadow, are the stamens, with the bottom edge of the petals catching the light. A small stem, together with two bracts, attaches the floret to the cylindrical stem.*

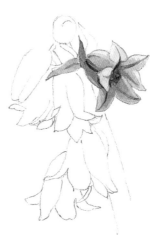

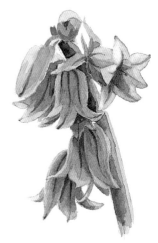

▲ *Note how the individual flower shapes overlap in an alternative arrangement around the stem. They are more widely spaced at the bottom, clustering together towards the top – these top flowers open last. Paint the foreground florets first to establish the shape.*

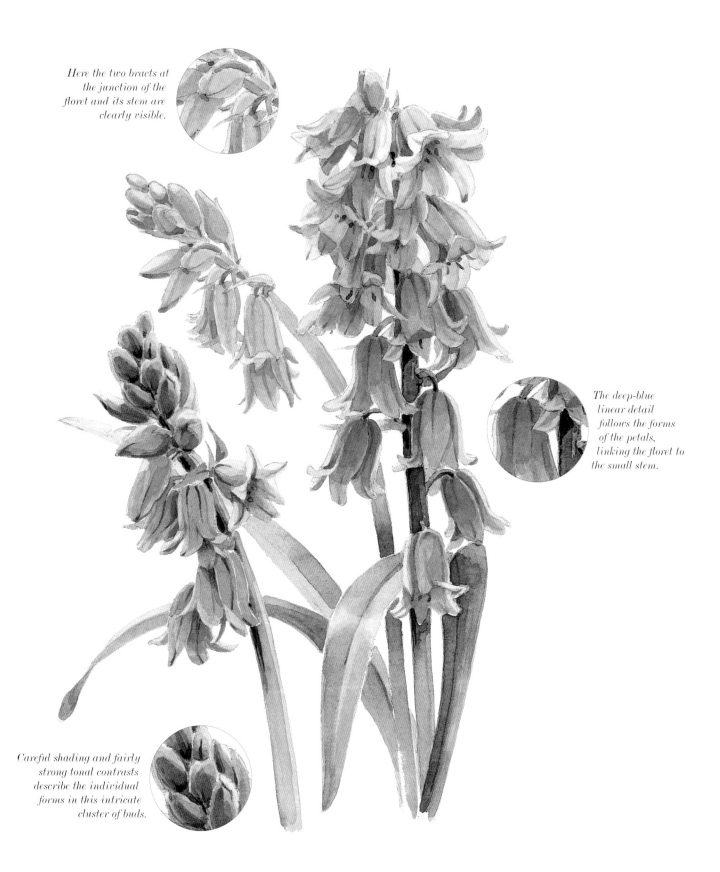

Here the two bracts at the junction of the floret and its stem are clearly visible.

The deep-blue linear detail follows the forms of the petals, linking the floret to the small stem.

Careful shading and fairly strong tonal contrasts describe the individual forms in this intricate cluster of buds.

Hyacinthoides hispanica

Hydrangea Hydrangea

A hydrangea is a multi-headed flower made up of simple, flat, close-toned individual florets. These are grouped together on a single supporting stem, which must be strong enough to support the flower. It is this collection of clusters that forms the large spherical head shape, and this basic form must be kept in mind when building up the flower. In observing the overall shape, look closely at the planes of each small floret as they form ellipses when they turn away to the side.

sequence start to finish

Quinacridone Magenta

Dioxazine Violet

Indigo

French Ultramarine

Cobalt Blue

Cerulean Blue

Olive Green

Green Gold

1 After careful analysis, start to shape out the flower. On hot-pressed paper, using a 2B pencil, begin by faintly drawing in the flattened sphere of the whole head. Draw in loosely, petal by petal, the large front florets, working your way round to the sides and towards the back. Then start on the leaves.

2 Well-defined side light will help to show the form of the flower. Those parts which catch the light will be noticeably paler in tone, while those in the shadow will appear darker. Working from light to dark, paint each floret directly with a medium-round brush. Starting with the prominent left-hand florets, wash in a mix of pale Cerulean Blue. Before it is dry, touch in some pale Quinacridone Magenta to create the variety: each floret is a slightly different colour from the next. Once the first floret has dried, move onto the next, deepening the colours for the areas in shadow.

3 You will have to keep modifying some of the tones with a wash of French Ultramarine and Cobalt Blue to make the background florets cooler so that they recede. When the washes are dry, go back to the first florets and strengthen them in parts with added touches of darker Cerulean Blue. Proceed across to the right and to those in shadow, adding washes of mid-toned Cerulean Blue, French Ultramarine and Quinacridone Magenta, some warmer and others cooler. Allow to dry.

4 Using washes of the previous colours, add the defined shadows cast by the side lighting. Paint the negative shapes between the florets in the foreground in darker, richer shades of the same colours. Then move on to the back florets.

5 Linear texture can be added at this stage with a small, fine brush and Quinacridone Magenta in spidery lines to suggest the petal veins. A

strong Cerulean Blue painted in the central button of each floret will also add texture. The flower centre consists of numerous small, round buds – paint these with Cerulean Blue and Cobalt Blue.

6 Wash over the leaves and flower stem with mixes of Green Gold and Cobalt Blue. Allow to dry. Then add stronger mixes of the same colours to build up their form. Paint round the central cluster of blue buds with the leaf mixes.

7 Add final definition and detail to the florets with small dabs of Indigo, especially on the shadow side of the centre buttons. Add touches of Dioxazine Violet to the petal edges. Paint in the small floret stalks and bud stalks with crisp strokes of Olive Green, touched with Quinacridone Magenta. Finally create further leaf texture with small amounts of Olive Green.

special detail floret forming

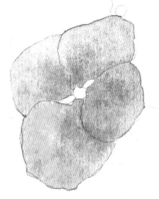

▲ *Paint in a mid-tone wash of Cerulean Blue on dry paper over the four petals. Drop in mid-tone Quinacridone Magenta while still wet, especially near the centre, so that it blends and diffuses. Allow to dry.*

▼ *Pick out each petal by painting in shadows using darker French Ultramarine, Quinacridone Magenta and Cerulean Blue. Soften edges in parts with a clean, damp brush, but leave other areas hard-edged. These colours will help create granular texture.*

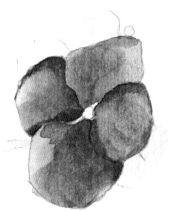

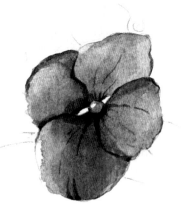

▲ *Paint in the central button with Cerulean Blue. With a small, fine brush dipped into Dioxazine Violet and Indigo, paint in small accents on the petal tips and on the shadow side of the central dome. Linear texture can be added by fine lines radiating out from the centre in Quinacridone Magenta.*

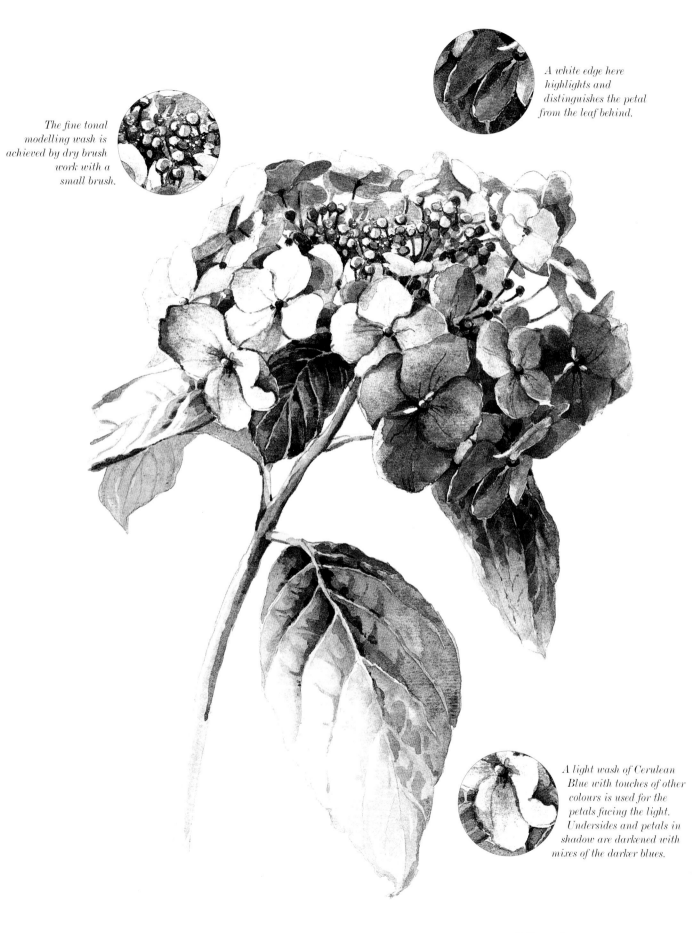

The fine tonal modelling wash is achieved by dry brush work with a small brush.

A white edge here highlights and distinguishes the petal from the leaf behind.

A light wash of Cerulean Blue with touches of other colours is used for the petals facing the light. Undersides and petals in shadow are darkened with mixes of the darker blues.

Hydrangea sp.

Ipomoea Morning Glory

This native of South America is a fast growing, twining climber that has been known to climb trees as tall as 95 feet (around 30 metres). The trumpet-shaped flowers open only during the morning, hence the name, and have faded by early afternoon, but there is usually an abundance of buds ready for opening on each successive morning over a long period. The colours range from deep purple to bluish purple or reddish flowers with white throats. The light green, heart-shaped leaves are carried on long thin stems, and the buds are furled. Look out for the cast shadows that play an important role in adding interest to these otherwise simple flowers, and also for the many twining stalks that create lively patterns as well as linking everything together.

sequence start to finish

Transparent Yellow

Dioxazine Violet

Indigo

French Ultramarine

Cobalt Blue

Cerulean Blue

Sap Green

Olive Green

Quinacridone Gold

Brown Madder

1 Start with the two main flowers, painting loose washes of a Cobalt Blue and French Ultramarine mix over all the petals, and adding a touch of Cerulean Blue towards the throats to blend. Then with a clean, damp brush lift off colour (SEE LIFTING OUT) towards the flower centre where it grades to white at the throat, and tint this with pale Transparent Yellow. With the paper still slightly damp, paint thin lines down either side of the petal veins with a rigger brush (see BRUSHMARKS) and pale Dioxazine Violet. Paint all the flowers in the same way and leave to dry.

2 With a small, moist brush, paint over the petal veins to lift out the colour and blot with tissue. Repeat if necessary (the paint is rather harder to lift when dry). Then paint in the flower shadows and cast shadows with a Dioxazine Violet and Cobalt Blue mix before reinforcing the petal veins with the rigger and a stronger mix of the same colours. Paint the very centre of the flower on the left with Quinacridone Gold, and soften the right-hand edge into the petals.

3 For the leaves, start with mixes of Cerulean Blue, Transparent Yellow and Sap Green, dropping some of these colours into the first washes, depending on whether the leaf is in sun or shade – shaded areas will need more blue, and light-struck ones more yellow. Paint the strong twining stalks with Brown Madder combined with the leaf colours and touches of Dioxazine Violet, varying the tones.

Allow to dry, and then paint in the cast shadows on the leaves with an Olive Green and Sap Green mix, dropping in Cerulean Blue in places for variety. For the darkest accents, use an Indigo and Sap Green mix.

4 When the leaves are dry, lift out the leaf veins in the same way as for the petal veins, then darken the shadowed areas of the stalks with the previous colours plus Dioxazine Violet. Finally, lay a wash of Quinacridone Gold and Dioxazine Violet on the furled buds, and paint in the furled lines with a rigger and dark mix of the leaf colours.

special detail lifting out colour

▲ Lay a French Ultramarine and Cobalt Blue wash on the flower petal. Add Cerulean Blue at the centre. Using the side of the bristles of a damp brush, lift off the colour at the throat, and then tint it with the palest Transparent Yellow. Wash a Sap Green and Transparent Yellow mix onto the leaf, dropping in Cerulean Blue at the base, then allow to dry.

▲ Using a small, damp brush, paint over the petal veins and blot with a dry tissue to lift away the colour. Leave to dry before reinforcing the petal veins on either side of the lifted-out shape with a rigger brush (see BRUSHMARKS). Tint part of the centre with a Quinacridone Gold and Olive Green mix, and brush in a light wash of Quinacridone Gold down the centre right vein.

▲ Paint in the cast shadow on the leaf with a watery but dark mix of Olive Green and Sap Green, dropping in Cerulean Blue to blend. When dry, lift out the leaf veins as before, then leave to dry again. Add accents with an Indigo and Sap Green mix, painting in the small shape of the background leaf with strong Olive Green.

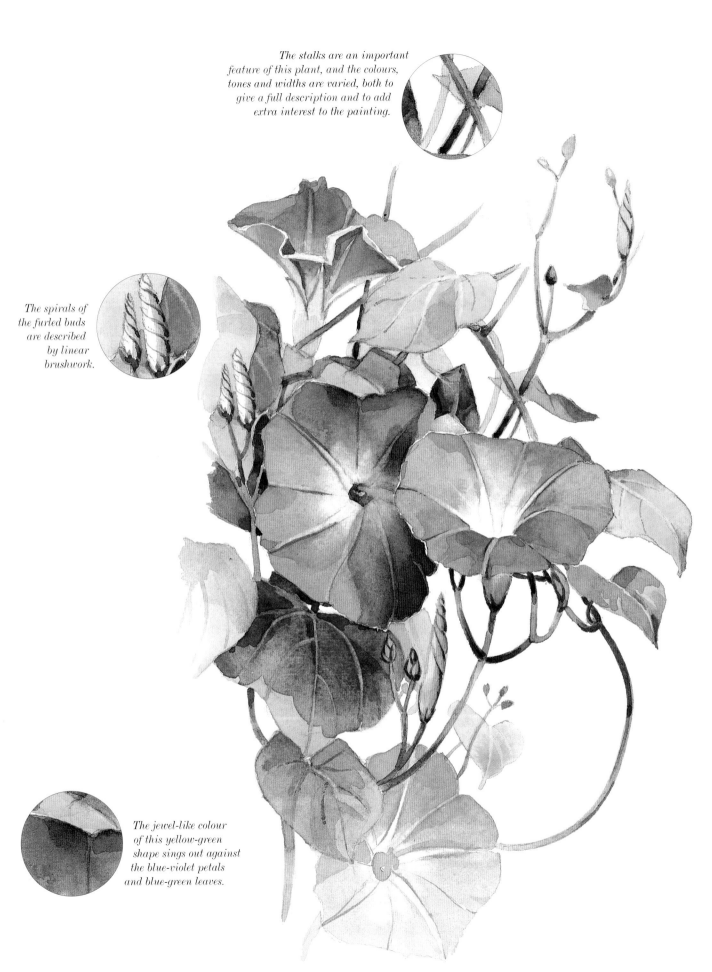

The stalks are an important feature of this plant, and the colours, tones and widths are varied, both to give a full description and to add extra interest to the painting.

The spirals of the furled buds are described by linear brushwork.

The jewel-like colour of this yellow-green shape sings out against the blue-violet petals and blue-green leaves.

Ipomoea purpurea

Iris Pacific Coast Iris

The iris is a strangely shaped yet sophisticated flower, with a glamorous appeal that makes it indispensable in the garden. The pre-Raphaelite painters loved irises, and Gertrude Jekyll, one of the most famous English gardeners of the early twentieth century, designed gardens especially for them. Each flower comprises three usually large 'falls' (pendant petals), some of which have conspicuous beards or crests, plus three generally smaller 'standards' (erect or horizontal petals) and three branched styles, which can be petal-like. Look carefully at the way petals bend and curl away from the light, and at where they overlap and cast shadows.

sequence start to finish

New Gamboge

Permanent Rose

Dioxazine Violet

French Ultramarine

Cobalt Blue

Cobalt Turquoise

Phthalo Green

Sap Green

Olive Green

Quinacridone Gold

1 Make a light, careful drawing, paying attention to form and construction. Starting with the middle-right standard petal, load a brush with a mix of pale Cobalt Blue and a little Permanent Rose, and paint from top to bottom. Leave white paper for veins, as well as on the bottom half of the petal where it catches the light. Allow to dry before going back to add a little pale New Gamboge to the outer vertical edge, at the base. Build up the first mix and paint pockets of darker tones, especially on the petal's nearest edge, to create a ruffled look.

2 The left-hand petal is more in shadow, so use the same colours as before, but a little stronger to make a mid-tone, adding French Ultramarine to the mix for the shadowed vertical part of the petal. The back standard petal shows more of the inside shape, so use pale Cobalt Blue only on the curved outer section, then make the colour veer toward violet with a higher proportion of Permanent Rose. Before the inside wash is

fully dry, paint in the central vein with mid-toned Quinacridone Gold, and introduce darker French Ultramarine plus Dioxazine Violet to the outer edge.

3 Lay a wash of pale Cobalt Blue and Cobalt Turquoise plus a touch of pale Permanent Rose on the front-branched style, and repeat for the other two styles, adding mid-toned washes of Cobalt Blue and Permanent Rose on the inside surfaces. When dry, streak on stripes of Quinacridone Gold following the curves.

4 For the three large 'fall' petals, it is best to finish one at a time, beginning with the front one. On dry paper, paint in the yellow area with New Gamboge, fanning the colour out at the edges, and then LIFTING OUT a little colour with a clean damp brush. Before the yellow is dry, paint Cobalt Blue at the base of the petal, working down the petal edge to the yellow. Darken the blue by adding Dioxazine Violet near the petal tip, and add mid-toned Permanent Rose on the

right underside of the petal to suggest reflected light. Before all the washes are quite dry, paint in petal veins with a small brush, using the same mix as before but intensifying the colour at the tip for emphasis. Treat the other two fall petals in the same way, noting that the left-hand petal has a shadow cast by the standard petal. To render this, leave the first colours to dry and lay on top.

5 To finish the flowers, add the dark details in the centre, using Quinacridone Gold, Dioxazine Violet and Permanent Rose. Go back over the flower to put dark accents where required.

6 The leaves are painted from light to dark, starting with mixes of New Gamboge and Sap Green and then adding some leaf veins with a small brush and stronger Sap Green before quite dry. When dry, put in dark accents with Olive Green and Phthalo Green.

special detail variegated wash

▼ Work on dry paper to control the colours while at the same time allowing them to merge where they meet. Using New Gamboge and a fully loaded brush, paint the central shape, starting at the base and working down, fanning the colour outward to the tip. Build up the yellow half way, then dab out a little of the paint along the centre veins with a clean tissue.

▲ Before the yellow has begun to dry, paint pale Permanent Rose and a little Dioxazine Violet at the petal base and into the petal veins at the sides. Then quickly start painting a Cobalt Blue wash from the base to the tip, in between the pinkish veins, and in the middle touching the yellow markings. Add Dioxazine Violet to Cobalt Blue for the lower section, and a hint of Permanent Rose and Dioxazine Violet at the bottom right edge.

▼ When dry, add extra details to the petal veins, using a small brush with dark Dioxazine Violet. Make slightly broken brushstrokes so that the lines don't appear too harsh in contrast to the soft veins achieved earlier.

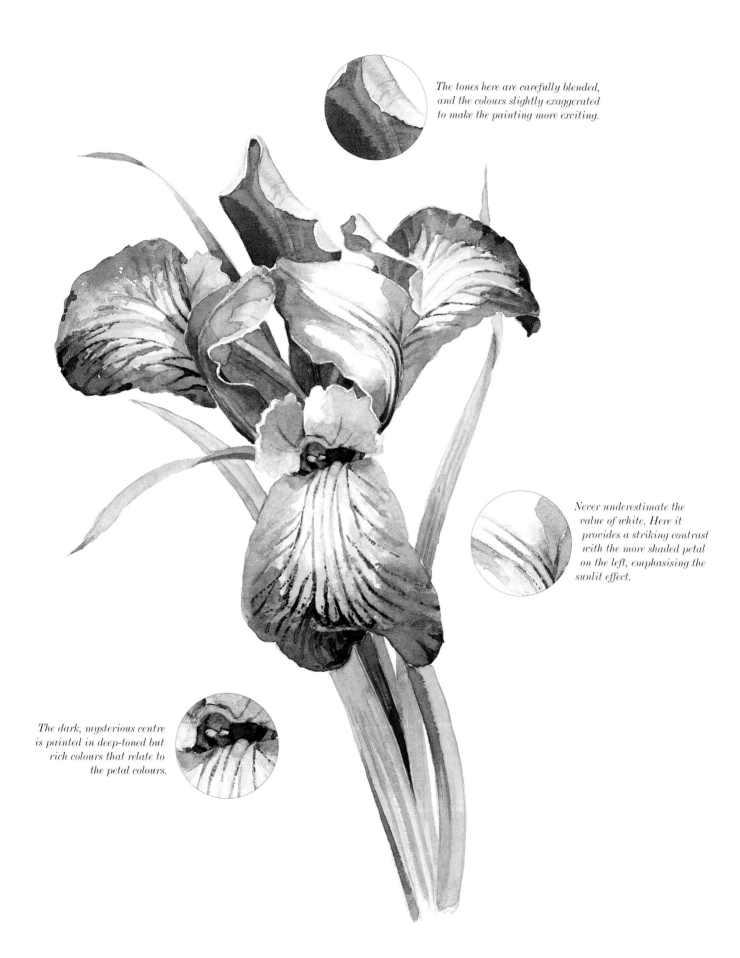

The tones here are carefully blended, and the colours slightly exaggerated to make the painting more exciting.

Never underestimate the value of white. Here it provides a striking contrast with the more shaded petal on the left, emphasising the sunlit effect.

The dark, mysterious centre is painted in deep-toned but rich colours that relate to the petal colours.

Iris douglasiana

Kniphofia Red Hot Poker

The mention of these flowers always seems to provoke strong passions – either of love or of loathing. Some people admire them profoundly, while others consider them vulgar and altogether too vigorous, for they can reach a height of 6 feet (1.8 m). A healthy plant makes massive mounds of bold, strap-shaped, channelled dark green leaves from which rise stout stems. Each of these bears a dense terminal raceme of tubular bright orange-red flowers, which fade to yellow with age. The flower spikes form a simple pointed cylinder, so to express this roundness of form, pay attention to the direction of the light and look for the shade it casts on the overall shape. Notice also how the florets become smaller towards the top of the stem.

sequence start to finish

Transparent Yellow

Phthalo Red

Quinacridone Red

Alizarin Crimson

Dioxazine Violet

Indigo

Cobalt Blue

Sap Green

Quinacridone Gold

1 Make a careful drawing before MASKING off just a few of the stamens protruding from the lower florets. The latter are tipped in yellow, but orange-red towards the base, so use a two-colour stroke for the initial washes (see BRUSHMARKS). Dip the whole of a No. 8 round brush into a pool of Quinacridone Red, then take up some Transparent Yellow with just the tip. Starting at the top of a floret, lay the brush tip onto the paper and pull the colour towards the base, at the same time pressing down with the brush to release the red. Repeat the process on each floret, except the lower ones, which are only yellow. If you need to reveal more of the yellow on any of the florets, blot the tip lightly with a tissue. Leave to dry.

2 To separate the florets, you need to paint the shadows cast as they disappear into the centre of the spike, without losing sight of the overall form. The light is coming from the right, so use Quinacridone Red on the right, changing to Phthalo Red in the middle and Alizarin Crimson towards the left side. Continue to use the No. 8 brush, again leaving the yellow tips showing. Add shading to the yellow lower florets with a mix of Quinacridone Gold and Cobalt Blue.

3 Paint in the stalk with a Sap Green and Transparent Yellow mix, adding a stronger Sap Green and Indigo mix WET-IN-WET on the shadow side. Show how several of the leaves are bent over by painting in darker

shading beneath the curve, using Sap Green and Indigo mixes. Paint the heavy ridges down the leaf centres with a small brush, then use a strong mix of the leaf colours to paint tiny dark accents in the centre of the raceme where the stalk is just visible, taking these right up to the top.

4 Rub off the masking on the lower stamens, then either leave white or tint with Quinacridone Gold and/or a mix of Quinacridone Gold and Dioxazine Violet.

special detail two-color brushstroke

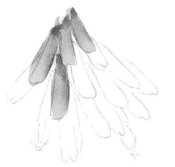

▲ The petals are orange from centre to base, and yellow at the tip. Dip a No. 8 round brush into a mid-toned Quinacridone Red, and, keeping the brush horizontal, dry the tip with tissue before dipping it into Transparent Yellow. Paint with the brush held as near horizontal as possible, placing the point on the petal's tip. Then pull it down to the base, pressing the body of the brush down to release the red.

▲ When painting the whole flower, it is easier to start by painting the lowest petals first and working upward. There will be gaps between the florets, but these will be filled in later with darker colour. Before painting each stroke, dip the tip of the brush into the yellow first.

▲ Start to add depth to the florets from the base, where they attach to the central stem. On the right, where there is most light, shade between the florets with mid-toned Quinacridone Red, changing to Phthalo Red from centre to left. Darken still more with Alizarin Crimson on the left, and add the small shapes of the central stem with dark Sap Green. Where the tips of the top florets are in shadow, paint small shapes with a Cobalt Blue and Quinacridone Gold mix.

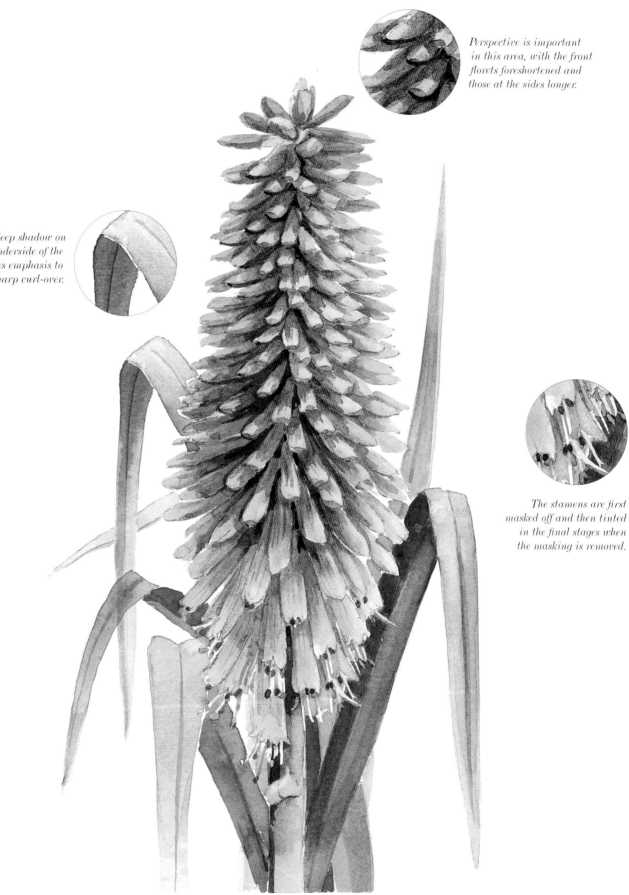

Perspective is important
in this area, with the front
florets foreshortened and
those at the sides longer.

The deep shadow on
the underside of the
leaf gives emphasis to
the sharp curl-over.

The stamens are first
masked off and then tinted
in the final stages when
the masking is removed.

Kniphofia uvaria

Lathyrus Sweet Pea

A Sicilian monk, Friar Cupani, first noted the existence of a cultivated variety of sweet pea in the monastery gardens in 1695. Now, 300 years later, gardeners have a choice of hundreds of cultivars in an enormous range of colours. This two-tone sweet pea is a tendril climber with oval glaucous green leaves and racemes of three or more fragrant flowers, each with one large upright (standard) petal and two wing-like petals with a keel. Careful observation is needed to understand the construction, which is not always clear when the flower is seen head-on.

sequence start to finish

Transparent Yellow

Quinacridone Magenta

Thioindigo Violet

Dioxazine Violet

French Ultramarine

Cobalt Green

Phthalo Green

Sap Green

1 Paint the main lower flower first, using a medium-sized round brush. Lay a wash of mid-toned Quinacridone Magenta on the upright large petal, dropping in a stronger mix of the same colour while still wet. For the two winged petals, use a mix of Quinacridone Magenta and Dioxazine Violet, dropping in French Ultramarine and Dioxazine Violet separately to blend. Paint the lower keel shape with pale Dioxazine Violet. Paint the other flowers in the same way, and for the bud, start with Transparent Yellow at the base before changing to the flower colours.

2 Lay first washes on the front leaves and stalks with mixes of Cobalt Green and Transparent Yellow, adding touches of Quinacridone Magenta at the stalk and leaf joints. Paint those in the background – the stalk with buds and curled leaves – with a pale mix of Cobalt Green, adding a little Dioxazine Violet at the stem and leaf joints.

3 Return to the flowers, starting with the dark purple upright petal. Load the brush with mid-toned, fluid Thioindigo Violet, and lay on the colour, leaving small amounts of the first washes at the base and edges, and blending the dark colour into the lighter one by softening the edges as you work. While still wet, dot in very strong Thioindigo Violet, using the same colour to draw in some petal veins with the brush's tip. Paint the shadows on the lower wing petals with Dioxazine Violet, dropping in French Ultramarine, and darken the tone of the keel with mixtures of the petal colours, washing over with Transparent Yellow when dry. Complete all the flowers and buds in this way.

4 The foreground leaf and stalk now need to be emphasised more to make them come forward. Complete the leaf by painting WET-IN-WET with a stronger Phthalo Green and Sap Green mix, dropping in Cobalt Green and then drawing in a few veins with a rigger brush (see BRUSHMARKS). Before working on the main stem, add a little more detail to the back stalk, bud and leaves using Dioxazine Violet and stronger Cobalt Green to wash in the pale sections, but keeping the value no darker than mid-toned.

5 Build up the tones of the main stem, small flower sepals and bud casing with Sap Green and a little Dioxazine Violet, and when dry, draw in the stem central ridge with Dioxazine Violet and the rigger.

special detail creating colour links

▲ *Lay a wash of Quinacridone Magenta on the petals, and then begin the background stalk in Cobalt Green and the foreground one with a mix of Cobalt Green and Transparent Yellow.*

▼ *Lay very watery Thioindigo Violet at the tops of the petals, softening the colour downward with a damp brush. Add stronger Cobalt Green to the back stalk, then strengthen the main flower stalk with more Cobalt Green and Dioxazine Violet.*

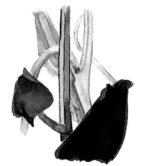

▲ *Add details to the back stalk with fairly pale Dioxazine Violet. Wash Thioindigo Violet on the foreground stalk where it meets the right-hand side petal, and on the adjoining small flower stem. To describe the ridges on the foreground stalk, paint fine lines of Dioxazine Violet with a small brush. The violets provide the link with the colour of the petals.*

This soft effect is achieved by blending the colours WET-IN-WET, carefully judging the wetness of the paper.

This is the area of strongest and most dramatic colour contrast, with the blue-red petal against the green leaf forming the main centre of interest.

Small characteristic details such as this delicate tendril help to build up a realistic impression of a plant.

Lathyrus odoratus

Lilium Stargazer Lily

Lilies are graceful plants with three to five elegant, flamboyant flowers carried on strong stems, and long, lance-shaped leaves scattered broadly. The flower shape resembles a trumpet – an outward-flaring cone that is seen most clearly in the half-opened flowers. Observe how the flower heads and leaves join the stem, and when drawing the flowers make sure that the central petal veins curve into the point where they meet the stem.

sequence start to finish

Transparent Yellow

Cadmium Orange

Quinacridone Red

Alizarin Crimson

Permanent Rose

Cobalt Blue

Phthalo Blue

Phthalo Green

Olive Green

Green Gold

Quinacridone Gold

1 After drawing, mask off (see MASKING) the stamens to paint the flowers freely WET-IN-WET. Treating the flowers at first as if they were pure white, and working on dry paper, flood on pale washes of Cobalt Blue and Cadmium Orange, depending on whether the petals are in light or in shadow. Allow to dry.

2 Now tackle each petal on the main flower individually. Wet the bottom petal with clear water, and when it has dried slightly, paint down the centre with a mix of pale Permanent Rose and Quinacridone Red, letting the colour flow outward and to the tip. Allow to dry slightly before strengthening the petal centre with a stronger mix of the same colours. Allow to dry a little more before

painting in a darker central vein with a stick (see USING A STICK) dipped in Alizarin Crimson. While still damp, dot in some small blobs with Alizarin Crimson, and at the base of the petal add a small amount of pale Quinacridone Gold with a barely damp brush to blend.

3 Work around the flower, treating each petal in a similar way, and then paint the top flower. This catches more light and is further away, so paint it paler and with slightly cooler mixes. Treat the bud and opening flowers with pale mixtures too, with a whisper of colour for the petals.

4 When dry, rub off the masking on the stamens, and paint them in with a mix of Transparent Yellow and Green

Gold. Use the same mix for the markings at the base of the petals, then add the anthers with a Cadmium Orange and Alizarin Crimson mix, and the stigma with Olive Green. Paint small shapes of dark Olive Green in the crevices at the centre of the main flower.

5 Paint the first washes on the leaves with mixes of Phthalo Blue and Phthalo Green, Transparent Yellow and Olive Green. Leave to dry, then build up with similar but stronger mixes. Paint some leaf veins negatively, by painting around them, and others positively, by making darker linear brushmarks. Finally, add darker touches with Olive Green or Olive and Phthalo Green mixes.

special detail creating dot patterns

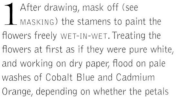

▲ These petals are mainly in shadow, so no white paper needs to be reserved. Lay separate washes of pale Cadmium Orange and pale Cobalt Blue and allow to blend on the paper. Leave to dry.

▼ Rewet the petals with clean water and then drop in a pale wash of Permanent Rose mixed with Quinacridone Red at the petal bases. Let the colour flow down and outward, but not to the very edges. While still damp, touch in a stronger mix of the same colours down the centre veins, using a small brush to tease some of the colour and suggest fine vein lines. Working quickly before the paint dries, add Quinacridone Gold touches at the petal bases to blend.

▲ Before the previous stage has dried completely, carefully paint in the dark central vein with a small brush and strong Alizarin Crimson, then dot in the petal spots with the tip of the brush. They should all soften just slightly. As the surface dries, add just a few darker hard-edged spots with dark crimson.

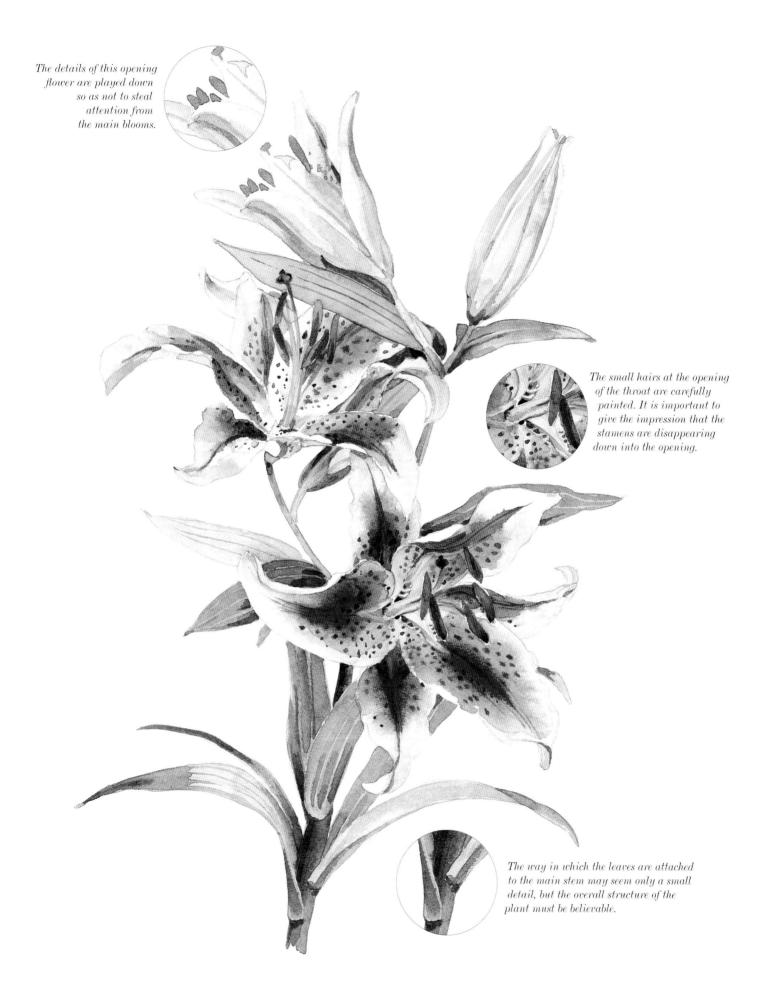

The details of this opening flower are played down so as not to steal attention from the main blooms.

The small hairs at the opening of the throat are carefully painted. It is important to give the impression that the stamens are disappearing down into the opening.

The way in which the leaves are attached to the main stem may seem only a small detail, but the overall structure of the plant must be believable.

Lilium orientalis

Magnolia Magnolia

Throughout the winter, anticipation of the spring blossoms is provided by prominent buds studding a canopy of branches, their cases covered in brown, furry hairs. The buds open first to tight cup shape, and then to an open bowl or half sphere, with white petals flushed the palest of pinks on the inside, and graded with a darker pink towards the base on the petal backs. The prominent central boss of the stamens is an important feature, so look carefully at its construction before beginning to paint or draw.

sequence start to finish

New Gamboge

Permanent Rose

Thioindigo Violet

Dioxazine Violet

Cobalt Blue

Sap Green

Olive Green

Brown Madder

Burnt Umber

Raw Umber

1 Make a light drawing, then mask off (see MASKING) the light tips of stamens in the centre, noting which way they curve or bend around the pistil. The subtle hues of the open flower can be created by the glazing technique (see WET-ON-DRY), blending from one hue to the next. Begin with a wash of pale New Gamboge laid on dry paper; paint with a well-loaded brush, making broad sweeps of colour on vertical petals and at their bases. Soften the edges and allow to dry.

2 Next, flood on pale Permanent Rose, varying the strength to suggest the twists and turns of the petals and the way they catch the light or turn away from it. When dry, wash pale Cobalt Blue over any shadowed areas, including cast shadows. Soften all the edges as you work with a clean damp brush, then leave to dry

before washing a darker Permanent Rose and Thionindigo Violet mix over the petal backs. Grade the colour on the main central petal, making it darker at base. Darken and adjust where needed with the previous colours, always softening edges before the colour has dried.

3 Starting at the base of the spherical bunch of stamens, use Brown Madder to paint between the masked-off tips. Proceed upward towards the tip, and paint this with a Sap Green and Olive Green mix, with a dab of New Gamboge at the very tip. Allow to dry, then rub off the masking and tint the white shapes with New Gamboge, leaving some tips white to catch light. Allow to dry. Finally add dark accents with a mix of Brown Madder and Dioxazine Violet.

4 For the bud petals, lay a wash of Permanent Rose, slightly darker than that for the flower, then drop in darker tones of a Permanent Rose and Thionindigo Violet mix to make shadows. Leave to dry before painting the furry bud case. Lay a first wash of Raw Umber, and immediately tease out the hairs around the edges with a very small brush. While still damp, paint into the first wash with a darker Raw Umber and Burnt Umber mix to create the form. Leave to dry, then add dark crevices in Burnt Umber and Thionindigo Violet.

5 Finally, paint in the branches and leaf buds, using varied mixes from Raw Umber, Cobalt Blue and Burnt Umber for the branches, to Sap Green and Olive Green for the small buds.

special detail mixing colours on the paper surface

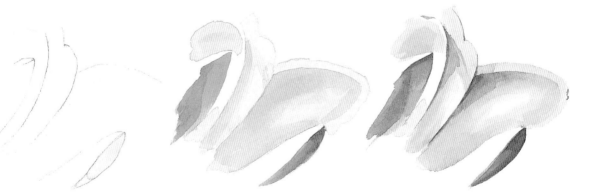

▲ *Working on dry paper, puddle on New Gamboge, making it stronger in some areas, and leaving parts white for strongest light and in places where you will not require yellow as a base colour. The yellow is most important, and since it cannot easily be added as a later wash, it is wise to get the depth of colour correct before moving on to the next stage. Allow to dry.*

▲ *The next colour is Permanent Rose, which will result in an orange hue where laid over the yellow, and a purer pink where there is no yellow underlayer. Lay the wash as before, again puddling on the colour and varying the strength, taking care not to disturb the yellow. The tone is darkest where the outside of the petals show. Allow to dry.*

▲ *The next layer is Cobalt Blue, which cools down the pink-yellow shades where required and describes the shadows and cast shadows. On each layer, soften edges when needed, and finish by adding touches of stronger accents, using mixes of the same three colours.*

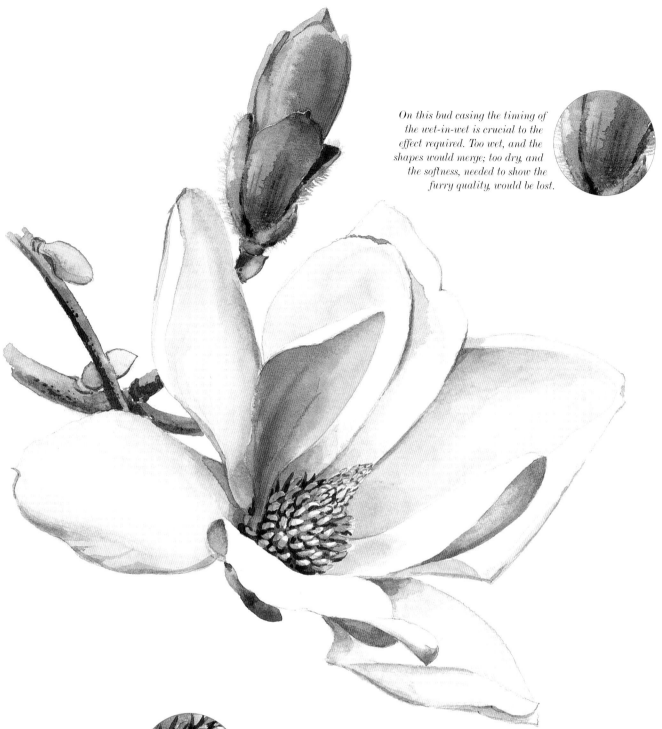

On this bud casing the timing of
the wet-in-wet is crucial to the
effect required. Too wet, and the
shapes would merge; too dry, and
the softness, needed to show the
furry quality, would be lost.

The individual stamens
were initially masked off,
but then carefully tinted to
describe the spherical shape
of the whole boss.

These subtle shades
are created by
glazing one colour
over another.

Magnolia x soulangiana

Meconopsis Himalayan Blue Poppy

This is one of the most breathtaking of early flowers, with its stunning, intense, lapis-blue blooms. As the name implies, it was discovered in the Himalayas – in the 1880s – and is now much sought after and widely admired. The cup-shaped flowers, each with four petals and a cluster of gold stamens, are carried on slender stalks above clumps of narrow tapered leaves. Like all poppies, the petals have a tissue-paper quality, which it is important to describe. The leaves are mid-green and oblong at the base. Notice too how the direction of the petal veining reinforces the tonal changes on the petals to describe the curving shapes.

sequence start to finish

Transparent Yellow

Permanent Rose

French Ultramarine

Cobalt Blue

Phthalo Blue

Cerulean Blue

Sap Green

Olive Green

1 Mask off (see MASKING) the stigmas and stamens and a few hairs on the stalks and buds, then paint the right-hand flower first, one petal at a time. With a No. 10 round brush and mid-toned Cerulean Blue, lay the first wash, lifting off some of the colour on the upward-facing surface while wet, and then dropping in pale Permanent Rose to blend, especially near the flower centre. Again while still wet, use a sharpened twig (see USING A STICK) to etch in petal veins following the curvature of the petal.

2 Finish the petals of the first flower, then complete the other main flowers in the same way as before, strengthening the curled-back edges of the petals that turn away from the light with Cobalt Blue and French Ultramarine. Paint the half-open flower on the left with the same colours, but add Permanent Rose at the top, and use the stick dipped into this same colour to paint in some wavy veins.

3 Paint the styles with a medium-sized round brush and a Cobalt Blue and Transparent Yellow mix, darkening at the top and base of the styles by dropping in Olive Green. Use the same mix for the two buds, this time dropping in Transparent Yellow and/or Cerulean Blue, and then flicking out a few small hairs at the edges with a rigger brush (see BRUSHMARKS).

4 If the flowers are a little too pale, glaze light veils of mid-toned Phthalo Blue over them when fully dry (see WET-ON-DRY) with the No. 10 brush. This is an especially transparent pigment, so allowing the colours beneath to shine through. Use the same colour to strengthen the light-facing flower at the back, and deepen the blue tones on the opening bud with Cerulean Blue and a little Permanent Rose.

5 Add dark accents to the flower stalks and leaves with a Phthalo Blue and Olive Green mix, adding Sap Green in places to create variety. Allow to dry, then rub off the masking, and tint the stamens with a Transparent Yellow and Permanent Rose mix. Use Transparent Yellow to tone down the white spots of the hairs on the stalks and buds.

special detail drawing with a stick

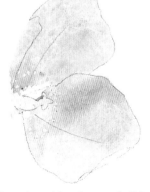

▼ *With the paint still wet, draw in some fine petal veins with the twig, pressing it down but taking care not to tear the paper surface. You will see the wet paint flooding into the impressed lines.*

▲ *Drawing with a sharpened stick makes impressed lines into which the damp paint flows, creating a more subtle effect than painting dark lines. Mask off the stigma and stamens, then lay a wet wash of mid-tone Cerulean Blue over both petals, dropping in watery Permanent Rose.*

▲ *When dry, glaze over the petals with pale Phthalo Blue washes. Paint the curled edges and the shadows with French Ultramarine and Cobalt Blue mixes. When dry, rub off the masking and tint the stigma's tip with Transparent Yellow, and its stalk with a Sap Green and Olive Green mix. Tint the stamens with a Permanent Rose and Transparent Yellow mix.*

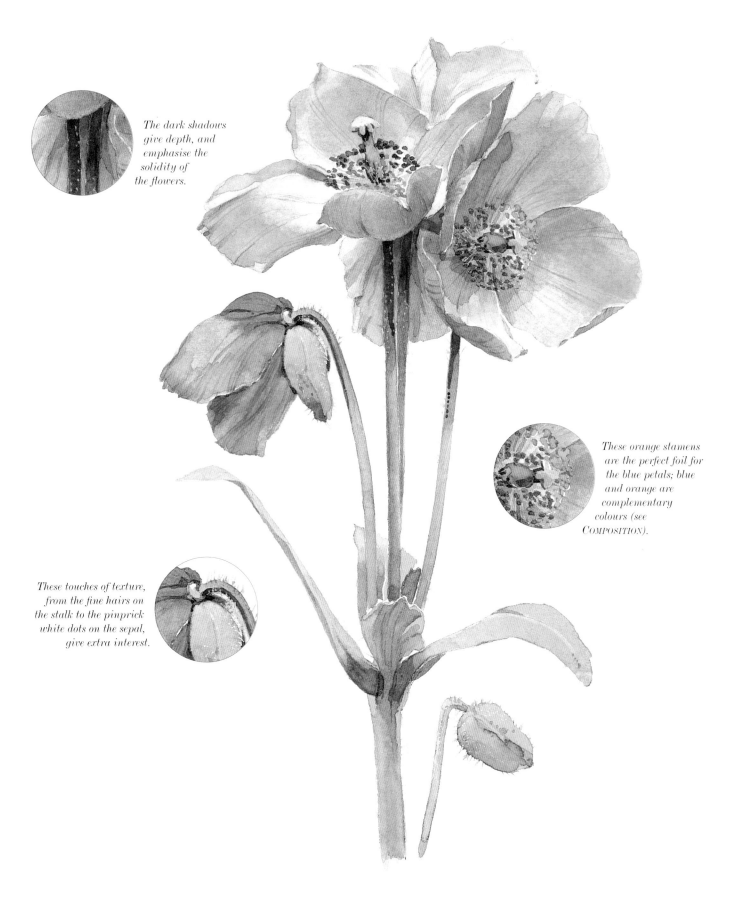

The dark shadows give depth, and emphasise the solidity of the flowers.

These orange stamens are the perfect foil for the blue petals; blue and orange are complementary colours (see COMPOSITION).

These touches of texture, from the fine hairs on the stalk to the pinprick white dots on the sepal, give extra interest.

Meconopsis grandis

Narcissus Daffodil

The native British wild daffodil, immortalised by the English poet William Wordsworth, has become something of a rarity in comparison to the modern hybridised forms originating from southern Europe. The leaves are numerous and strap-shaped, and the flower consists of a trumpet or cup (the corona) in the centre, surrounded by six outer radiating petals (the perianth), which together form a disc shape. When drawing, think of the basic shape as a flared cylinder set in the middle of a larger circle, which will form an ellipse as the flower turns away. When painting, look for slight differences in colour if the trumpet and petals are similar shades of yellow, and be prepared to exaggerate a little.

sequence start to finish

Transparent Yellow

New Gamboge

Cadmium Orange

Quinacridone Magenta

Cobalt Blue

Cobalt Green

Sap Green

Quinacridone Gold

Raw Umber

1 Paint the outer petals with Transparent Yellow, and the trumpets with New Gamboge, then leave to dry. To add some shading to the trumpets, paint in shapes with pale Cadmium Orange, reserving areas of the first wash where the petals catch the light. Paint first washes on the leaves with mixes of Cobalt Green, Sap Green and Transparent Yellow, and paint the buds with Transparent Yellow, shading with Raw Umber where the petals go into the sheaths.

2 Paint shadows on the outer petals with slightly stronger New Gamboge with a tiny touch of Cobalt Blue added. On the back flower, use Quinacridone Gold, also with a touch of Cobalt Blue. Yellow is one of the more difficult colours to shade, as it can easily become muddy. For the cast shadows on the outer petals, use a watery mix of Quinacridone Magenta, laying it on quickly without fiddling to avoid lifting the colours beneath. Paint in the darks inside the trumpets with a mix of Quinacridone Gold and Quinacridone Magenta, going around the stamens and stigmas.

3 Strengthen the greens of the leaves with mixes of Cobalt Green, Cobalt Blue and Sap Green, and then add the darkest small accents behind and beneath the flowers and paint in a few curved cast shadows on some of the lower leaves. To describe the delicate bud sheaths, use a rigger brush (see BRUSHMARKS) to paint in a few lines with fairly strong Raw Umber, adding a touch of Sap Green on the top bud at the base of the petals.

special detail darkening yellows

▼ *Yellows can easily become muddy unless care is taken with mixing the colours for the shadows. Lay a wash over all of the outer petals with Transparent Yellow, and a wash of New Gamboge on the trumpet, leaving the stigma and stamens white.*

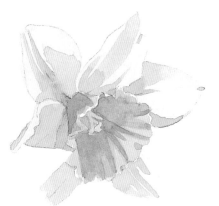

▲ *The light is coming from the right. On the outer petals, paint in the second tone with New Gamboge and a very small amount of Cobalt Blue, concentrating most of the colour in the shadow areas, mostly on the left. Paint the second tone on the trumpet with fairly pale Cadmium Orange.*

▼ *Use a pale Quinacridone Magenta to paint the cast shadows on the outer petals, which are mainly on the left, and at the base of the top petals. This magenta is relatively transparent, and will darken the yellow without muddying it. Strengthen the shade for the darkest accents in the crevices, and using the same colour add more shading inside the trumpet and on the outside, at the base. Paint over the tiny stigma and stamens with Transparent Yellow, using strong Quinacridone Magenta for the darkest accents on either side of the stamens.*

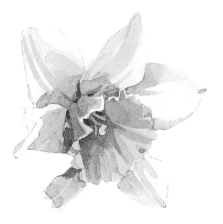

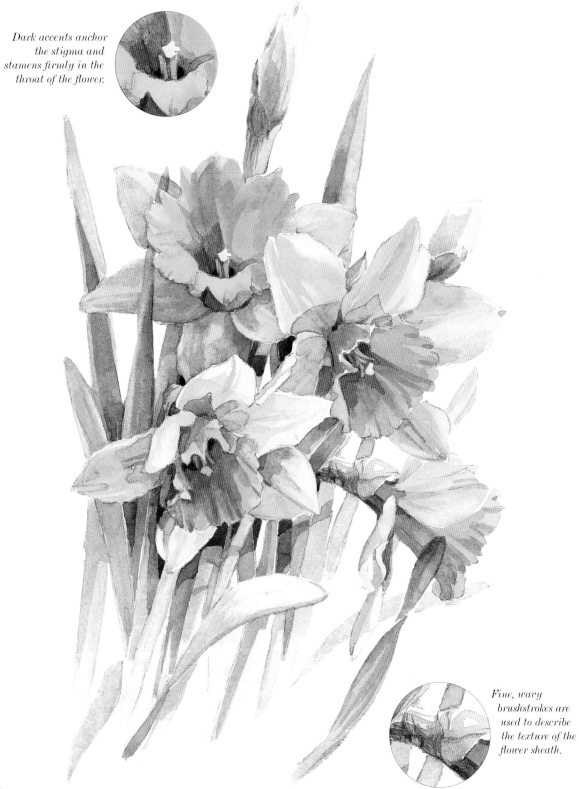

Dark accents anchor the stigma and stamens firmly in the throat of the flower.

Fine, wavy brushstrokes are used to describe the texture of the flower sheath.

Strategically placed darks give a realistically three-dimensional impression.

Narcissus sp.

Nymphaea Waterlily

Many of us associate waterlilies instinctively with Claude Monet's wonderful paintings of his lily pond at Giverny. Although his concerns were as much with the water surface as with the flowers, it is not surprising that he loved them: the waterlily has a serene and classical beauty. Standing just above the water, it has cup-shaped, semi-double petals and large, plate-like floating leaves on flexible stalks, deep green with red or purplish green undersides – these provide a perfect haven for fish. The whole plant is a series of overlapping circles and ellipses, and the perspective of these must be closely observed and consistent, especially as the leaves recede.

sequence start to finish

Transparent Yellow

New Gamboge

Alizarin Crimson

Dioxazine Violet

French Ultramarine

Cerulean Blue

Sap Green

Green Gold

Quinacridone Gold

Brown Madder

1 Notice that surfaces of the flat petals are cooler in colour, that is, bluer than the vertical light-facing ones, which have a yellow tinge. Painting one shape at a time, begin with washes of either Cerulean Blue or Quinacridone Gold, leaving the most light-struck areas as white paper. Then flood pale Quinacridone Gold into the centre of the flower. Allow to dry.

2 Paint the shadows and cast shadows with a stronger but still quite delicate mix of Dioxazine Violet and Cerulean Blue, and while still wet drop in Quinacridone Gold for reflected light. Again work on each shape separately, and soften edges where needed. Paint the shading on the bud with the same colours.

3 Work WET-IN-WET for the initial stages of the large leaves to create soft blends. Use puddles of pale Cerulean Blue and Sap Green, let them blend on the paper, and then drop in more Cerulean Blue on the top leaves and Green Gold on the nearest, warmer-coloured leaves. While wet, touch in Alizarin Crimson at the edges to blend. Leave to dry.

4 Return to the main flower, and darken the cast shadows where needed with Dioxazine Violet, concentrating most colour on the lower central petals. Paint the cast shadow on the leaves beneath the flower with a French Ultramarine and Sap Green mix, dropping in pure French Ultramarine and Green Gold to create variety. Leave to dry again.

5 To indicate the drops of water on the leaves, flood on a Cerulean Blue and Sap Green mix and allow the blobs of colour to dry so that they form crisp edges. Lightly indicate a few leaf veins, and when dry, paint in the lines of cast shadow below the leaf edges with a Sap Green and French Ultramarine mix.

6 Paint the flower centre from the top of the stamens with a mid-toned Quinacridone Gold and Brown Madder wash, softening the colour into the first wash at the lower edge. Allow to dry before painting the stamens with white gouache tinted with New Gamboge and Brown Madder (see BODY COLOUR). Then add white to Transparent Yellow for the highlighted tips.

7 Use the white gouache to touch in the water droplets on the leaves, and also to add sparkle. Paint in the water ripple at the top with pale Cerulean Blue.

special detail painting reflected light

▲ *This flower is in bright sunlight so the tonal contrasts are quite strong. Paint first washes on the petals with pale Cerulean Blue, dropping in watery Quinacridone Gold, and leaving white paper for the sunlit areas. Paint a wash of Cerulean Blue and Sap Green on the leaf, dropping in Quinacridone Gold.*

▲ *Yellow reflected light can be seen in the flower's cast shadows. Start with the purple shadow shape, loading the brush with mid-tone Dioxazine Violet. Drop in strong Quinacridone Gold at the petal's base to blend. Paint a loose second wash on the leaf with Cerulean Blue, Sap Green and Quinacridone Gold.*

▲ *The cast shadows on the leaf are the same colour as the leaf itself, but considerably darker. Paint these shapes with a French Ultramarine and Sap Green mix, dropping in Green Gold.*

The rippled water is suggested by just a few circular brushstrokes.

Tinted white gouache, sometimes known as body colour, is used here to paint the stamens over a fairly dark watercolour base.

The slight undulation of the leaf is shown by varying the width of the dark shadow beneath the edge.

Nymphaea x marliacea

Paeonia Peony

Painters and gardeners alike love these flowers, with their bold foliage and heavy, solid blooms, most often in various pinks and reds. This variety is an anemone peony, and is characterised by its broad incurving outer petals and a centre filled entirely with numerous, densely arranged, deeply cut narrow petaloids, derived from stamens. These collect to form a compact shape, ivory-yellow in colour. Taken as a whole, the flower is bowl-shaped, with the outer petals spiralling out from the centre with gentle, rounded curves.

sequence start to finish

Transparent Yellow

Alizarin Crimson

Permanent Rose

Thioindigo Violet

Dioxazine Violet

Cobalt Blue

Phthalo Blue

Olive Green

Green Gold

1 After drawing, mask off (see MASKING) the outer shapes of the central petaloids. Starting at the top of the flower, and working on dry paper, paint in the top petals with pale Permanent Rose. Carry on around the flower, adding Cobalt Blue to the Permanent Rose on the lower petals. Before dry, use a stick (see USING A STICK) to draw in fine lines following the direction of the petal curve. The paint runs into the slightly etched line to darken it, but this only works when the paint is still wet. Allow to dry.

2 Paint the leaves with watery mixes of Green Gold, Phthalo Blue, Cobalt Blue and Olive Green. In general, upward-facing or horizontal leaves need a cool, bluish shade, while the more vertical ones require a warmer, yellowish mix. Thus one leaf could have half cool greens and the other half warm.

3 The flower petals are painted mainly in three tones, so now apply the second tone. Deepen the shadows with mixes of Thionindigo Violet, Permanent Rose and Dioxazine Violet, looking carefully for changes in the colour temperature of the shadow, and adjusting the mixes to make them warmer or cooler. Apply the very dark crevices with an Alizarin Crimson and Dioxazine Violet mix. Soften edges with a clean damp brush as you work, before the paint is dry.

4 Now return to the leaves, and using a NEGATIVE PAINTING technique and a darker, stronger mix than before, of Phthalo Blue and Green Gold, paint around the veins on some of the leaves (see WET-ON-DRY). To tint the leaf ends, just tip them with a tiny amount of pale Permanent Rose. Add the last tone by adding Olive Green to the previous mix, and darken any areas that need it, for example cast shadows from other leaves

or the flower itself. Paint the outer casing of the small bud in Green Gold, with touches of Permanent Rose and Cobalt Blue added while still wet to blend, and the petals in Permanent Rose.

5 Remove the masking on the centre stamens, tint the white shapes with pale Transparent Yellow, and let dry. This intricate structure requires careful negative painting, so use a darker mid-toned wash of Permanent Rose and Transparent Yellow to paint around those most in light at the top. Work towards the foreground stamens, which are mainly in the second tone. When dry, add the darkest crevices, mainly in the foreground, with Dioxazine Violet. To suggest glimpses of seed in the centre, paint in Transparent Yellow and Permanent Rose, with Alizarin Crimson accents.

special detail masking off

▼ *Paint masking fluid on the petaloids, and leave to dry. Lay a wash of palish Permanent Rose, adding Cobalt Blue for the lower petals. Brush the colour well over the masking so that it gets into the crevices between the masking. Leave to dry again.*

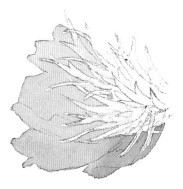

▲ *Strengthen the tones on the petals by painting with Permanent Rose, Thionindigo and Dioxazine Violets, using the darkest colours on the lower petals. Allow to dry, then rub off the masking with a soft putty eraser. Draw into the white shapes in places with a 2B pencil to show the way some of the petaloids overlap others.*

▲ *Tint all the petaloids with very pale Transparent Yellow, leaving the tips of some white. When dry, use a slightly darker mix of Permanent Rose and Transparent Yellow to paint some of the shapes, mainly those in the background, leaving the lighter top ones the original yellow. Tint some backlit petaloids with pale Dioxazine Violet. Allow to dry again, then add the darkest small negative shapes between the petaloids with strong mixes of the petal colours.*

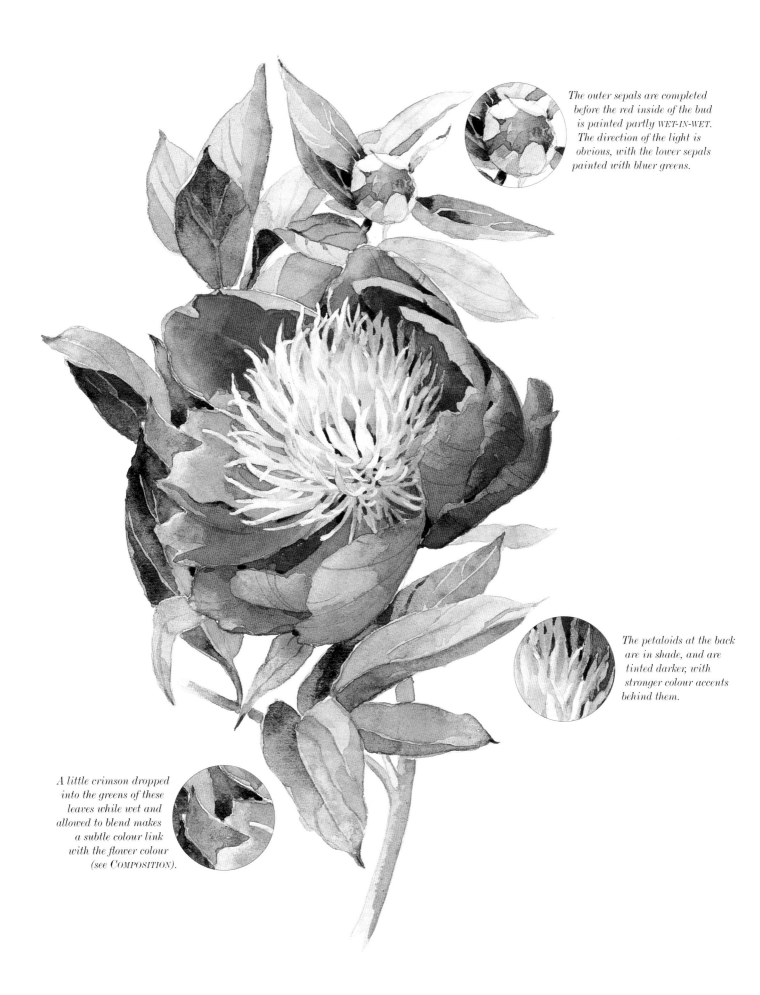

The outer sepals are completed before the red inside of the bud is painted partly WET-IN-WET. The direction of the light is obvious, with the lower sepals painted with bluer greens.

The petaloids at the back are in shade, and are tinted darker, with stronger colour accents behind them.

A little crimson dropped into the greens of these leaves while wet and allowed to blend makes a subtle colour link with the flower colour (see COMPOSITION).

Paeonia lactiflora

Papaver Poppy

These dramatic plants bear single, sturdy, brilliant vermilion, bowl-shaped flowers with dark centres. The petals have a papery quality, which it is important to capture, and another characteristic is the strength of shadow caused by the petals overlapping within the basic bowl shape. The bluish-green leaves have a rough, fuzzy texture and are broadly lance-shaped and toothed, and the buds are hairy with crinkly petals when about to unfold.

sequence start to finish

Transparent Yellow

Cadmium Orange

Phthalo Red

Quinacridone Red

Alizarin Crimson

Dioxazine Violet

Indigo

Cobalt Blue

Phthalo Blue

Sap Green

Green Gold

1 After drawing, mask out (see MASKING) the lightest parts of the centre seed head and some light-catching stamens. Also make tiny lines and dots of masking to suggest light hairs on the opening bud and stems. Paint the first wash on the flower and bud, using a loaded round brush to flood in a mix of Transparent Yellow and Quinacridone Red with touches of Cadmium Orange. This colour represents the palest areas, where the petals catch the light. Allow to dry.

2 Begin to build up the depth of colour in the shadows, this time with a slightly darker mix of Quinacridone Red and Transparent Yellow, painting around sections of the petals in light. Vary the mix going around the flower head, and soften some edges. While still wet, add fine petal veins by teasing out the colour to the petal tips. Deepen the colour with Phthalo Red towards the centre of the flower working WET-IN-WET. When almost dry, intensify the colour around the seed head with a strong mix of Alizarin Crimson and Phthalo Red, and allow to blend. Again, leave until almost dry before adding dark Dioxazine Violet in small shapes to make the characteristic markings at the base of the petals, letting them soften into the previous wash.

3 When fully dry, rub off the masking around the flower seed head. With a small brush and a mix of Cobalt Blue and Transparent Yellow, paint the base of the seed pod, then paint the top spindly shapes with mid-toned Dioxazine Violet. Use a mix of Indigo and Dioxazine Violet to paint the area around the pod, including some stamens. Tint the remaining masked-off stamens with pale Indigo, and finally, if you need to add a few more mid-toned stamens, use white gouache tinted with the appropriate watercolour (see BODY COLOUR).

4 Paint a first wash on the leaves using a pale, watery mix of Sap Green and Phthalo Blue, dropping in pale Green Gold to blend in places. As the leaves recede, becoming cooler in colour, add touches of Cobalt Blue to the wet wash. Don't try to control these washes too much; just see what happens as the paint begins to dry. When fully dry, work on the main leaf attached to the flower stem, strengthening the tone with a mix of Indigo and Green Gold, painting on either side of the central vein.

5 Now paint the bud, creating the roundness of the outer sepals with the same leaf mixes as before and adding tiny hairs on the outside edges with a very small brush. Use Phthalo Red for the crinkly petals, blotting into the wet paint with tissue at the top to suggest light, and then painting in darker crisp lines with Alizarin Crimson before fully dry. Rub off the masking on the bud and flower stem to reveal thin, light hairs.

special detail wet-in-wet – judging strength of colors

▲ *Paint all over the shape with pale Transparent Yellow and Quinacridone Red. Allow to dry, then add some shading with two tones of the same mix, worked in separate stages, and let dry again.*

▲ *Puddle Phthalo Red into the bowl-shaped centre of the flower, and while wet, drop in a darker tone of Alizarin Crimson. Move quickly on to the next stage.*

▲ *The dark blotches around the seed head must be painted before the deep red has dried, but not while it is too wet. Wait until the paint has almost lost its glistening quality, load a brush with a dark mix of Dioxazine Violet (darker than the previous red), paint in the blotch shapes, and watch them soften a little into the red. When almost dry, add accents of very dark Dioxazine Violet, lightly tipping in the colour with the point of the brush held vertically. Do not attempt to make corrections; leave the paint and see how it dries.*

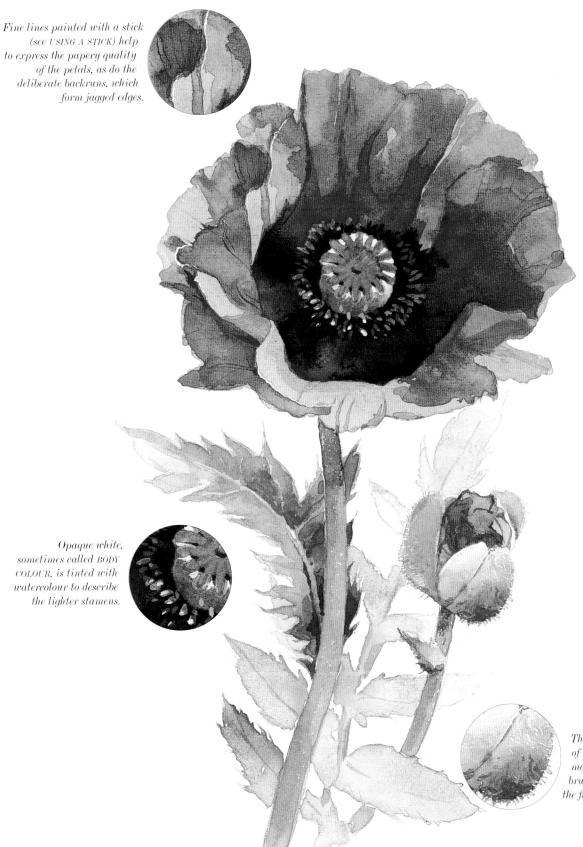

Fine lines painted with a stick
(see USING A STICK) help
to express the papery quality
of the petals, as do the
deliberate backruns, which
form jagged edges.

Opaque white,
sometimes called BODY
COLOUR, is tinted with
watercolour to describe
the lighter stamens.

The fine short hairs
of this sepal are
masked off with a small
brush before applying
the first washes.

Papaver orientale

Passiflora Passion Flower

This is a rampant climbing plant forming a tangled mass of long stems adorned with palm-shaped, lobed leaves. The spectacular flowers are unique. Each has ten outer petals that may overlap or spread flat to form a disc or circular shape. Five large stamens and three knobbed styles are borne together on a central stalk, which is surrounded at the base by one or two rows of filaments, tinted blue at the tips and purple at the centre. These radiate outwards like spokes on a wheel. All these circular shapes are seen as ellipses when viewed at an angle, as in this example, so care must be taken with the preliminary drawing. Notice that the basic shape of the bud is a cone.

sequence start to finish

Transparent Yellow

Thioindigo Violet

Dioxazine Violet

Cobalt Blue

Phthalo Blue

Sap Green

Olive Green

Green Gold

Quinacridone Gold

1 After making a careful drawing, mask off (see MASKING) the white sections of the long filaments. Start by painting the outer petals (tepals) with a loaded brush and watery pale Green Gold, leaving some white paper on light-struck areas. While still damp, drop in pale Cobalt Blue, especially on the lower tepals and those on the shadowed left side. Again work into damp paint, this time with a darker mix of Cobalt Blue and Green Gold, to make darker shadows under the filaments on the left side and below. When dry, use a small brush to apply the first washes to the stamens with pale Sap Green, outlining the edges with Transparent Yellow. At the same time, paint the three styles with pale Thionindigo Violet.

2 Now work on the leaves and bud. Paint the leaves with a well-loaded brush and various pale mixes of Sap Green, Cobalt Blue, Transparent Yellow and Olive Green. Paint over the bud with a pale Green Gold wash. Leave to dry. To depict the shine on the leaves, lay on second washes with darker mixes of the previous colours plus Phthalo Blue, then dab small sections with a tissue to lift off some colour. Don't overdo this, or the leaves will look patchy. Finally, strengthen the shadows, especially behind the flower, by painting in smaller shapes of rich dark greens made from Olive Green, Sap Green and Pthalo Blue. Keep the leaves simple as a foil for the intricate flower.

3 Build up the form of the bud by adding details directly with tones of Sap Green. Paint the tendrils, the small

pointed new leaves, and the main flower branch with tones of Sap Green.

4 Rub off the masking on the flower filaments, and paint the outer circle with a small brush and mixes of Dioxazine Violet, Cobalt Blue and Thionindigo Violet, varying the colours and tones. Give finishing touches to the five stamens with Olive Green, and to the styles with Dioxazine Violet, then paint the stalk with a mix of Green Gold and Dioxazine Violet.

special detail single-stroke linear brushmarks – varying the pressure

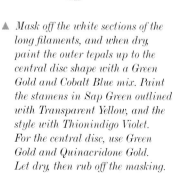

▲ *Mask off the white sections of the long filaments, and when dry, paint the outer tepals up to the central disc shape with a Green Gold and Cobalt Blue mix. Paint the stamens in Sap Green outlined with Transparent Yellow, and the style with Thionindigo Violet. For the central disc, use Green Gold and Quinacridone Gold. Let dry, then rub off the masking.*

▲ *Paint the filaments, using a No. 4 round brush and mid-toned mixes of Cobalt Blue and Thionindigo Violet. Press the brush down a little to judge the width of the long purple filaments, and paint each one with a single stroke, letting some cross over others.*

▲ *Using the same brush, darken some of the filaments with the addition of Dioxazine Violet to the previous mixes, then give extra emphasis to the stamens and style by painting the fine outlines with just the very tip of the No. 4 brush.*

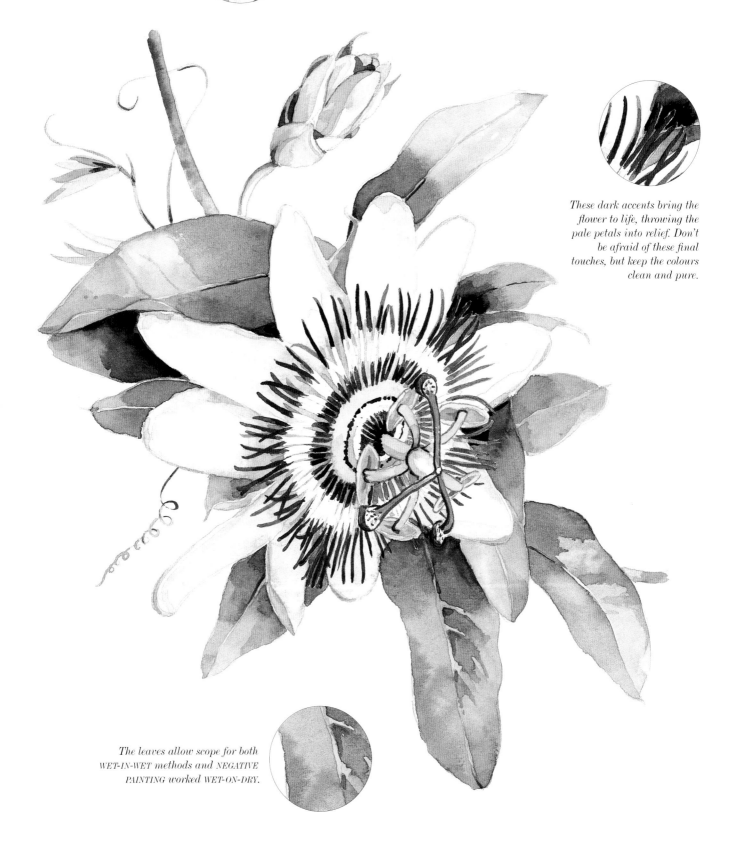

In keeping with the rest
of the plant, the bud is
crisply modelled in
several tones.

These dark accents bring the
flower to life, throwing the
pale petals into relief. Don't
be afraid of these final
touches, but keep the colours
clean and pure.

The leaves allow scope for both
WET-IN-WET methods and NEGATIVE
PAINTING worked WET-ON-DRY.

Passiflora caerulea

Pelargonium Geranium

Coming from hot, sunny climates, geraniums are the nearest those of us from cooler climes can get to evoking the feel of the Mediterranean. They are also attractive painting subjects, as both leaves and flowers are full of variety. The flowers are usually carried in quite densely packed mop-head clusters, and the florets have five petals forming simple star shapes. Colours range from hot reds or oranges to deep burgundies, pale pinks, and even whites. The soft, rounded or kidney-shaped leaves are sometimes attractively marked or coloured, as in this very old variety, where the foliage is the main focus. The passages of red among the varied greens help to create a link between foliage and flowers. Look carefully at the leaves, as no two are identical in shape, size or colour.

sequence start to finish

Transparent Yellow

Phthalo Red

Quinacridone Red

Alizarin Crimson

French Ultramarine

Sap Green

1 Begin with the flowers, painting the petal shapes with a well-loaded brush of wet Quinacridone Red and a mix of Quinacridone Red and Transparent Yellow, leaving small white eyes where the floret centre can be seen. On the more shadowed petals, below and towards the left, use wet Phthalo Red. To avoid waiting for each petal to dry before painting the next, leave a thin white line to prevent the colours fusing. On each petal, etch in a few veins with a sharpened twig (see USING A STICK) before the paint has dried.

2 The edges of the leaf patterns should be varied – some soft and others hard – so you will need to judge the wetness of the paper very carefully. First paint a wash of Transparent Yellow over each leaf,

leaving a small white space where any leaf edge curls up. Allow to dry a little, then use a Sap Green and French Ultramarine mix to paint the green shape, working from the center outward, but not taking the colour right to the edge. Before dry, etch in leaf veins with the twig, then allow to dry a little more, and paint the dark zonal pattern over the green with a Phthalo Red and Sap Green mix, letting the colours blend just a little.

3 Paint the small buds and stalks with mixes of Transparent Yellow, Sap Green and French Ultramarine, and before dry, add touches of pale Alizarin Crimson to blend. Reinforce the shadows on the leaves, notably those at bottom and top right, with a diluted French Ultramarine wash, and strengthen parts of the zonal

markings with stronger accents of the previous colours. When dry, lift out a few leaf veins on the nearest leaves with a damp brush (see LIFTING OUT).

4 Strengthen the colours of the flowers with darker accents of Phthalo Red and Alizarin Crimson, then use Sap Green and Phthalo Red mixes to hint at some visible, background stalks and sepals. Finish by painting darker accents on the stalks with a stronger red-green mix; these accents on the flowers and stalks are important, as they provide a balance to the strong tones and colours of the leaves.

special detail separating areas of colour

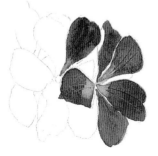

▲ *Leaving a thin white line between each petal allows you to paint without having to wait for each one to dry. Using a Quinacridone Red and Transparent Yellow mix, paint the nearest petals first, then paint in some of the top petals on the right of the shape, changing to just Quinacridone Red as you proceed to the left side. Before the paint has dried, lift out a little of the colour at the floret's throat.*

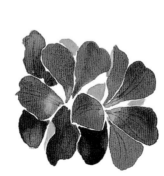

▲ *Use Phthalo Red alone for the underneath petals, continuing to leave a very thin white line between each one. While still damp, etch in some petal veins with a pointed twig.*

▼ *When dry, paint shadows with a darker mix of Phthalo Red and Alizarin Crimson. Paint in the background sepals with Sap Green, and add a final dark accent to the centre of the small floret with a mix of Sap Green and Phthalo Red. Strengthen the red petal veins at the throats with a small amount of Phthalo Red.*

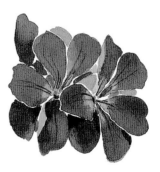

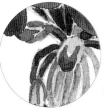

Shading from middle to dark tones pushes some of the buds forward in space, while others recede into the flower head.

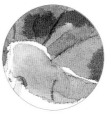

The white edge of the upward-curling part of the leaf separates the two planes.

The main leaf, with its strong red-on-green markings, makes a colour link with the flower head, which is emphasised by its central placing.

Pelargonium x hortorum

Petunia Petunia

Petunias, with their showy, trumpet-shaped, vividly coloured flowers and oval, deep green leaves, are popular all over the world. They belong to the potato family, and the garden cultivars come from a wild species of tropical South America. Notice how the petal veining on this cultivar is echoed by that of the leaves to make attractive patterns. These could form a major element in a painting, but you will need to decide how much of the veining to indicate, or you might sacrifice the fragility of the petals or overwork the leaves.

sequence start to finish

Transparent Yellow

Thioindigo Violet

Dioxazine Violet

Indigo

French Ultramarine

Sap Green

Olive Green

1 Paint the open flower first, starting by flooding in pale Dioxazine Violet and leaving it to dry until the wash has lost its shine (see WET-IN-WET). The colour for the veining needs to be applied before the wash has dried, so that it blends slightly into the pale colour. With a well-loaded brush and a dark mix of Dioxazine Violet and Thioindigo Violet, paint the shape down the five central petal veins, so that it spreads outward into the body of each petal. Allow to dry a little more, then use a rigger brush (see BRUSHMARKS) and a dark mix of Dioxazine Violet and Indigo to emphasise the main veins, teasing out a few of the smaller ones into the body of the flower. Paint a few shadows on the frilled petal edges with a pale French Ultramarine and Dioxazine Violet mix, letting the colours blend a little into the damp first wash. Allow to dry fully, then paint the shape of the dark throat with strong Indigo.

2 Now work on the trumpet-shaped flower. As it emerges from the base, the colour is a dull violet, so paint this nearest section with a fairly pale mix of Dioxazine Violet and Indigo, dropping in Sap Green at the base to blend. Allow to dry a little, then paint the three most prominent veins with a mix of Thioindigo Violet and Dioxazine Violet, taking some of this colour up to the frilly top edge. Lay a wash of pale Dioxazine Violet on the upward-facing flared part of the flower, and while damp, drop in shadows on the edges with a French Ultramarine and Dioxazine Violet mix. Paint the bud with the same colours, but leave it understated.

3 Paint the leaves in a similar way to the flowers. Using a No. 12 round brush, cover the main leaf on the left with a Sap Green, Transparent Yellow and Olive Green mix, then drop in watery French Ultramarine where the leaf turns upward. While

still damp, use the same brush to paint negatively around the leaf veins (see NEGATIVE PAINTING) with a darker mix of Sap Green and Olive Green with French Ultramarine added. Repeat the process on the other leaves and the calyx of the small bud. Leave to dry.

4 Continue to define the leaves, but don't overdo it – you want to give just an idea of their structure. Emphasise some of the veins by painting negatively around them with mixes of Sap Green, Transparent Yellow and French Ultramarine.

5 Using a small, clean, damp brush, lift out colour (see LIFTING OUT) for the central stamens in the throat of the open flower, and blot with a tissue.

special detail exploiting shape and pattern

In some plants, the flower shapes contrast with those of the leaves, but here the petals and leaves are not dissimilar in shape, and both have strong veining. Repeated shapes and built-in pattern elements can be played up for exciting effect.

▲ *Paint a wash on the leaf with a Sap Green and Transparent Yellow mix, then drop in French Ultramarine on the right edge to blend. When the surface has dried slightly suggest the leaf veining with a stronger Sap Green and Olive Green mix.*

▲ *Paint the petal section with pale Dioxazine Violet, and while damp, touch in the stronger colour with a darker Dioxazine Violet and Thioindigo Violet mix, indicating a few veins with a rigger brush (see BRUSHMARKS).*

▲ *Add dark accents to the leaf with a Sap Green and Olive Green mix, painting around the veins to reinforce them, and keeping the colour paler on the right side. Return to the petal, and paint in the thin, wispy veins with the rigger brush and a Dioxazine Violet and Indigo mix. Although the veining on the leaf is achieved by NEGATIVE PAINTING, and that on the petal by positive painting, the patterns themselves are very similar.*

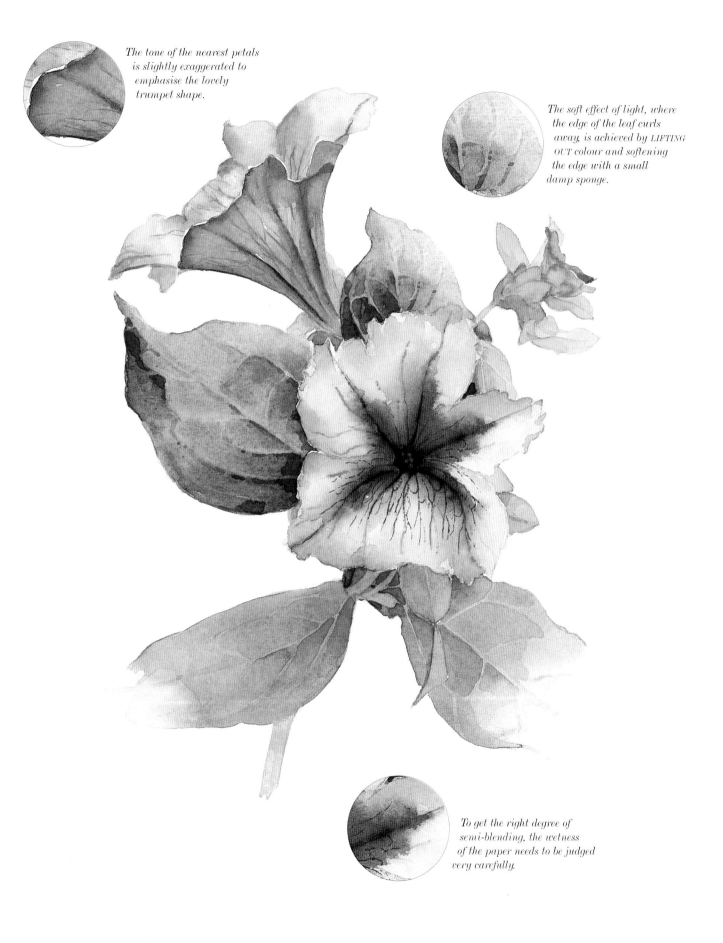

The tone of the nearest petals is slightly exaggerated to emphasise the lovely trumpet shape.

The soft effect of light, where the edge of the leaf curls away, is achieved by LIFTING OUT colour and softening the edge with a small damp sponge.

To get the right degree of semi-blending, the wetness of the paper needs to be judged very carefully.

Petunia sp.

Primula Primrose

This most familiar of all the primulas, the woodland-loving wild primrose, is one of the spring flowers that we delight in seeing after the bleakness of winter. Growing up to 6 inches (15 cm) high, it has rosettes of bright green, lance-shaped, crinkly leaves and clusters of pale yellow flowers with darker yellow centres. The five-petalled blooms are produced singly on short pink tinted stems. This type of flower, classified as star-shaped, is the easiest to draw and paint, but remember that the basic circle will form an ellipse when seen at an angle. Look for cast shadows that will make the flowers stand out, and also pay attention to the attractive texture of the leaves.

sequence start to finish

Transparent Yellow

New Gamboge

Dioxazine Violet

French Ultramarine

Cobalt Blue

Sap Green

Green Gold

Quinacridone Gold

Brown Madder

1 Make a drawing of the whole plant and lay a VARIEGATED WASH underpainting over all of the flower and leaf shapes. To do this, start by wetting all the painting area, inside your drawing lines, with a round No. 12 brush and clean water. Tip the board a little so that the wash will run down slowly (see VARIEGATED WASH). Starting at the plant's top, puddle on mid-toned Transparent Yellow, and begin to add Cobalt Blue about halfway down. The yellow will run into this, making a pale green. Carry on with the blue to the bottom of the plant, letting the yellow continue to run down. Leave to dry with the board at the same angle.

2 The light is coming from the right, so the darkest, coolest colours will be on the left of the flowers and the cluster. With a No. 8 round brush, paint in the shading on the flowers with Transparent Yellow,

New Gamboge and Cobalt Blue, using mixes of the colours in some places and pure Cobalt Blue in others. With the paint still wet, use the brush point to tip in strong New Gamboge in a star shape around each flower centre. When the flowers are dry, emphasise a few of the cast shadows with a thin glaze (see WET-ON-DRY) of Dioxazine Violet. Paint Cobalt Blue washes on the leaves, starting to indicate the crinkly texture. This colour will throw the flowers into focus. Paint in the thin stalks with pale Brown Madder.

3 Using a mid-toned mix of French Ultramarine and Green Gold, and the same brush as before, paint the leaf patterns made by the veins. Try not to make the leaves too uniform and leave some of the first wash where suitable, for a good range of tones. The cast shadows will be painted later, so just concentrate on

the leaf structure, looking for the light and shade that explains the forms and how they turn away from the light. Paint around the bud at centre left so that it stands out as a pale negative shape (see NEGATIVE PAINTING), but make the other bud darker than the background – a positive shape.

4 Using a mid-toned watery French Ultramarine and Sap Green mix, paint the cast shadows on the leaves. Take some of this colour out into the leaf veins for emphasis.

5 Return to the flowers, and accent the centres with touches of Quinacridone Gold. Touch in a spot of Dioxazine Violet in the very eye. Finally, add dark Dioxazine Violet accents in the small spaces at the base of the plant.

special detail creating colour harmony by underpainting

▼ *For shading, paint on a New Gamboge and Cobalt Blue mix on the left of the centre petals, dropping in more Cobalt Blue. Leave until almost dry. Paint in the centre star shape with strong New Gamboge. For the leaf's texture, paint on shapes with thin Cobalt Blue, leaving the veins and areas that catch the light as the first wash.*

▲ *Where there are no strong colour contrasts, a painting can be begun by laying a one-colour or VARIEGATED WASH, using a base colour and dropping others into it. Start with a Transparent Yellow wash, dropping in Cobalt Blue towards the leaf base.*

▲ *When the flower colour has dried, glaze over most of it with thin Dioxazine Violet. Accent the centre with Dioxazine Violet. Paint the leaf's cast shadow with a watery French Ultramarine and Sap Green mix, using this for some of the leaf veins and the calyx. Strengthen the veins with a mix of the blue and green.*

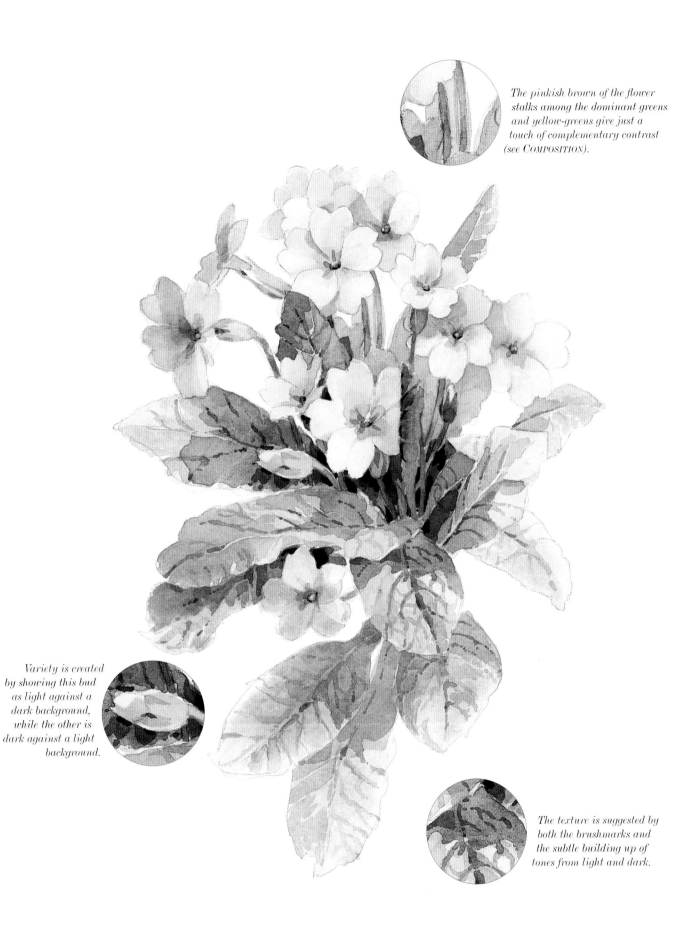

The pinkish brown of the flower stalks among the dominant greens and yellow-greens give just a touch of complementary contrast (see COMPOSITION).

Variety is created by showing this bud as light against a dark background, while the other is dark against a light background.

The texture is suggested by both the brushmarks and the subtle building up of tones from light and dark.

Primula vulgaris

Rhododendron Rhododendron

Indigenous to South Asia, but now found in a great many different parts of the world, rhododendrons were first introduced into Great Britain from China in the 1850s. But this desirable species is named after Yakushima, a small, mountainous, windswept island lying close to the southern tip of Japan. There are now many hybrids and a large range of colours from white, some being blotched or bi-coloured. The lovely blue-green broadly oval leaves have a heavy, woolly brown leaf covering underneath, which is a characteristic of these plants. The individual florets are cone-shaped and grouped together on a single stem to form a dome. You will need to be aware of this overall spherical shape and note how the light affects it before engaging with the separate florets.

sequence start to finish

Transparent Yellow

Quinacridone Red

Permanent Rose

Indigo

Cobalt Blue

Phthalo Blue

Cobalt Green

Sap Green

Olive Green

Quinacridone Gold

1 After making the drawing, lay a restricted wash over the flower head with watery Permanent Rose, reserving white paper for petals or parts of petals that catch the light – note that the light is coming from the left. When dry, use a damp brush to soften edges where they need to blend into the white petals (see HARD AND SOFT EDGES). Paint the closed bud petals with pale Permanent Rose, then allow to dry a little. Paint the sepals with a Cobalt Green and Transparent Yellow mix, allowing the colours to merge slightly.

2 Lay the first washes on the glaucous green leaves with mixes of Cobalt Green and Phthalo Blue, dropping in very watery Transparent Yellow in places, especially on the leaf tips. For the leaf on the left, where the underside is showing, wash in Quinacridone Gold and drop in Cobalt Green. Allow to dry.

3 Return to the flower head, and continue to build up the florets' forms by darkening the tones. The strongest tones are on the right outside edges. Using Permanent Rose, Cobalt Blue and Quinacridone Gold, work WET-ON-DRY, letting each layer dry before glazing on the next colour. Allow to dry, then add the red blotches with a Quinacridone Red and Permanent Rose mix. Allow to dry. Dot in the upper petal spots with a small brush and the same mix, radiating them out from a centre line to follow the petal's form. Carefully paint the red stigma and stamens with the same brush and colour.

4 Strengthen the bud's tones with stronger Permanent Rose, adding Cobalt Blue for the darker, cooler shades on the right side. Darken the green sepals with a Cobalt Green, Sap Green and Transparent Yellow mix, and when dry, wash Permanent Rose over the lower parts where the bud joins the stem.

5 Build up the tones of the leaves, varying the greens as much as possible while keeping mainly to the blue-green shades. Use various mixes of Phthalo Blue, Sap Green, Olive Green and Indigo.

6 Add final dark accents to the bud with a stronger Permanent Rose and Cobalt Blue mix – for the darkest of all, on the right, mix Indigo with Permanent Rose.

7 Add more definition to the brown felting on the underside of the leaf on the left, using darker Quinacridone Gold and Cobalt Green. To finish, put in a small amount of Olive Green at the darkest point.

special detail analysing shapes on multi-headed flowers

▼ *The flower heads are so densely packed that it can be hard to see the cone shapes of the individual florets. These are arranged around a central stem, meeting at just one point on it. To suggest this, vary the planes and angles – here the main florets are shown as a series of ellipses, with the central one the widest.*

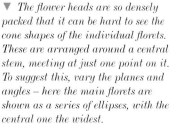

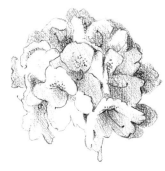

▲ *In its simplest form, the flower head can be thought of as a ball or sphere, and the placing of the shadows must emphasise this feeling of roundness. Reserve the darkest tones for the shaded right side of the sphere and the crevices between the florets.*

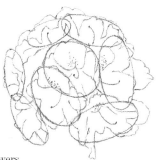

▼ *Colour also plays a part in building up the shapes of the flower head and the florets, the petals most in shadow being darker and cooler in colour. For the darker shading, go from pink to a violet shade rather than just strenthening the pink, and add a touch of yellow to suggest a glow of reflected light.*

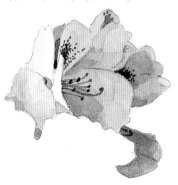

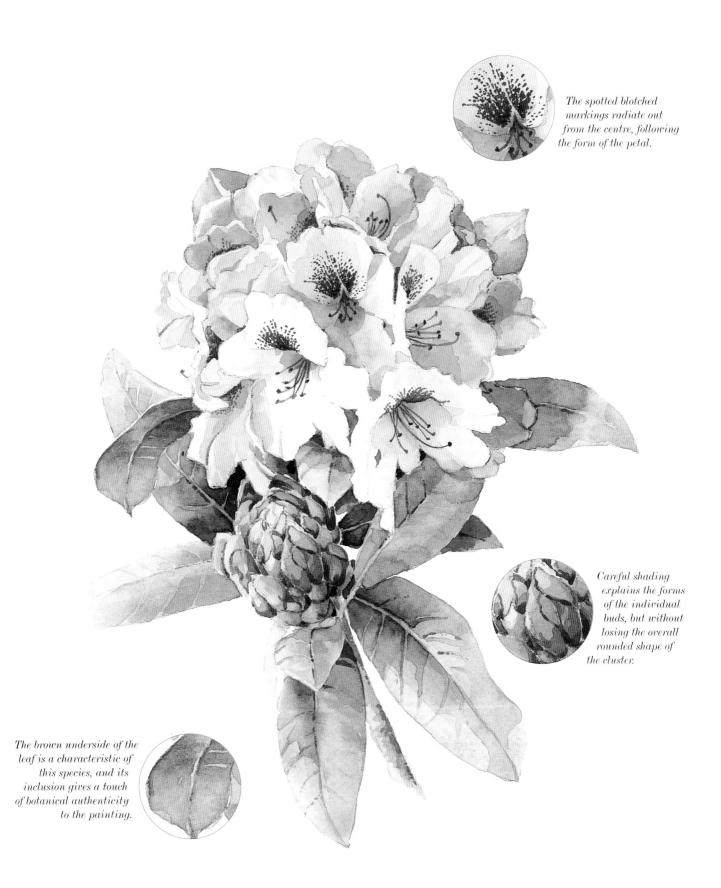

The spotted blotched markings radiate out from the centre, following the form of the petal.

Careful shading explains the forms of the individual buds, but without losing the overall rounded shape of the cluster.

The brown underside of the leaf is a characteristic of this species, and its inclusion gives a touch of botanical authenticity to the painting.

Rhododendron yakushimanum

Rosa Rambler Rose

The rose is deservedly one of the most popular of all plants, and over the centuries many varieties of shrub and bush roses have been developed. It is also one of the finest of all climbing plants; rambler roses in particular are superb for clothing walls, producing masses of flowers in huge sprays, on arching, thorny stems. This variety has reddish salmon buds that open to reveal sweetly scented, loosely double, coppery pink flowers borne in clusters. The dark green leaves are divided into five to seven oval-toothed leaflets with pointed tips. When painting these flowers, look for the tonal variations, and for the differences in colour temperature from warm to cool. Also keep in mind the overall cup shape of the flowers and how the lighting affects this shape.

sequence start to finish

Transparent Yellow

Rose Doré

Permanent Rose

Cobalt Blue

Olive Green

Quinacridone Gold

Brown Madder

1 Take care with the drawing, as the flowers have complex shapes, with petals curving both inward and outward, but all radiating from the flower centre. Starting with the largest lower flower, lay on an overall wash of watery Rose Doré, reserving the parts of the petals that catch the light – mainly at the top of the flower – as white paper. While still wet, drop in watery Cobalt Blue down the right side and on the lower petals, and allow to blend. When dry, soften any edges that have dried looking too hard. Use Rose Doré again to lay a wash on the top two flowers and lower left flower, leaving small white areas on the top nearest flower. Darken the colour slightly for the buds, dropping some Quinacridone Gold into the pink on the central opening bud to give variety. Lay first washes on the leaves with mixes of Cobalt Blue and Transparent Yellow, making the colours cooler on the more horizontal surfaces.

2 Build up the tones on the main flower, using Rose Doré, Cobalt Blue and Transparent Yellow mixes. Soften edges as you paint, and pay attention to colour temperature – the larger outside petals tend to be cooler on the edges where they curl away from the light, while the colours are slightly warmer towards the centre. Complete the other three top flowers in the same way, adding touches of Permanent Rose, and using less of the blue. Avoid using dark tones on the lower left flower so that it does not compete for attention with the main flowers.

3 Continue to build up the main flower by glazing on (see WET-ON-DRY) veils of Cobalt Blue, Permanent Rose and Rose Doré. This flower is mostly in shadow, and thus cooler in colour than the top flower, requiring more blue. The crevices, however, are relatively warm, so for these, use darker mixes of Rose Doré, Permanent Rose, and Quinacridone Gold.

4 Paint the second tone on the leaves with Cobalt Blue and Transparent Yellow, ignoring the cast shadows at this stage. Indicate a few of the thin leaf veins to describe the fall of the leaf. Allow to dry, then paint on strong cast shadows with a watery Cobalt Blue and Olive Green mix, and add small accents of this colour around the main flower.

5 Complete the flowers, darkening the crevices of the three in the foreground with small amounts of Brown Madder and Rose Doré. Add details on the top and left flowers with the same colours, but in this case making them no darker than mid-toned. Add accents on the three small buds with the first darker mix, and use this also to paint the tiny thorns on the branch at bottom right.

special detail convex and concave shapes

▲ Towards the centre of the flower the petals are concave, while the outer ones are convex. Lay on first washes of watery Rose Doré, dropping in pale Cobalt Blue towards the right edge, and leaving white paper for the areas catching most light. Allow to dry.

▲ The shapes of the shadows and the colour variations are important. The surfaces of the petals curling into the centre are warm in colour, while the outer ones on the right are relatively cool. Use Rose Doré and Cobalt Blue mixes to paint the shadow shapes.

▲ Leave to dry again before continuing to strengthen the shading with the same two colours. Paint the warm-coloured dark crevices, blending in Transparent Yellow in the flower centre.

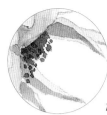

Small details, such as
this glimpse of the
center of a dead flower,
add to the overall
picture of the plant.

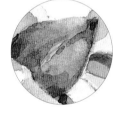

The lower petal of
the bud is a warm salmon
pink, caused by reflected light
from the yellow-green leaves.

The interesting
shadow shapes cast on
the leaves by the petals
are washed on last.

Rosa wichuraiana

Strelitzia Bird of Paradise

This spectacular plant, once seen and never forgotten, is a native of South Africa. It is a unique flower, not appearing to fit into any of the usual categories of flower shapes. The plant is clump-forming with somewhat fan-shaped groups of foliage – large, stout, evergreen blue-green leaves which are bluntly spear-shaped and borne on long stems. The exotic flower, shaped like a bird's head, opens at the top of a long, strong stem. It has showy orange sepals and bright blue stigmas which both rise up out of a sheath-like structure held at right angles to its stem. Because this flower is not easy to categorise in terms of shape, care must be taken in its construction. For example, make sure that the 'plumage' – sepals and stigmas – appear to be emerging from the sheath at the top.

sequence start to finish

Transparent Yellow

Cadmium Orange

Alizarin Crimson

Dioxazine Violet

French Ultramarine

Cobalt Green

Phthalo Green

1 Make a careful drawing, then paint the orange sepals using a No. 8 round brush and Cadmium Orange. Paint from the tip downward, leaving strips of white to suggest shine. Towards the base, drop in Transparent Yellow to blend, leaving white paper at the very bottom. While these washes are drying, proceed to the beak-like sheath from which the sepals rise. Wet the shape, down to the stem to where it meets the enclosing bracts, with clean water, then drop in Cadmium Orange along the top edge. Use stronger Cadmium Orange where the sheath turns into the stem, and paint the rest with pale Phthalo Green, dropping in Transparent Yellow at the pointed tip and the stem.

2 Now work on the three blue stigmas, painting them carefully with a small brush and French Ultramarine, dropping in Dioxazine Violet on the back two while still wet.

Allow to dry before returning to the orange sepals. Using an Alizarin Crimson and Cadmium Orange mix, paint in lines to suggest shading and form as the sepals turn away from the light. Use a darker mix of the same two colours to paint in the cast shadow and any linear accents.

3 Add shading to the blue stigmas in the same way, using dark French Ultramarine, and then give a little texture to the sheath by very faintly dry brushing (SEE DRY BRUSH) along the shape with a fairly pale Alizarin Crimson and French Ultramarine mix.

4 With the flower almost complete, start on the leaves, painting the large background one first with a Cobalt Green wash. Before the wash is dry, use stronger Cobalt Green and the tip of the brush to paint in leaf veins. Again before dry, add a Cobalt Green and Transparent Yellow mix to some of the edges, and paint a wash on the curled-back lower leaf sections, indicating some leaf veins with a stronger mix of the same colours. On the smaller, nearer leaf, lay a Cobalt Green and French Ultramarine wash on the right side, and a wash of Cobalt Green and Transparent Yellow on the left. Before the washes have dried, use stronger mixes to paint in some leaf veins. Allow to dry.

5 To finish the leaves, add darker linear details to some of the veins on the nearer leaf with mixes of Cobalt Green, Phthalo Green and French Ultramarine. On the back leaf, glaze (see WET-ON-DRY) a thin veil of French Ultramarine at the bottom of the leaf and into the stalk and paint in some darker leaf veins on the right side where the leaf curls away.

special detail using colour granulation

Some pigments dissolve entirely in water, while others precipitate – that is, the particles of pigment tend to separate from the water, giving a slightly speckled effect when laid on paper. Cobalt Green is one colour with this property.

▶ *Lay a wash of fairly pale Cobalt Green over all the shape – it begin to granulate almost immediately. If a rough paper is used, the effect is more pronounced, as the colour is broken up even more by the grain of the paper.*

▶ *Before this first wash has dried, paint the leaf veins with the tip of the brush and a darker Cobalt Green, letting the brush describe the gentle curve of the leaf.*

▶ *Finally, add some warmer passages from the right edge towards the leaf centre with a mix of Cobalt Green and Transparent Yellow. This new colour will also granulate, as Cobalt Green is one of the components of the mix.*

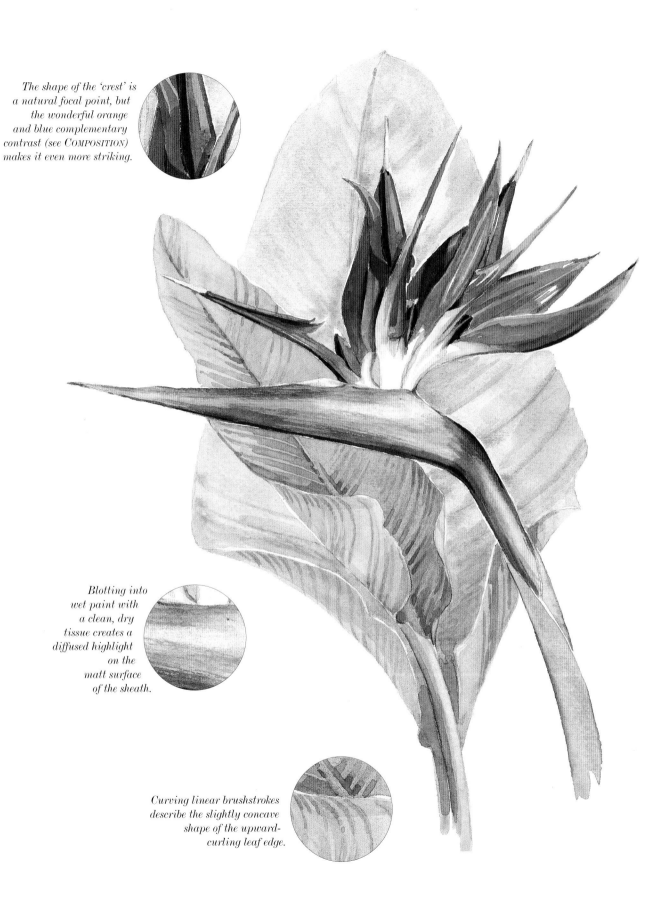

The shape of the 'crest' is a natural focal point, but the wonderful orange and blue complementary contrast (see COMPOSITION) makes it even more striking.

Blotting into wet paint with a clean, dry tissue creates a diffused highlight on the matt surface of the sheath.

Curving linear brushstrokes describe the slightly concave shape of the upward-curling leaf edge.

Strelitzia reginae

Syringa Lilac

Lilac is one of the loveliest of all spring-flowering shrubs. The name comes from the Persian word for blue – *nilak* – as the unimproved original was bluish in colour. The tiny individual florets, tubular in shape, achieve their spectacular effect by the way in which they are thickly massed together to form large cone-shaped spikes or panicles, offset by fresh-looking light green, heart-shaped leaves. When painting, always try to convey the solidity of the basic cone shape, looking for the play of light on this basic form. Think too about how much detail you want to include; you may only need to describe a few florets to give a good impression of the flower.

sequence start to finish

Transparent Yellow

Quinacridone Magenta

Cobalt Violet

Dioxazine Violet

Cobalt Blue

Sap Green

Olive Green

1 The light is coming from top left, so when you have made the drawing, mask off (see MASKING) just a few of the florets, or parts of them, on the left side of each cone. Paint the left-hand cone first, starting at the top. Using a No. 12 round brush and watery Cobalt Violet, stipple the outside edges to give the impression of small petals. Work down the cone, dropping in watery Cobalt Blue on the right side and towards the bottom of the cone. Repeat the process on the right-hand cone, and before the paint has dried, lay the first washes on the leaves with a Cobalt Blue and Transparent Yellow mix. Allow to dry.

2 While painting the cones, keep half-closing your eyes so that you see the overall shading without being too distracted by detail. Starting at the top of the left cone, and using a No. 8 brush and watery Quinacridone Magenta, begin to paint around some of the florets to reserve them as the first-wash colour. Concentrate most of this NEGATIVE PAINTING on the right side and middle, as the cone is lightest on the left side. In some cases, where areas are in shadow, paint whole florets in this middle tone. Drop in Cobalt Blue from the centre to the right side to blend, and towards the bottom of the cone, increase the strength of the magenta, dropping in Dioxazine Violet and Cobalt Blue. Then work up from the bottom of the right cone, using the darker mid-tone of Quinacridone Magenta for the lower right side.

3 Apply the second tone on the leaves, adding detail such as the veins, and using mixes of Sap Green and Olive Green with Cobalt Blue added to cool where needed. Leave more of the first wash showing on the left-hand leaves, which catch the light, and use just Transparent Yellow for the back leaf on the left. For the right-hand leaves, leave just a hint of the veins in the first-wash colour. Allow colours to blend in places.

4 Rub off all the masking and tint some of the small white shapes with pale Cobalt Violet. Then add some further definition to the flowers, paying attention to the variations in colour. With a No. 8 brush and Quinacridone Magenta, Cobalt Blue and Dioxazine Violet, continue to paint around some of the florets. The lowest edge of the left cone casts a dark shadow on the right one, so here use a strong mix of Dioxazine Violet and Cobalt Blue.

5 Finish the flowers with small, strong accents of Dioxazine Violet and Quinacridone Magenta, painting tiny negative shapes among the already quite dark tones. Avoid any strong accents on the light-struck sides of the cones, concentrating on the shadow areas.

special detail painting around complex shapes

▼ *Using thin Quinacridone Magenta mixed with Cobalt Blue, paint on the next tone, taking the colour around some of the small petals and florets, and dropping in Cobalt Blue towards the right (shaded) edge. Allow to dry, and then rub off the masking.*

▲ *The initial drawing must be carefully done, showing the shapes and placing of the florets that are to be reserved as white paper during the first wash. Mask these off and then lay a wash of Cobalt Violet over the shape, dropping in Cobalt Blue on the right side. Allow to dry.*

▲ *Tint some of the small white shapes with pale Cobalt Violet, leaving those on the left side mainly white, then continue to paint around the florets with a darker mix of Quinacridone Magenta, Cobalt Blue and Dioxazine Violet. Strengthen the colour towards the right edge, going from light through mid-toned to dark.*

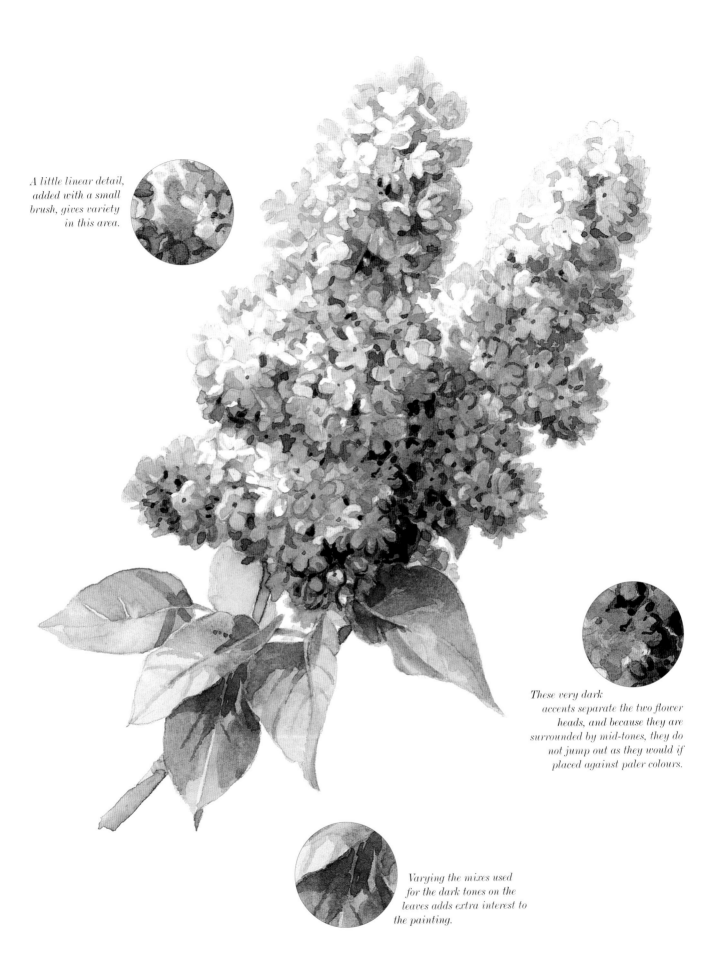

A little linear detail, added with a small brush, gives variety in this area.

These very dark accents separate the two flower heads, and because they are surrounded by mid-tones, they do not jump out as they would if placed against paler colours.

Varying the mixes used for the dark tones on the leaves adds extra interest to the painting.

Syringa vulgaris

Tropaeolum Nasturtium

These bright, cheerful, easy-to-grow flowers, originally hailing from Peru, were well known in Elizabethan England, where their attractive flowers and peppery leaves were valued as salad ingredients – there has recently been a revival of interest in their culinary properties. The flowers are orange, red or yellow, and the flat, rounded, bluish-green leaves, which are instantly recognisable, are often semi-trailing. The flowers form open-mouthed trumpet shapes with long spurs, with each bloom carried on a long stalk, which winds around supports. The flower has two upright, usually heavily veined, petals and three bearded lower petals, with the long spur clearly visible when seen from the side.

sequence start to finish

Transparent Yellow

New Gamboge

Cadmium Orange

Quinacridone Red

Alizarin Crimson

Thioindigo Violet

Indigo

Cobalt Blue

1 Make a careful drawing to show how the plant grows, then use a No. 10 brush to paint a wet wash of strong New Gamboge over the middle larger flower. Immediately work in Cadmium Orange WET-IN-WET on the shaded petals. Drop in Quinacridone Red for further shade, mainly on the two upright petals. While still wet, etch in small petal veins with a fine pointed twig (see USING A STICK), and drop in a stronger Quinacridone Red and Alizarin Crimson mix at the base of the two upright petals – the throat of the flower – fanning the colour out along the petal veins. Bring all the flowers to this stage, and paint the small buds with the same colours.

2 The blue-green leaves are a perfect foil for the brilliant orange of the flowers, and the colours to use for these are Phthalo Blue, Sap Green, Transparent Yellow and Cobalt Blue. Paint the majority with a Phthalo Blue and Sap Green

mix, laying on the first washes with a No. 10 round brush, and dropping in Transparent Yellow in places. In some areas, leave thin strips of white for leaf veins, but not for the leaves in shadow. Allow to dry.

3 Now lay the second wash on the leaves, glazing on (see WET-ON-DRY) mixes of Phthalo Blue and Sap Green on the greener leaves, and mixes of Cobalt Blue and Sap Green on the blue leaves. Leave this layer to dry, and then paint the darkest accents with a Sap Green and Indigo mix, softening edges as you work (see HARD AND SOFT EDGES). The shadowed areas of the flowers need to be darker in tone, so glaze over these with Alizarin Crimson. This is one of the more transparent pigments, which allows the previous colours to show through. Add a little Alizarin Crimson to the buds also, but keep the painting of these uncomplicated.

4 The two upright petals have dark crimson petal veins tapering into the throat. Slightly strengthen the crimson shading on these, and then paint in the petal veins with Thioindigo Violet and a small brush, darkening them where they disappear into the throat with an Indigo and Thioindigo Violet mix. Paint the shape formed by the inside of the spur with a New Gamboge and Phthalo Blue mix, and paint in the orange bearded shapes protruding from the lower petals, using Cadmium Orange darkened with Alizarin Crimson.

special detail exploiting warm/cool colour contrasts

▼ *Start with the 'local' (actual) colours of the petals and leaf. For the warm yellow-orange petals, use a wash of New Gamboge, immediately dropping in watery Cadmium Orange to blend. Lay a Sap Green wash on the leaf, and allow to dry.*

▲ *Next, adjust the leaf colour: Blue is the complementary colour to the orange of the flower, so add Cobalt Blue washes to parts of the leaf, mainly at the top and towards the bottom of the shape. This makes the green cooler, providing a contrast to the brilliant orange.*

▲ *With leaf colour established, that of the flower can be adjusted accordingly: red and green are complementaries, and the leaf is green, so paint a second tone on the flower with a thin wash of Quinacridone Red, leaving some of the first wash for light areas. The red intensifies the orange and makes it still warmer, glowing out against the cool green of the leaf.*

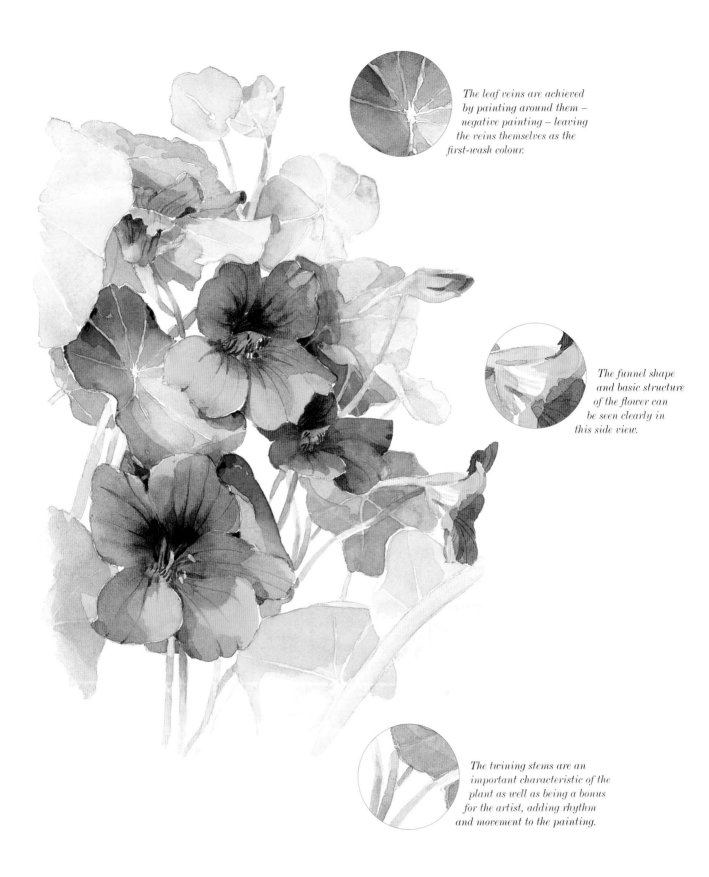

The leaf veins are achieved by painting around them – negative painting – leaving the veins themselves as the first-wash colour.

The funnel shape and basic structure of the flower can be seen clearly in this side view.

The twining stems are an important characteristic of the plant as well as being a bonus for the artist, adding rhythm and movement to the painting.

Tropaeolum majus

Tulipa **Tulip**

One reason we find ourselves drawn to flowers is because of their incredible colours, and the brilliantly flamboyant parrot tulip is no exception. Subtle shifts in hue within each petal, from yellow to orange to red, are an exciting challenge to paint. When painting this multi-ruffled flower do not lose sight of the overall 'cup' shape. Notice also the light and shade on the whole flower as well as on the individual petals.

sequence start to finish

Transparent Yellow

Phthalo Red

Quinacridone Red

Alizarin Crimson

Permanent Rose

Dioxazine Violet

Indigo

Cobalt Blue

Olive Green

Quinacridone Gold

1 First you need to plan out the different painting stages. Working on smooth (hot pressed) paper, make a loose drawing with a 2B pencil showing the twists and curls of the petals. Smooth paper will allow the paint to flow quite freely. Mask out (see MASKING) the central stigma and the surrounding pointed shapes with masking fluid.

2 Once the paper is dry, working as usual from light to dark colours, use a No. 10 round brush with Transparent Yellow to paint in the yellow on the lower, large petal. Now, onto the damp paper, paint Quinacridone Red into the rest of the petal and let it blend with the yellow. Add touches of Phthalo Red in shadow areas, and allow it to blend a little. This stage is an example of free washes within a shape, using WET-IN-WET on dry paper. The wet shapes are contained by surrounding dry areas, so the technique is quite controlled.

3 Before the washes are quite dry, take a twig dipped into Quinacridone Gold to create the petal veins (see USING A STICK). Then use the Phthalo Red in the same way for the red lines. Carry out the same procedure to paint the rest of the petals, varying the proportions of red and yellow as you proceed. For the top back petals, use a cooler Permanent Rose strengthened in parts with Alizarin Crimson to give an impression of depth and recession.

4 Allow to dry. Define the depth of the flower by deepening the shadows with touches of Alizarin Crimson, darkened with Dioxazine Violet in the deepest crevices. Soften this into the surrounding reds with a damp brush.

5 When all the paint is dry, rub off the masking fluid in the centre of the flower. Tackling the white, pointed shapes surrounding the stigma, wash in a mix of Quinacridone Gold and Cobalt Blue. Tease the dry, red edges into the edge of the shapes to soften them. Paint the top of the stigma with a weak mix of Transparent Yellow and the stem of the stigma with Olive Green. When dry, paint the stamens in Indigo.

6 Paint the flower stem in one stroke with a No. 10 round brush using a mix of Transparent Yellow and Cobalt Blue. Paint the leaves in the same way using the same mix as before. While the leaves are still wet, add a watery mix of Quinacridone Gold to the left-hand leaf and Transparent Yellow to the right-hand leaf. To suggest leaf veins, dip the twig into Olive Green and pull the stroke upward from the bottom.

special detail flooding in a darker area

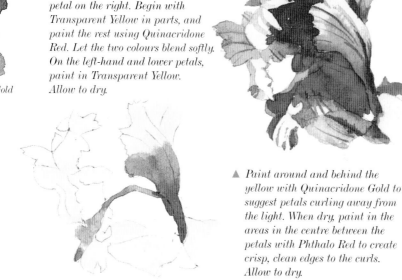

▼ *Paint in the local colour of the petal on the right. Begin with Transparent Yellow in parts, and paint the rest using Quinacridone Red. Let the two colours blend softly. On the left-hand and lower petals, paint in Transparent Yellow. Allow to dry.*

▲ *Paint around and behind the yellow with Quinacridone Gold to suggest petals curling away from the light. When dry, paint in the areas in the centre between the petals with Phthalo Red to create crisp, clean edges to the curls. Allow to dry.*

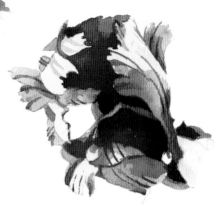

▼ *Paint strong Alizarin Crimson into the crevices to strengthen and further define the deeper shadows. Add a few delicate touches of Dioxazine Violet to this. Soften the Alizarin Crimson into the Quinacridone Red where needed, leaving other parts sharp-edged.*

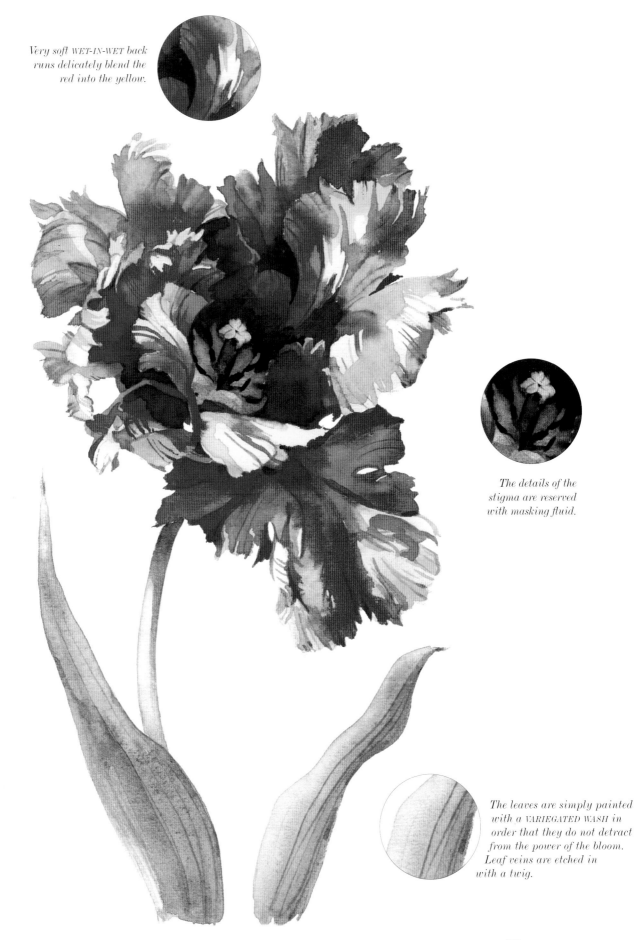

Very soft WET-IN-WET back runs delicately blend the red into the yellow.

The details of the stigma are reserved with masking fluid.

The leaves are simply painted with a VARIEGATED WASH in order that they do not detract from the power of the bloom. Leaf veins are etched in with a twig.

Tulipa sp.

Viola Pansy

The delightful pansy, with its wonderfully coloured, velvety, flat-faced flowers has a long association with lovers. The flowers have five overlapping petals, the upper two often longer and erect, and the middle lower one usually broader with a yellow nectary at its base. Most varieties have at least two contrasting shades: sometimes one colour forms a fringe around the petals, and sometimes the flower will have a 'face' – usually a dark mask-like blotch – of another colour at its centre. The leaves range from pale to dark green, and may be oval or heart-shaped. The challenge in painting pansies is how to achieve their velvety texture whilst retaining their delicacy.

sequence start to finish

Transparent Yellow

New Gamboge

Quinacridone Magenta

Dioxazine Violet

French Ultramarine

Cobalt Blue

Sap Green

1 Draw the plant lightly and then mask off the yellow flower centre (see MASKING). Tip the board forward slightly, and begin by painting the shadowy areas of white on the flower, using different pale to mid-toned mixes of New Gamboge, Cobalt Blue and Dioxazine Violet, and radiating the strokes outward to form petal ridges. Make the colour a little warmer – more yellow – on the front petal, and a cooler blue-violet behind.

2 Now begin to paint the dark colours WET-IN-WET, working on one petal at a time, and leaving thin white lines between them. Starting with the two upright back petals, load a No. 12 round brush with a mid-toned mix of Quinacridone Magenta and Dioxazine Violet and paint all the front petal. Immediately, add brushstrokes of a dark, very liquid mix of Dioxazine Violet and Quinacridone Magenta, tapering them downward from the tip to the throat of the flower. While still damp, use a sharpened twig (see USING A STICK) to etch in a few fine petal veins

radiating outward from the throat, then use the same colours to paint the visible part of the back petal, varying the tones slightly.

3 Dampen the whole of the front petal with clean water, and working quickly with a well-loaded No. 12 brush, paint the central marking with the same mix as before, letting the colour fuse slightly into the white strip. Immediately, etch in some prominent petal veins with the twig, taking the lines out into the white banding. Add very dark Dioxazine Violet to the marking at the throat and let it run down a little. Paint the outside edge with the violet and magenta mix, tapering off the strip from the centre triangle. Paint the two winged side petals in the same way, making the colour a little paler at the edge of the right petal, where it catches the light.

4 When dry, reinforce some of the shadows on the markings with Dioxazine Violet, and lighten other areas where you need to push them

back or bring them forward by carefully lifting out some of the colour with a damp brush (see LIFTING OUT). Rub off the masking at the centre of the flower, and tint with New Gamboge, Transparent Yellow and Cobalt Blue shading.

5 Paint the leaves and stalks with various mixtures of Cobalt Blue, Sap Green and Transparent Yellow, taking care to make some of the greens warm and others cool (see COMPOSITION). Allow to dry, then re-dampen each leaf with clean water and darken the greens, using Sap Green and French Ultramarine mixes. Allow to dry. Add stronger accents to the leaf veins in places with darker mixes of the previous colours and touches of Dioxazine Violet.

special detail leaf construction

Leaves are often neglected in a painting, or treated with less care than the flowers, but although they can be played down, they must be given sufficient attention to make the structures clear.

▶ *The central rib should be drawn first, then the outline of the leaf. Always carry the line of the central vein in a smooth curve – to make each line join the others in a natural way it helps to think of the leaf initially as being transparent. This leaf is deeply toothed, narrow and tapering.*

▶ *Paint in the first washes, using mixes of Cobalt Blue, Sap Green and Transparent Yellow. Make the colour cool on horizontal surfaces and warmer on the more vertical ones.*

▶ *Using mixes of Sap Green and French Ultramarine, add the darks in distinct positive shapes that emphasise the curl of the leaf.*

Petal veins are
drawn into the wet
shape with a stick
(see USING A STICK),
and the lines teased
out at the edge.

A characteristic thin white
edge is left when painting
the petals.

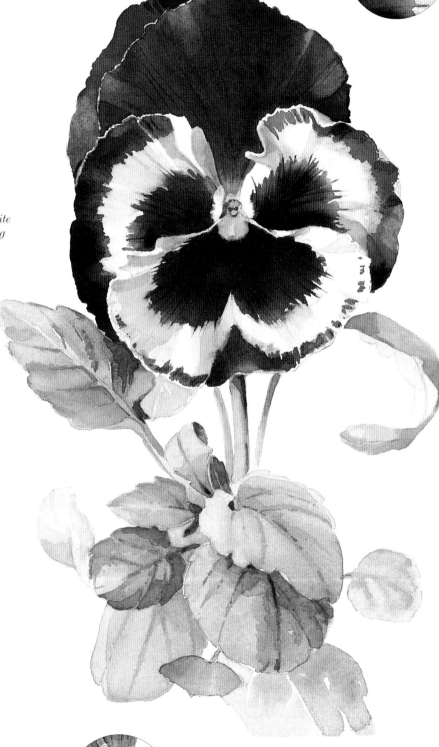

Purple and yellow are
complementary colours, and
consequently the yellow
nectary forms an eye-catching
focal point (see COMPOSITION).

Viola x wittrockiana

Wisteria Chinese Wisteria

Few plants are more romantic than wisteria, with its long falls of cascading tresses. These lovely climbers are most often seen trained up the walls of houses or over pergolas. This Chinese wisteria differs from the Japanese floribunda wisteria in that its whippy stems twine anticlockwise. It is extremely vigorous, and the bluish-violet racemes of pea-like, scented flowers open just before or at the same time as the young oblong, alternate leaves. Before painting observe closely the structure of the open florets, and notice how they overlap each other and change direction and shape as they go around the central flower stalk.

sequence start to finish

New Gamboge

Permanent Rose

Cobalt Violet

Dioxazine Violet

Cobalt Blue

Sap Green

Olive Green

Quinacridone Gold

1 After making the drawing, use a No. 10 round brush to start painting a light wash of a Dioxazine Violet and Permanent Rose mix from the top of the main raceme, leaving any white shapes – mainly on top – where the florets catch the light. Use a pale mix to begin with, darkening it a little as you paint down towards the tip. Treat the raceme as a whole at this stage. When you reach the smaller buds about half-way down, stop and go back to the top, as you need to drop in other colours before the wash is dry. Paint the lipped pouches at the base of each upright petal with Cobalt Blue and allow to blend a little. Again before dry, make strokes of New Gamboge at the base of each upright petal. Allow to dry.

2 Finish painting the first washes on the rest of the racemes, including the tiny buds at the bottom, which alternate down the

stem. Use the Dioxazine Violet and Permanent Rose mix as before, dropping in Cobalt Violet while wet. Now return to the top florets, using the same mix with touches of Cobalt Violet to grade the tone darker towards the left. Paint some of the florets, mainly those of the outside left edge, as positive shapes and treat others as negative shapes, painting around them (see NEGATIVE PAINTING).

3 With the same flower colours of Cobalt Violet, Dioxazine Violet and Cobalt Blue add warm shades behind some of florets on the right to suggest background flowers. Starting at the top, go over the whole of the two main racemes, strengthening where necessary with mixes of these colours. Paint the visible parts of the stalks with Olive Green, darkened with Dioxazine Violet.

4 The leaves, which start to open at the same time as the flowers, are a pale bronze-green colour. Lay in first washes with a pale Quinacridone Gold and Sap Green mix. Leave to dry, and then darken some with stronger mixes of the same colours, adding leaf veins and stalks, especially to those on the left. When dry, paint a small area of WET-IN-WET background around the top florets to suggest flowers and foliage, using pale Quinacridone Gold and Sap Green, and dropping in Dioxazine Violet and Cobalt Violet. Paint the twiggy branches with Quinacridone Gold, Olive Green and Dioxazine Violet, keeping them light and understated.

special detail analysing irregular flowers

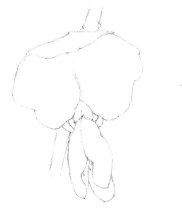

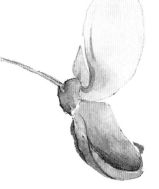

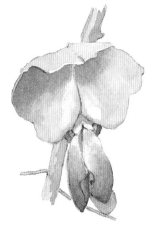

▲ *Seen from the front, these florets are symmetrical, but unlike most flowers, they are bilaterally symmetric, which means that they can be divided into just two corresponding parts along a mid-line running from top to bottom.*

▲ *When the floret is viewed from the side, you can see the back of it, and the way in which it joins the stem. Before drawing an unusual flower shape like this, look at it from different angles to make sure you understand the structure.*

▲ *Another important thing to observe is the variation in the colours. The upper petal is a pale lilac with a touch of yellow at its base, and the three pouched lower petals are a deeper, bluer shade.*

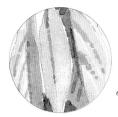

These leaves are known
as 'opposite', meaning that
they are arranged in pairs
along the stem.

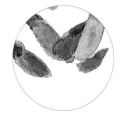

The buds at the bottom of
the spike, which open last,
make an attractive shape
in contrast with the full-
blown blooms above.

Subdued colours worked
WET-IN-WET to give hazy
outlines provide a
suggestion of further
blossoms in the
background.

Wisteria sinensis

Zantedeschia Calla Lily

This beautiful native of tropical South Africa is grown for its erect, funnel-shaped flowers and large arrow-shaped, long-stalked leaves. These are a lustrous deep green, while the flowers range in colour from white, yellow and orange to pink and lilac. The curled petal of the calla lily that encircles the central yellow spike is in fact a modified leaf called a spathe, which flattens around the erect spike as it opens. The veins in both the waxy flower and the leaves need to be painted carefully as they explain the structure and curl of the forms. Also ensure when drawing that the central flower spike is a continuation of the flower stalk, as are the central leaf veins and their stalks.

sequence start to finish

New Gamboge

Dioxazine Violet

Cobalt Blue

Viridian

Olive Green

Green Gold

Naples Yellow

Quinacridone Gold

1 After drawing, start painting the main flower, laying a wash with a Naples Yellow and Green Gold mix, and leaving a strip of white on the front edge. Grade the wash so that it is darker on the left outside edge. For the funnel shape where the flower joins the stem, start with a Green Gold wash, making it slightly lighter on the right, and then darken the colour on the left with Viridian. For the stem itself, just use Green Gold. Before the washes have dried, etch a few lines on the funnel with a sharpened twig (see USING A STICK). Paint the first washes on the tight bud at top left and the unfurling bud and stalks, using a mix of Naples Yellow and Green Gold. Drop in Viridian on the shaded left side of the tight bud and on the two stalks, then before dry, etch in some curling lines on the tight bud.

2 To paint the leaves, tip the board forward slightly (see VARIEGATED WASH), and lay on a very wet Green Gold wash over all the larger left leaf. Immediately drop in watery Cobalt Blue on the cooler-coloured right side of the central vein, and allow it to run to the outside edges. Repeat the process on the smaller right-hand leaf and the lower leaf. Allow to dry, then use a clean, wet brush to lift out (see LIFTING OUT) some leaf veins on the right side of the centre vein on both of the top leaves. Blot dry with a clean tissue. Continue to build up the darker tones of the leaves, using Viridian and Quinacridone Gold mixes. Paint around the veins with these darker colours, and when dry, glaze (see WET-ON-DRY) Cobalt Blue over the cooler-coloured section towards the right edges. Add cast shadows to the stems with Viridian and Olive Green.

3 Return to the main flower, laying washes of a Cobalt Blue and Viridian mix over the shaded areas of the white spathe. Add touches of pale Dioxazine Violet in the centre and at the left side where the form curls away into shadow. This colour warms up the white a little, and also helps to make the spathe stand out from the background leaves. Paint the centre spike with a wash of New Gamboge, darkening on the left with Quinacridone Gold.

4 Use white gouache (see BODY COLOUR) to paint light touches on the veins of the leaf at top right and in the central area of the leaf behind the flower. Use a small brush to describe a few linear highlights on the contours of the flower and the lower bud. Finally, go over the whole painting and accent with the white gouache where needed – you may find you want to either bring a section forward or separate it from the background leaves if the tones are too similar.

special detail using white gouache for highlights

▲ *White gouache is often used for final highlights in watercolour painting, and is also sometimes added to watercolour to give pale colours a milky appearance. Start by painting watery Green Gold over the shape, and dropping in watery Cobalt Blue towards the right side. This pushes the Green Gold to the right. Allow to dry.*

▲ *Lay Cobalt Blue on the right side of the centre rib, going around the leaf veins and strengthening the colour on the right edge. On the left of the centre rib, paint around the leaf veins with a Viridian and Quinacridone Gold mix.*

Paint the stalk with the same mixture as before adding shading and dark accents with a strong mix of Viridian and Olive Green. Allow to dry.

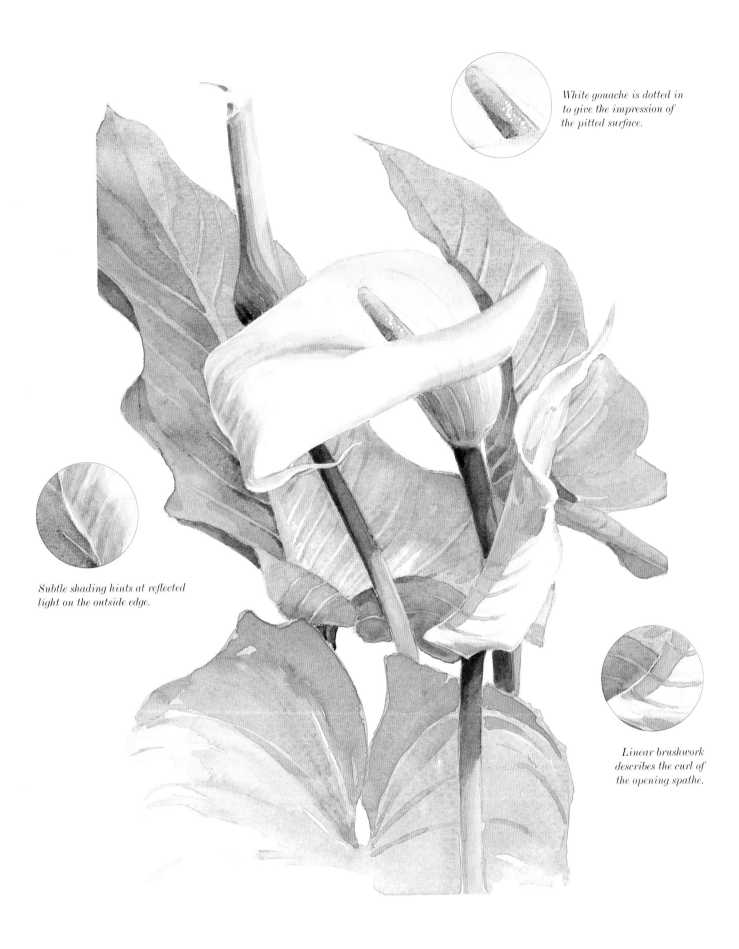

White gouache is dotted in
to give the impression of
the pitted surface.

Subtle shading hints at reflected
light on the outside edge.

Linear brushwork
describes the curl of
the opening spathe.

Zantedeschia aethiopica

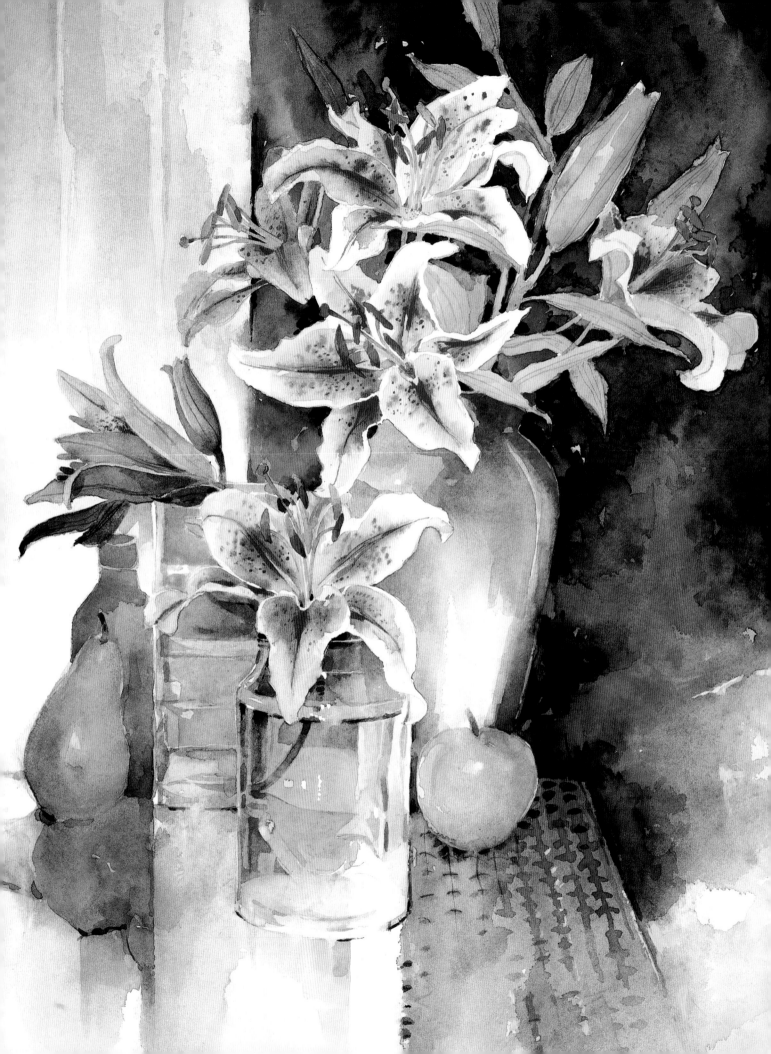

composing floral groups

So far, you have been concentrating on painting individual flowers, on mixing colours that do justice to nature's hues, and on practising a variety of techniques that help to describe the special qualities of petals and leaves. Now that you have acquired these basic skills, you are ready to take a step further into the realm of creative painting by tackling full-scale floral groups, and to do this successfully you will need to consider various aspects of composition.

Painting floral groups is a branch of still-life painting. You are in control of the subject and can arrange the components of the picture in any way you choose. Because a large part of the composition is done before you lay brush on paper, it pays to take time over the initial arrangement. Try out your chosen flowers in different vases and set them against different backgrounds. Explore various light effects – you can do this by carrying the vase of flowers around the house and placing it on a table near a window to provide top- or side-lighting, or even on a windowsill so that the light comes from behind. When you have found the right place for your group, look at it through a viewfinder to check whether it fits comfortably within the picture area (you can make a viewfinder very simply, by cutting a rectangular aperture in a piece of card). Once you begin to look at it as a potential picture, you may find you need to make adjustments. For example, a tall central flower might require cutting down so that it does not go out of the picture at the top, or one at the front arranged to overlap the top of the vase.

ADDING EXTRA COMPOSITIONAL ELEMENTS
You may also notice that there is a lot of dull empty space around and beneath the vase. This is one of the problems inherent in floral groups, because most of the interest is concentrated in one area. A compositional device often used by flower painters is to pick one or two of the blooms and place them beside or in front of the vase, thus both adding interest and making a link between the two main areas of the composition. If your group is in strong light, there may be cast shadows that you can exploit as a compositional element to balance the

◀ Stargazer Lilies

This is an excellent example of the way in which the viewer's eye can be led into the picture. There is a natural tendency to follow a diagonal line, so the table's edge acts as the first 'signpost', from which we travel upward through the curve of the apple to the gentler curve of the vase and thence to the focal point, the main group of flowers.

ACHIEVING COMPOSITIONAL BALANCE
Here the balance of the composition appears top-heavy with the mass of flowers dominating the top half of the design. To achieve design unity, objects must fill the picture area. So one shape can be allowed to dominate with smaller, contrasting elements added in.

The glass vase with its single flower has been brought in to overlap the larger one, thus linking the front and back areas of the composition and giving the overall design a greater degree of balance. Try to play down the glass vase and the small bottle on the left so that they do not attract too much attention.

Here the number of lilies in the vase has been reduced to simplify the composition, and fruit added in for extra interest. Notice the directional lines that lead the viewer's eye through the painting and impart it with movement. Background shapes are just as important as the subject matter and here, a dark background shape helps display the paler flowers.

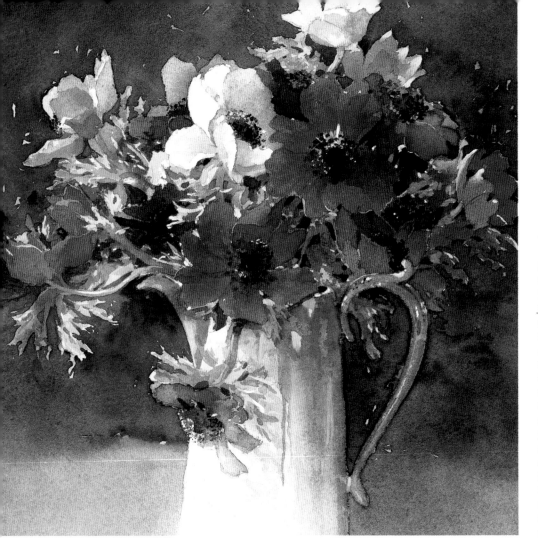

In this painting you can see both the contrast and repetition of shapes. The mass of flowers is arranged to form a rough oval shape, which contrasts with the straight sides of the vessel. But the curve of the handle echoes those of the flowers and stems, and a further curve has been brought in on the table top, where the light tone meets the darker one. To help unify the background with the flowers, reds have been dropped into the wet green background washes to blend, especially on the right-hand side. And hints of the flower colours have been used to tint the white jug. The artist has solved the problem of empty space below the vase by cropping it so that it goes out of the picture at the bottom.

CREATING VARIETY

Here the jug is shown without the curling handle and the front falling down flower, so the composition is duller by comparison. Tonal interest is created by the addition of the contrast of the dark background with the white jug, together with highlights on the flowers and leaves.

shapes of the flowers. And, of course, you can bring in other objects – fruit is often used as a component of floral still life, and can be chosen either to contrast with the flower colours or to harmonise with them. Avoid cluttering the composition with too many other objects, though, and don't allow them to compete with the flowers for attention. Remember that these are the major 'stars' of the picture, with other objects playing a secondary role.

LEADING THE EYE

Most paintings have a centre of interest, known as a focal point, to which the viewer's eye is led by a series of visual 'signposts'. A diagonal line in the foreground – perhaps a strategically placed mat on the table, or the edge of the table itself – will lead the eye up to the vase and thence to the flowers. If you are including other objects, try to arrange them so that they lead in to the focal point and also create relationships between one area and another. For example, a piece of fruit overlapping a vase ties the two objects together as well as establishing their individual positions in the picture space.

COMPOSING WITH SHAPES

Whether you are setting up an elaborate group or a simple bunch of flowers in a vase, try to forget about the petals and leaves initially. Instead, concentrate on the main shapes, viewing them as an abstract arrangement rather than as specific objects. A contrast of shapes can give a sense of drama to a painting. For example, the overall shape of the massed flowers might be a rough circle or oval, which would contrast well with a straight-sided vase. Exploiting the contrast

▶ White Peonies in a Jar

In a painting like this, which has a very limited range of colors, tone plays a major role, and the pattern of light and dark has been used skillfully. Placing the main contrast of tone high up in the picture area ensures that the eye is drawn in to explore the picture before reaching the focal point. The use of a large area of negative white space in the foreground helps to draw the eye in, though its primary purpose is to act as a balance for the white flowers thus emphasising them.

between man-made objects and natural ones is a good way of emphasising the free forms of the flowers – you could arrange them in front of the geometric grid of a window frame, or play up the contrast between the flowers and vase and the straight horizontal or diagonal lines of the table top.

But you don't always want to go for drama and contrast – it very much depends on the subject. A more restful impression is created by repeating shapes, especially if these are based on circles and curves, as are many flower shapes. Roses, or daisy-type flowers, could be painted in a round-sided vessel, or perhaps on a circular table, so that the theme of curves runs right through the painting, or you could bring some fruit, such as apples or a bunch of grapes, into the composition to provide a series of large and small circles.

LIGHT AND DARK
Although you don't always need shape contrasts, tone (the lightness or darkness of the colours) is an area where contrast is always needed. Without it the painting can look dull and lifeless. Sometimes tonal contrasts will be provided for you – white flowers against dark green leaves, for example – but frequently you will have to introduce it yourself by choosing the background and vase with tone in mind. If you are painting flowers in their natural habitat, it may be necessary to exaggerate any darks, especially if the light is not strong, suggesting foliage or a dark sky with deep greens, blues and blue-greys. Newcomers to flower painting tend to be afraid of dark-toned colours, believing that they may sacrifice the delicacy of the flowers, but as long as the colours themselves are kept clean and pure this is unlikely to happen.

EDITING NATURE
Painting flowers outdoors is in many ways more challenging than working from an indoor setup. Not only may you need to adjust, or even invent, tones and colors, you will also almost

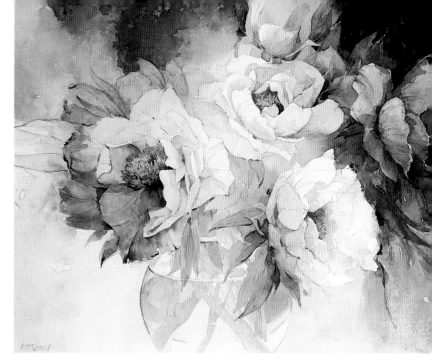

▲ Peonies in a Fishbowl

This lovely painting is as much about shapes as it is about flowers. The flowers form a series of curves, and the artist has cleverly chosen this unusual round vessel to ensure that the theme runs right though the painting. She has again cropped the vase at the bottom to exploit the curve of the right edge of the vessel, which leads the eye into the picture and up to the larger open flower. The tones have been carefully controlled to enhance the pattern element, with the dark shadows on the left side of this flower balanced by the negative dark tone behind the top right flowers.

REPETITION OF SHAPES
Before painting a composition it is useful to have an abstract in one's mind of the dominant shapes at play in the overall design. Dominance and rhythm can be achieved with the repitition of curved shapes – in this case, of the flowers, glass bowl and background tones – which provide a contrast with the shapes of the leaves.

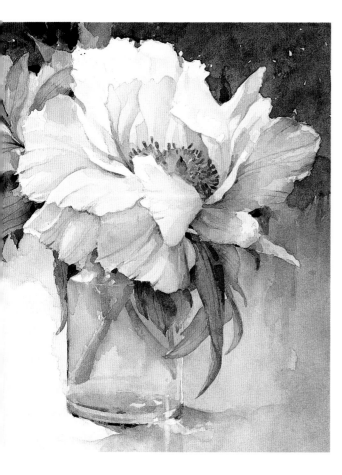

THE IMPORTANCE OF TONE
Don't be afraid of strong tones – here the white flowers are not shown to full advantage, because the negative background shape is not providing enough contrast. There are no other white shapes to interchange with the flowers to add variety.

Here, placing the major contrasting tone high in the painting gives the viewer time to explore the picture before the focal point is reached. The artist has cleverly left the lower background space white to emphasise, and act as a balance to, the white flowers.

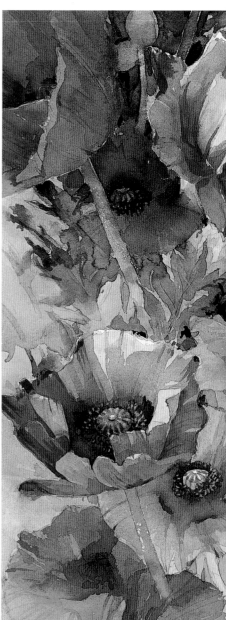

◄ Sunflowers

The artist has made an exciting and unusual composition from an outdoor subject by omitting extraneous detail and rearranging the flowers on paper to give more impact and interest. Unusually, she decided on a horizontal format for the tall upright flowers because she wanted to contrast their verticality with the banded, horizontal feeling of the background shapes. More contrast has been achieved through colour, with the dark sky area throwing the flowers forward and giving them an extra sparkle. Notice too how she has linked the two separate groups of flowers by overlapping the leaves in the centre, almost as though they were holding hands.

COMPOSITIONAL RHYTHM
Here the two items are set side by side, equally spaced, so they look static and contrived. There has been no attempt to design the negative background shape and tonally the design is flat and uninteresting.

This image has more variety. Bringing the flowers slightly closer to each other and hence altering their relative sizes creates movement, with the larger left-hand flower coming forth and the flowers on the right receding slightly into the background.

Here the vertical appearance of the flowers is contrasted with the banded, horizontal feeling imparted by the background shapes. Further variety is achieved with the dark sky area which throws forward the sunflowers and makes them sparkle.

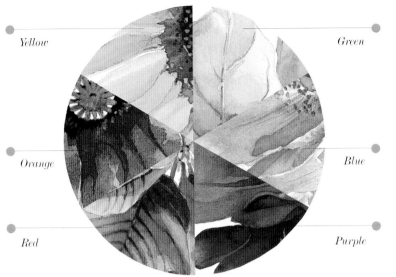

Yellow

Green

Orange

Blue

Red

Purple

THE COLOUR WHEEL

The colour wheel shows how the warm colours are grouped together on one side, and the cool ones on the other. These groups, either of warm or cool colours, create harmonious effects, while the complementary colours – those opposite one another – create strong contrasts. These colours have another use in painting, as they can be mixed together to make neutral greys and browns.

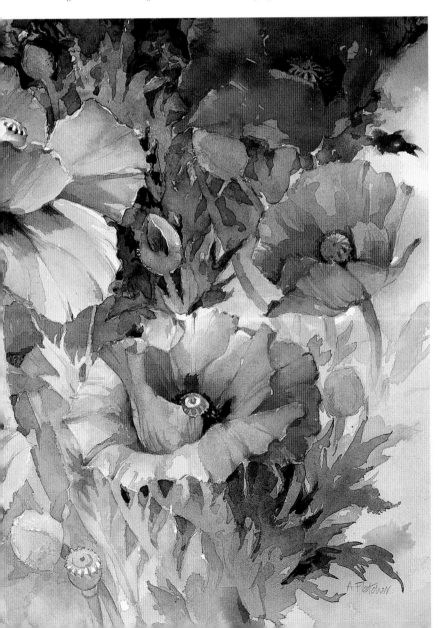

certainly have to edit the subject, leaving out some elements and rearranging others. A flowerbed in high summer may be the gardener's pride, but it doesn't necessarily provide a ready made composition. You as the artist will have to decide what to focus in on, how to structure the composition, and how to choose the focal point and lead the eye in to it. Painting just what you see could lead to a weak and confused jumble of shapes and colours, so be ruthless, decide on the group of flowers that most interests you, and give these pride of place, emphasising them through tone and colour contrasts.

COLOUR: CONTRASTS AND HARMONIES

You can draw the eye to a certain area of the painting by juxtapositions of colour as well as by tonal contrast. The most powerful colour contrasts are achieved through use of the complementary colours – those that are opposite one another on the colour wheel. The main complementary pairs are red and green, orange and blue, and yellow and mauve. Most red flowers have inbuilt complementary contrast, as leaves are green, but for orange, yellow or blue flowers you might consider bringing in this type of contrast through your choice of background colour – yellow flowers against a mauve backcloth, for example. But you don't have to make complementary contrasts this obvious; they can be used in a very subtle manner. If you are painting orange flowers, touches of blue on the leaves, or blue-green mixes, will give a lovely sparkle to the painting and emphasise the brilliance of the orange.

If the subject demands a quieter, more restful colour scheme, the colours to use are those that are close together on the wheel, which create gentle harmonies. Try setting up a group of blue, white and mauve flowers – blue is the most restful of all the colours. For a stronger but still harmonious scheme you could combine yellows and oranges, or pinks and reds.

WARM AND COOL COLOURS

Blue is restful partly because we associate it with the sky, and partly because it is one of the colours described by artists as cool, whereas red, orange and yellow are perceived as warm. The contrast between warm and cool colours plays a very important part in painting, because the former tend to come forward in space while the cool colours recede. Making the colours cooler in the background of a painting, or for any area you need to 'knock back', enables you to create the impression of space and three-dimensionality. Juxtaposing warm and cool colours is also one of the major ways of setting up contrasts: surrounding a warm colour such as orange with blue-green leaves makes the orange appear brighter than it would if surrounded by warmer yellow-green leaves. The most important fact to realize about colour is that it is relative – each colour owes its character to those that surround it or are next to it.

◄ Oriental Poppies

The leaves have been painted in cool colours to emphasise the warm, glowing oranges, reds and pinks, and at the top of the picture, behind the orange-yellow flower, touches of complementary mauve have been brought in on the leaves. To give a feeling of life to the subject, the shapes run out of the frame on three sides, suggesting that the flowers continue to grow outside the picture area. This was a compositional device often used by Degas, to give a sense of movement and immediacy.

Glossary

Cross-references to entries in the glossary are in *italics*

anther the part of the flower's *stamen* that produces and contains pollen, and is usually borne on a *filament*.

backruns the result of applying paint against an area before it is completely dry. The new colour seeps into the old, creating interesting effects. Many watercolour painters use backruns deliberately, both in large areas and small, as the effects they create are unlike those achieved by conventional brushwork.

blending the achieving of a smooth, gradual transition from one colour to another so that there is no discernable boundary between them. This is a slightly trickier process with watercolour paints than it is with oil or pastel because water-based paints dry quickly.

body colour opaque paint, usually the result of using *gouache* colours or mixing watercolour with white gouache to lessen its transparency.

boss a conical protuberance rising from the centre of a flower or surface.

bract a modified and often brightly coloured leaf.

calyx the outer part of the flower, usually green and formed of several *sepals*, which protects the bud.

complementary colours colours that are immediately opposite each other on the colour wheel (see page 125). For example, orange is complementary to blue,

as green is to red. These colours mutually enhance each other and therefore appear more intense when used together.

composition the arrangement or design of the different elements – lines, objects, shapes, colours and textures – to be expressed within a painting or work of art.

cool colours the colours associated with the sensation of cold, usually in the range of blue, violet and green. However there are so many varying tones of each colour that a red-based blue can appear warm while a green-based blue can seem cold.

corolla the petals of a flower.

dry brush the method of painting with just the bare minimum of paint on the brush so that the colour only partially covers the paper, creating a broken-colour effect.

filament the *anther*-bearing stalk of the *stamen*.

floret a small flower, usually one of a dense cluster.

focal point the object or area in a painting that attracts the most attention and to which the eye is naturally drawn.

glazing applying a wash of colour over a dried colour to amend it or give it more depth.

gouache opaque watercolour. Unlike pure watercolour, it does not dry as a transparent colour with the underlying background influencing it, but as a solid, flat colour. Artists like to use white gouache for highlights, or mix it with a watercolour to add details or emphasis to certain areas in a painting.

lifting out the method of creating light shapes and highlights in a watercolour painting by lifting out parts of a wash while it is still wet. Small sponges or paper towels are usually used for this method.

masking the method of laying masking fluid over white paper or dry paint to reserve fine lines or small details before the area is treated with a general wash. When the painting is finished the masking fluid is rubbed off or peeled away.

negative painting the method of reserving light shapes and highlights in a painting by painting darker colours around them.

pistil the seed-bearing organ of the flower consisting of the ovary, *stigma* and *style*. It is usually located in the centre of the flower.

stippling a technique of applying paint where the painting is built up entirely with tiny strokes of a fine, pointed brush. Alternatively, some artists use a broad, flat brush, charging it with just a little paint and allowing it to follow the direction of a form.

sepal one of the outermost circles of modified leaves surrounding the reproductive organs of a flower, and comprising a *calyx*. Sepals are usually green and found below the main petals.

stamen one of the male, pollen-bearing organs of the flower, consisting of the *anther* and *filament*.

stigma the usually uppermost part of the *pistil* of a flower, which receives the pollen grains and on which they germinate.

style the usually tapered part of the *pistil* that connects the ovary to the *stigma*.

warm colours the colours associated with the sensation of heat or warmth, usually in the range of red, orange and yellow. However, a blue-based orange may appear cool, while a red-based orange may appear warm.

wet-in-wet a standard watercolour technique in which colours are laid into or over one another while still wet.

wet-on-dry a standard watercolour technique in which successive washes are worked over colour which has already dried.

Index